Salvador Dalí

Catalogue Raisonné of Prints II

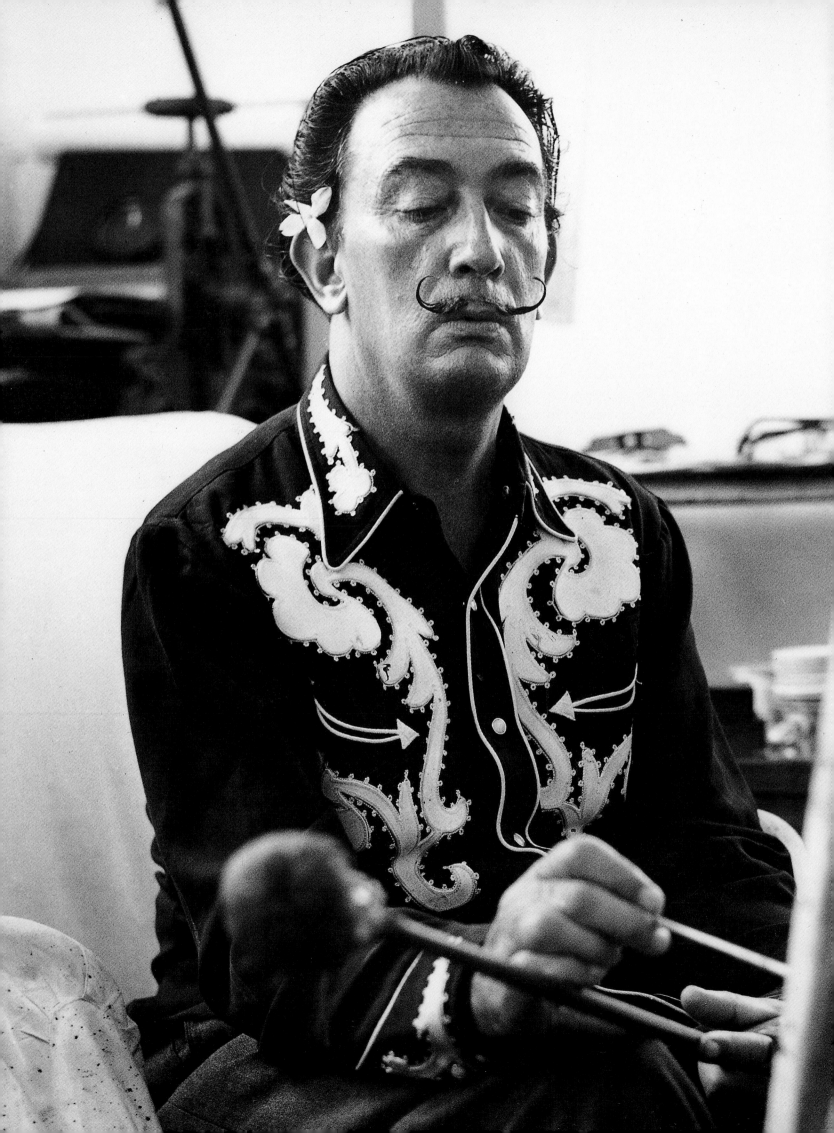

Salvador

DALI

Catalogue Raisonné of Prints II

Lithographs and Wood Engravings
1956-1980

Edited by
Ralf Michler and Lutz W. Löpsinger

With a foreword by
Robert Descharnes

Prestel
Munich · New York

© 1995 by Prestel-Verlag, Munich and New York
© for all works by Salvador Dalí: DEMART PRO ARTE B.V., Amsterdam, 1995
Photographic Acknowledgements: p.192
© for the photographs 2–6 (page 13): Descharnes & Descharnes. Photo: Robert Descharnes

Front cover: *Fille de Minos (Daughter of Minos)*, 1978 (cat. 1538)
Back cover: *Tilting at the Windmills,* 1956/7 (cat. 1011)
Frontispiece: Salvador Dalí in the late 1950s (photo: Fritz Rosewe)

Translated by John Brownjohn
Copy-edited by Simon Haviland

Prestel-Verlag
Mandlstrasse 26, D-80802 Munich, Germany, Tel. (89) 381709-0; Fax (89) 381709-35 and
16 West 22nd Street, New York, NY 10010, USA, Tel. (212) 627-8199; Fax (212) 627-9866

Designed by Heinz Ross, Munich

Typeset by OK Satz GmbH, Unterschleissheim near Munich
Offset lithography by Brend'amour, Simhart GmbH & Co., Munich
Printed and bound by Passavia GmbH, Passau

Printed in Germany

ISBN 3-7913-1602-8 (English edition)
ISBN 3-7913-1492-0 (German edition)

Contents

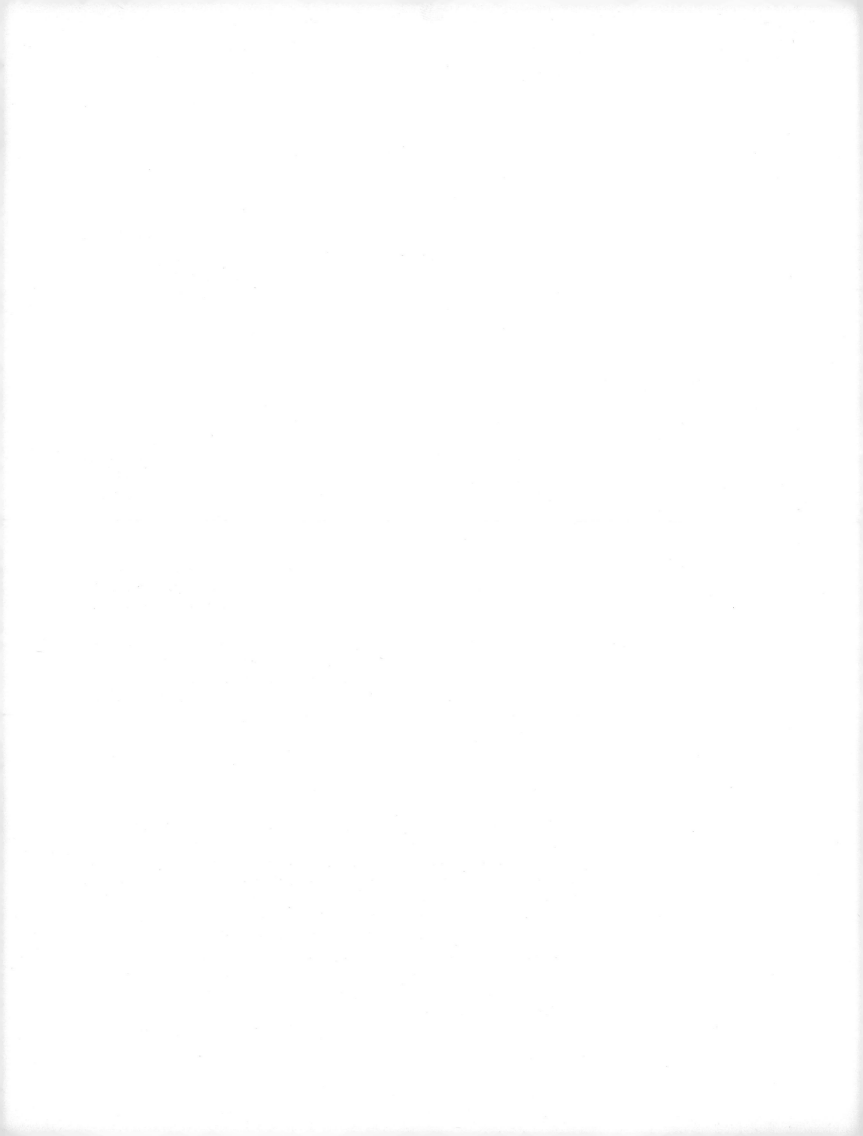

Foreword

Dalí: The Image and its Magic

Where Dalí's adventures in print-making are concerned, the engravings that were executed on metal – on copper, steel, gold, silver, or platinum – are an easy enough subject to tackle. In their case, Lutz Löpsinger and Ralf Michler have furnished the requisite guide in their *Catalogue Raisonné of Etchings and Mixed-Media Prints, 1924–1980.*

The prints Dalí produced with the aid of other media are quite another matter. Now, in this companion volume, *Salvador Dalí: Catalogue Raisonné of Prints II, Lithographs and Wood Engravings*, the same authors have been courageous enough to penetrate a veritable Amazonian jungle of prints. There is no doubt that their work blazes an extremely useful trail through the creative profusion Dalí left behind him.

Although I am not convinced that everyone will readily or immediately rediscover all his 'babies' in this volume, genuine explorers such as the present authors possess an inalienable right to venture into the unknown. They have brought us back an account as indispensable to the art lovers of today as it will be to the inquiring minds and researchers of the future. They have, in fact, forged a valuable tool.

Let us take a closer look at this important aspect of Dalí's irrational activity. How did such an abundance of prints come into being? How was it able to grow, flourish, multiply and proliferate? Between 1956 and 1979, or within the space of little more than twenty years, hundreds of different subjects were created.

Having been fortunate enough to live and work in close proximity to Salvador Dalí for almost four decades, I was in a privileged position as a close observer. As regards the field of activity that interests us here, I daily witnessed the gradual unfolding of a struggle that can only be described as 'Dalí versus Lithography'.

Here is an example of one of these contests.

The Promoter of the Match

Joseph Foret turned up at Port Lligat one evening in the late summer of 1956. Known to his friends as 'Oncle Jo', the publisher barged in on Dalí and proposed that he illustrate a book on Paris with some lithographs executed on stone. I remember that first encounter, at which I was present, as if it were only yesterday. Dalí's reaction was brusque: 'Monsieur, the answer is no! I have a horror of the libidinous and bureaucratic lithographic process. Yes, I'll illustrate a book, but it'll be "The Life of St John of the Cross" with engravings on steel. Anyway, all those stones would probably give me renal colic.'

A little man of Auvergne stock, Joseph Foret had the tenacity of his breed. Undeterred, he returned to the attack and gradually gained ground by accepting the conditions Dalí imposed: complete freedom to indulge his experimental whims. Paris and St John of the Cross were ditched: it would be *Don*

Quixote. At this stage Dalí thought he had won, thereby averting the danger of kidney- or gallstones! The more readily Foret sanctioned his experiments, however, the more the little publisher quietly but firmly refused to budge in the matter of the lithographic process. Outplayed, or so it seemed, Dalí finally gave in. In reality, though, he had devised a strategy of which more will be said below.

The Adversaries

Lithography

The lithographic process is a triumph of subtle gradations, half-tones, and softnesses. Spaces seem to become charged with the moisture that so effectively diffuses the luminosity and blue of the skies of the Île de France. Inks and lithographic crayons convey transparency, but they are far too dense ever to attain the gossamer lightness of watercolour or Indian ink wash. The artist has also to wage an unremitting battle against the grease that, inevitably, constantly adheres to his fingers. Above all, though, images reproduced by the lithographic process emit a sentimental, melancholic aura which Dalí both feared and detested.

Salvador Dalí

In Dalí, quite the contrary applies. The hierarchy of space is imperialistic. Washed by the Mediterranean wind and sun, it imposes and glorifies purity of line. A reservoir of explosive colour and light accumulates in blank surfaces strictly defined with linear rigour. In other words, there was nothing Dalí liked less than tussling with lithographic stones.

The Contest

The contest's greatest moments occurred at Port Lligat and in Paris. Never having genuinely tackled lithography hitherto, Dalí used every available means, in this first major confrontation, to get the better of his opponent without actually touching him. Stones and zinc plates were subjected to a multifarious avalanche of falling, flowing, spreading, proliferating, traversing, crashing, trickling, exploding elements loaded with ink. In short, these precious intermediaries worked for Dalí, a born manipulator, under his supreme direction. Here is an incomplete list of them:
– a Catalan hunter with a practised eye
– a well-maintained Spanish rifle
– cartridges filled with ink
– a harquebus with a spread of shot like a blunderbuss
– a packet of 'Silly Putty' (a kind of Plasticine)
– some wide-awake snails
– a pair of gazelle horns for drawing
– a flock of sheep on a visit to Paris
– two live octopuses from Port Lligat
– some broken rocks from Cap de Creus
– a greengrocer's barrow
– Don Quixote and Sancho Panza, two extras who have since
 become celebrated actors.

As protracted as all epic struggles, the contest went on for nearly a year, during which time Dalí notched up points. Lithographic stones were forever shuttling back and forth between Port Lligat and Paris. Carried away by creative inspiration in the heat of battle, the man in Port Lligat could not, on occasion, avoid touching the greasy ink with his fingers. It was the price of victory: a novel form of lithographic expertise had just been born.

The Victor

Satisfied with his success, Dalí at once had proofs made on paper of all the experiments he had conducted at Port Lligat and in Paris. Thereafter he 'quantified' the result of each manipulation. This qualificatory procedure consisted of detecting and, with the aid of a pen and paintbrush, conjuring up scenes from *Don Quixote* which were vaguely suggested by the random damage inflicted on the stones. Lithographers then transposed these modifications into the lithographic matrices from which definitive impressions were made.

Laurels and Trophies

The publication of *Don Quixote* with illustrations by Dalí was more than a success: Dalí's lithographs revolutionized the genre as a whole. Not to be outdone by the artist, Joseph Foret took the market aback by selling Copy No. 1 for a million old francs, ten times the price of the finest contemporary bibliophiles' edition.

The Surrealist Strategy

Don Quixote heralded a whole series of exploits. Dalí's Port Lligat manipulations had, of course, been preceded by a wide variety of experiments in painting during the surrealist period. This, however, was the first time he had exercised almost total freedom in the field of illustration.

Previously, during the 1930s and 1940s, Dalí had meticulously drawn and coloured each scene in this particular genre. One has only to compare the *Don Quixote* of 1946 with Joseph Foret's edition of a decade later. In the latter, the creative inspiration is freer and Cervantes's epic dream more violent. Dalí had taken a leap into new realms of the imagination.

The Image and its Magic

Dreams and day-dreams on the subject multiplied and their translation into images gained pace. The images themselves became more mysterious. The eye travels from one discovery to another in an ocean of stimulating visual sensations not devoid of a certain hermetism. Creative outpourings of this kind engender the worst as well as the best, but no matter. Dalí was in a hurry, and heedless of those who censured him for brazenly combining the most exalted techniques with the most commonplace methods of mechanical reproduction. He pressed on regardless, employing Heraclitus and Tantalus to render the interpretation of his images abstruse and difficult.

In Defence of Lyrical Confusion

Then began Dalí's boldly, universally inventive period. No longer concerned about the original quality of his prints, he made use of every available procedure. Above all, being a man of the Mediterranean, he preferred water to greasy ink. At this stage, when his fame was considerable, he had a compulsion to seem as dazzling in his person as in his works. This was the time of his gouaches and watercolours 'à la baignoire', which were subsequently reproduced as lithographs. Dalí's recipe was to draw the subject directly on a thick sheet of paper with tubes of gouache or watercolour. The Master was quite capable of instructing a friend or an unexpected visitor to apply paints to paper at random, straight from the tube. He would then go off to the bathroom, where he carefully manipulated the prepared sheet of paper in the bathtub or shower so as to obtain a mixture, a true blend of colours brought out by the effect of water. Once satisfied, Dalí never returned to the drawing-board. Some of the prints he produced in this way were titled, signed, dated, and delivered to the publisher as they stood. They are often among his most extraordinary creations.

Dalí's Dynamic Legacy

Those who are more enthralled by artistic creation than by the pecuniary value of a work of art; those who possess the poet's capacity for wonder and dread; those who are inhabited by dreams; those who know that love and war are fundamental to human existence – such people will forget the few miasmas that are already being dissipated by the winds of time. In this volume they will encounter the landmarks that enable one to discover and comprehend the battles which Salvador Dalí waged, all obstacles notwithstanding, in order to sow the seeds of the graphic art of tomorrow.

Robert Descharnes

Paris, 22 August 1995

Acknowledgements

We owe a special debt of gratitude to the Dalí Museum, St Petersburg, Florida, and, in particular, to Joan Kropf and Peter Tusch, who enabled us to work in their archive and check the sheet and print area sizes of many original designs. Multifarious contacts with national and international police authorities, Interpol included, made it possible for us to examine stocks of confiscated prints. In this connection we should like to say a special word of thanks to Hauptkommissar Ernst Schöller of the Landeskriminalamt, Baden-Württemberg, Chief Inspector Ellis of New York, and Kriminalhauptkommissar Kind of the Bundeskriminalamt, Wiesbaden. Through their good offices, we were able to examine 40,000 forgeries.

We should also like to thank Dalí's private secretaries, Captain Peter Moore and Enrico Sabater, who on several occasions examined the manuscript and provided valuable information.

We are grateful to the following persons and institutions for useful advice of many kinds: Karin von Maur, Staatsgalerie Stuttgart; the late Joseph Foret, publisher, Paris; Dr Rainer Cordes, Munich; Jacob Baal-Teshuva, New York; Daniel Meier, Basel; Ateliers Mourlot, Paris; Museum Boymans van Beuningen, Rotterdam; Albertina, Vienna; Nationalmuseum, Stockholm; San Diego Museum of Art; Philadelphia Museum of Art; Albright-Knox Art Gallery, Buffalo, N. Y.; Yale University Art Gallery, New Haven, Conn.; Kresge Art Museum, Michigan; Wendy Weitman of The Museum of Modern Art, New York; National Museum of Canada, Ottawa; Musée d'Art Moderne de la ville de Paris; Bibliothèque Nationale, Paris; Musée de l'Athénée, Geneva; Kunstmuseum, Berne; Öffentliche Kunstsammlung, Basel; Graphische Sammlung der Technischen Hochschule, Zurich; Museo Español de Arte Contemporáneo, Madrid; Museu d'Art Modern, Barcelona; Glasgow Art Gallery; Tate Gallery, London; Fogg Art Museum, Harvard University, Cambridge, Mass.; Birmingham Museum of Art; Kunstmuseum Düsseldorf; Hecht Museum, Wolfenbüttel; Städtische Kunsthalle, Mannheim; Von-der-Heydt Museum, Wuppertal; Kupferstichkabinett, Herzog Anton Ulrich Museum, Braunschweig; Staatliche Graphische Sammlung, Staatsgalerie Stuttgart.

Many auction houses were kind enough to grant us access to their records, notably Auktionshaus Karl & Faber, Munich; Auktionshaus Ketterer, Munich; Sotheby's, London; Christie's, London; Auktionshaus Winterberg, Heidelberg; and Auktionshaus Dörlin, Hamburg.

We should also like to thank the following establishments for entrusting us with graphic material: Galerie Orangerie-Reinz, Cologne, Galerie Bayer, Bietigheim, and Kunsthaus Artes, Rheda-Wiedenbrück. Dr Gloria Ehret of *Weltkunst*, Munich, deserves a special vote of thanks for all the help she has given us over the years. Last but not least, our gratitude for the indispensable work of proof-reading goes to Gusti Lanzenberger, Maria Niederschweiberer, and Galerie Susanne Berr.

The Editors

Explanatory Remarks

The market in Salvador Dalí's lithographs, as opposed to the etchings and mixed-media prints listed in Volume I, is an extremely dubious and indeterminate area. After researching his entire lithographic œuvre for nearly fifteen years we have been forced to conclude that, from the early 1970s onward, almost everything of Dalí's that even remotely lent itself to printing was printed, with or without his authority.

We should therefore like to emphasize at the outset that we cannot altogether exclude the possibility that isolated lithographs by Dalí, especially if distributed in the United States, have escaped our notice. By the same token, we cannot entirely exclude that possibility that one or two unauthorized lithographs may have crept into our catalogue.

In view of Dalí's sworn statement of 1 June 1985 and his further statement of 14 August 1986 (see Volume I, pp. 6–8) to the effect that he had signed his name fewer than one hundred times in 1980, we have not included any lithographs that originated after 1980, because Dalí from that time on was no longer in a position to sign print cycles. The only exceptions are *Flordali® I* and *Flordali® II* (cat. 1586 and 1587), which date from 1981 but are not hand-signed.

It is, of course, possible that a few lithographs were printed after 1980 on so-called 'pre-signed' blanks. We approach such prints with great caution, however, and share the view of the Print Council of America that they should be rejected on principle.

There exist books and portfolios containing illustrations after designs by Salvador Dalí (gouaches, watercolours, etc.), the majority of which were lithographically printed. Some of these illustrations (lithographs) were published separately in other formats and signed and numbered, as for instance Dalí's outstanding works for *Le Mille e una notte* and *L'Odyssée*. We list these lithographs in their original context (see cat. 1588–1607).

In contrast to our experience while researching Dalí's etchings, we found that certain publishers and their associates were far less helpful and far less interested in furnishing us with precise figures for editions of lithographs. We should therefore like to stress that, in isolated cases, numbered prints or cycles may exist which are not listed in the present volume. Although this need not by any means imply that they are forgeries, collectors should be on their guard in such cases.

Forgeries are dealt with, as in Volume I, in the Appendix. If a print is not listed there, this does not mean that no forgeries of the relevant subject exist; it simply means that none has so far come to our notice.

<div align="right">Ralf Michler</div>

Dalí's Lithographic Œuvre

Ralf Michler

Fig. 1 Salvador Dalí and Joseph Foret, editor of the *Don Quichotte* cycle of 1956/7, inspecting the lithograph *The Fight against Danger* (cat. 1009)

Quotations from:
Salvador Dalí/Michel Déon, *Histoire d'un grand livre: Don Quichotte*, illustrated by Dalí, Paris 1957

Fig. 2–6 Salvador Dalí executes the lithograph *The Aura of Cervantes* (cat. 1005) by shaking lead balls dipped in lithographic ink out of a shell

Salvador Dalí rejected any form of lithography as a medium of artistic expression for aesthetic, moral and philosophical reasons. He considered the technique bureaucratic, lifeless, liberal, and 'a method devoid of rigour, monarchy and Inquisition'. Not until he was more than 50 years old, and only in collaboration with the artist Georges Mathieu and at the insistence of the art publisher Joseph Foret, did Dalí take a closer interest in this technique. In 1956, Foret finally persuaded Dalí to commence work on his first lithographic cycle (*Don Quichotte*, cat. 1001–1012).

In his foreword to this volume, Robert Descharnes – who worked together with Dalí for many years and was witness to many of his wild demonstrations – describes how Joseph Foret's persistence and shrewdness paid off. Although Dalí developed a strong feeling of aggression towards Foret, describing him as "la sainte insistance", he did eventually start working with this medium. With as eccentric an artist as Dalí, it goes without saying that his methods were in no way conventional. The techniques adopted are vividly described by Descharnes. These even include a number of snails in his list of general 'assistants'. Dipped in Indian ink, they were left to crawl over the stone. Dalí also used empty snail shells, filled them with ink and fired them at the lithographic stones from a musket. In this and other manners, the first tachiste print cycles were created. He mixed original and photolithographic techniques. 'The most paradoxical elements were employed, and the teams worked according to the most peculiar methods, but the master had the last word in every case, so a mixture of techniques of this kind defies imitation.' Dalí's fantasy in devising new lithographical methods was boundless.

The Aura of Cervantes (cat. 1005), for example, was effected with the aid of 'Silly Putty' and some lead balls dipped in lithographic ink and shaken out of a shell (see fig. 2–6). When creating *The Battle with the Wineskins* (cat. 1006), which originated in Manequin's workshop, Dalí hurled an egg filled with lithographic ink at the revolving stone (see fig. 7–10) and described the result as circulating blood.

The lithograph *Gala, My Sistine Madonna* (cat. 1010), based on a subject by Raphael, was executed by Dalí on transfer paper, then crumpled and sprayed with ink.

In *Dulcinea* (cat. 1002), he threw small pieces of gravel and crushed a sea urchin. In *Tilting at the Windmills* (cat. 1011) he 'drew' a subject straight on to

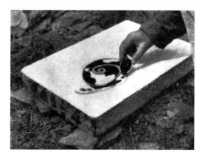
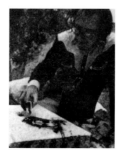
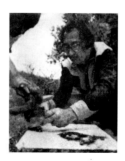
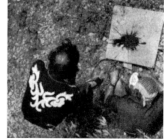

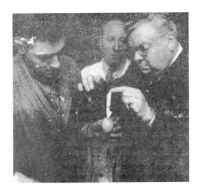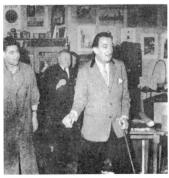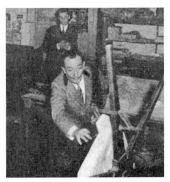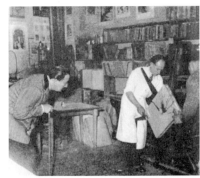

the stone using two rhinoceros horns filled with lithographic ink. Despite the fact that almost all these early lithographic works were produced with the aid of photolithography, Dalí was fascinated by such 'bouletiste' techniques. 'Bouletisme' is a word created by Dalí, derived from the French 'boule' (ball) and used to describe his work with rounded projectiles of all shapes and sizes, ranging from eggs to live ammunition.

Although Dalí never abandoned his prejudices against the lithographic technique, he was forever letting publishers of all kinds talk him into creating special designs for reproduction by a printer, sometimes lithographically. Some of these prints were later reworked by hand, with the result that many of them acquired an 'original' character.

Undoubtedly, one of Dalí's best set of designs is *La Divine Comédie* of 1960 (cat. 1039–1138). The wood engravings for these 100 watercolours were lavishly executed in Jacquet's and Taricco's workshops. The series originated as a commission from the Italian government. Dalí illustrated the *Divina Commedia* to harmonize with the individual cantos of Dante's dreamlike, secular epic, the introductory canto being followed by 33 each devoted to Hell, Purgatory and Paradise. A few years later, in 1964, Dalí himself produced two original zinc lithographs of Dante and Beatrice (cat. 1141 and 1142).

From 1965 onwards Dalí began to work closely with the American publisher Sidney Z. Lucas in New York (see fig. 11). Their association gave rise to such masterly lithographs as *The Cosmic Rays Resuscitating the Soft Watches* (cat. 1144) and *Drawers of Memory* (cat. 1145).

In *Drawers of Memory* Dalí reverted to the motif of *La Cité des tiroirs*, the 1936 pen – and – ink drawing now in the Paul L. Herring Collection in New York (fig. 12). Its meticulous draughtsmanship suggests that, although the publisher describes it as an original lithograph, Dalí enlisted a printer's photomechanical assistance. It should always be borne in mind, however, that the American definition of original character has for many years differed from the European. This lithograph must none the less be accounted one of the most attractive subjects in all of Dalí's graphic work. The subsequent transposition of the 'chest-of-drawers woman' into sculpture should be thought of in the same context.

As in France when creating the *Don Quichotte* cycle of 1956/7, so in America, Dalí liked to stage large-scale happenings:

As soon as I arrived in America the television producers scrambled for my *bouletisme* happenings. For my own part, I slept incessantly so as to see in my dreams how the holes for filling my balls should be mathematically arranged. In company with specialists in the arms trade I had myself awakened every morning by the rifle fire of the Military Academy of New York. Every shot engendered a complete lithograph, and all I had to do was add a signature, which art lovers wrested from my hands for a lot of money. I found, yet again, that I had anticipated the most important scientific discoveries when,

Fig. 7–10 Salvador Dalí executes the lithograph *The Battle with the Wineskins* (cat. 1006) by throwing an egg filled with lithographic ink at the rotating stone

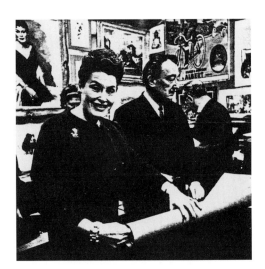

Fig. 11 Salvador Dalí in the Phyllis Lucas Gallery, New York, the gallery of the publisher Sidney Z. Lucas

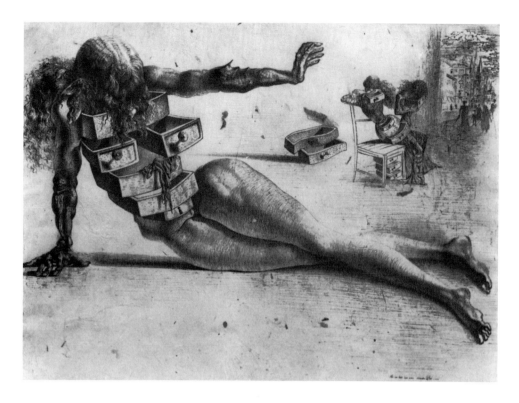

three months after my first rifle shot, I learned that astrophysicists were employing ballistics to explore the Big Bang theory, the mysteries of creation.

From 1966 onwards many publishers repeatedly urged Dalí to produce watercolours or gouaches on literary or musical subjects. The designs were then transferred to plates by lithographers or engravers or reproduced by photomechanical means. These Dalí later amplified in part, reworked, and sometimes altered completely. Certain cycles contain both pure engraver's work and original reworking.

In 1966 Dalí was commissioned by the publisher Gerschman to produce ten watercolours on themes from Hans Christian Andersen's fairy-tales. This idea appealed to Dalí, with his lifelong interest in literature, and he turned out some colourful designs for lithographs such as *The Ugly Duckling* and *The Girl Who Trod on the Loaf* (cat. 1168 and 1170).

Fig. 13　*Nebuchadnezzar*, 1964. Watercolour on handmade paper, 48 x 36. Dr Giuseppe Albaretto Collection, Turin. Design for a lithograph for *Biblia Sacra* (cat. 1600)

Fig. 14　*The Elephants*, 1966. Watercolour on paper, 39 x 28. Dr Giuseppe Albaretto Collection, Turin. Design for a lithograph for *Le Mille e una notte* (cat. 1602)

During the same period he painted the watercolours for *Biblia Sacra* (fig. 13) and *Le Mille e una notte* (fig. 14), which were intended as designs for the books published in Milan by Rizzoli (cat. 1600 and 1602). These lithographic book illustrations are listed separately at the end of the Catalogue, together with a selection of other books (cat. 1588–1607).

In 1968 and succeeding years Dalí produced illustrations for portfolios such as *Aliyah* (cat. 1193–1217), *Three Plays by the Marquis de Sade* (cat. 1232–1256), *Carmen* (1304–1328), and *Les Songes drolatiques de Pantagruel* (1398–1422).

From 1975 onwards Dalí's prints repeatedly borrowed other artists' subjects and subjected them to surrealistic alienation. Among other things, he made some small collages based on adapted works by artists such as Ingres and Cranach, thus producing numerous tarot motifs (see fig. 15) intended for a James Bond film but never conceived as prints (see cat. 1486–1494; 1501–1503; 1516–1524; 1539–1542; 1552; 1557–1561; 1569–1570). These lithographs are free translations based on these tarot motifs. Where printing techniques are concerned, one must in most cases speak of coloured lithographs (photomechanical translations), some of extremely poor quality. Marginal squiggles, largely unrelated to the subject, are taken as original reworking, and subjects were wrested from their original context and lumped together in new series.

It can in general be said that, from 1974 on, few lithographs or wood engravings were reworked by Dalí himself (cat. 1516, 1517). For all the criticism levelled at his late prints, two cycles of 1978 are worthy of mention. *Babaou* (cat. 1543–1549), embodying illustrations of which some were reproduced on paper as wood engravings, is a portfolio based on the book of the same name, published in 1932 by Edition des Cahiers Libres. The second noteworthy cycle is the portfolio *L'Art d'aimer d'Ovide* (cat. 1525–1538), published by the Centre Culturel, Paris. The thirteen wood engravings and one lithograph captivate the eye with their exceptional wealth of colour.

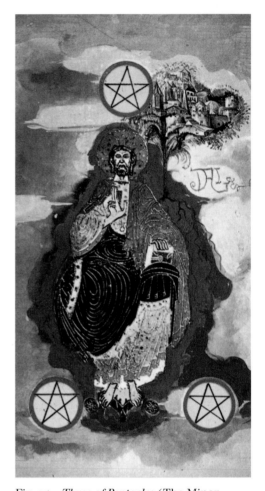

Fig. 15 *Three of Pentacles* (The Minor Arcana). Tarot motif. Original design after the lithograph *Pantocrator*, 1976 (cf. cat. 1486)

PLATES

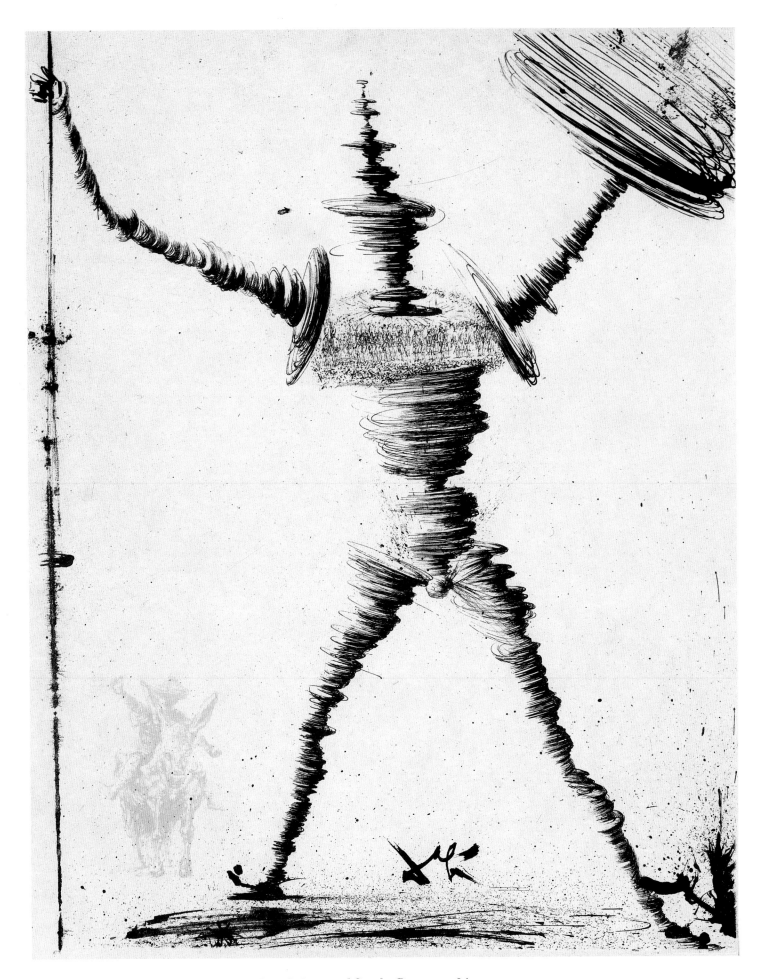

1 Don Quixote and Sancho Panza, 1956/7 cat.1001

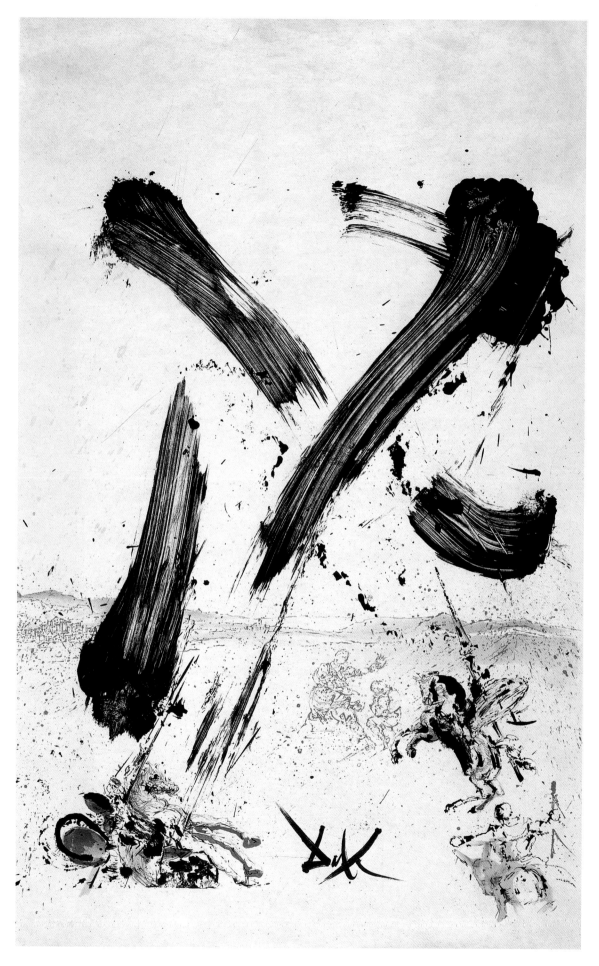

2 Tilting at the Windmills, 1956/7 cat.1011

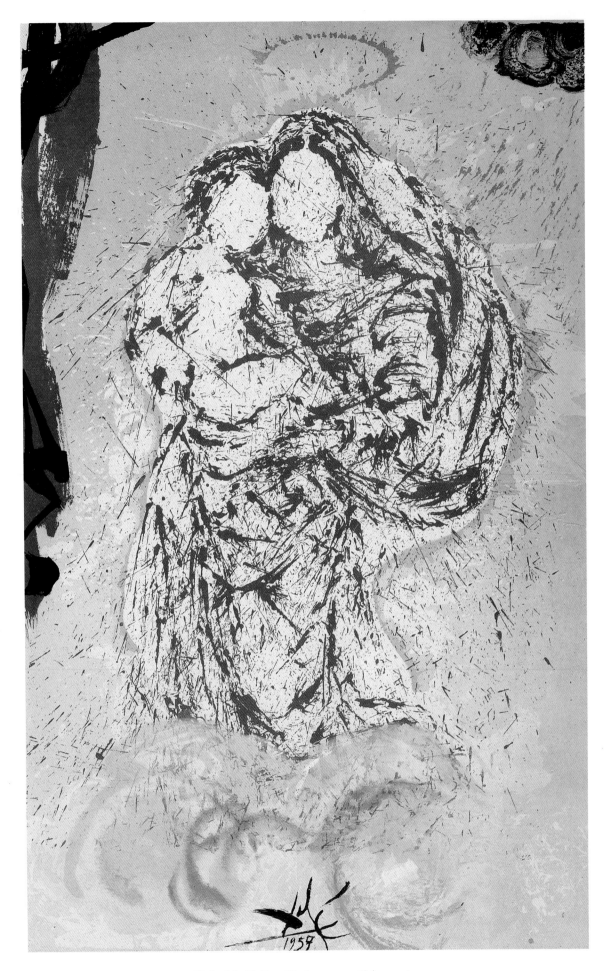

3 Gala, My Sistine Madonna, 1956/7 cat.1010

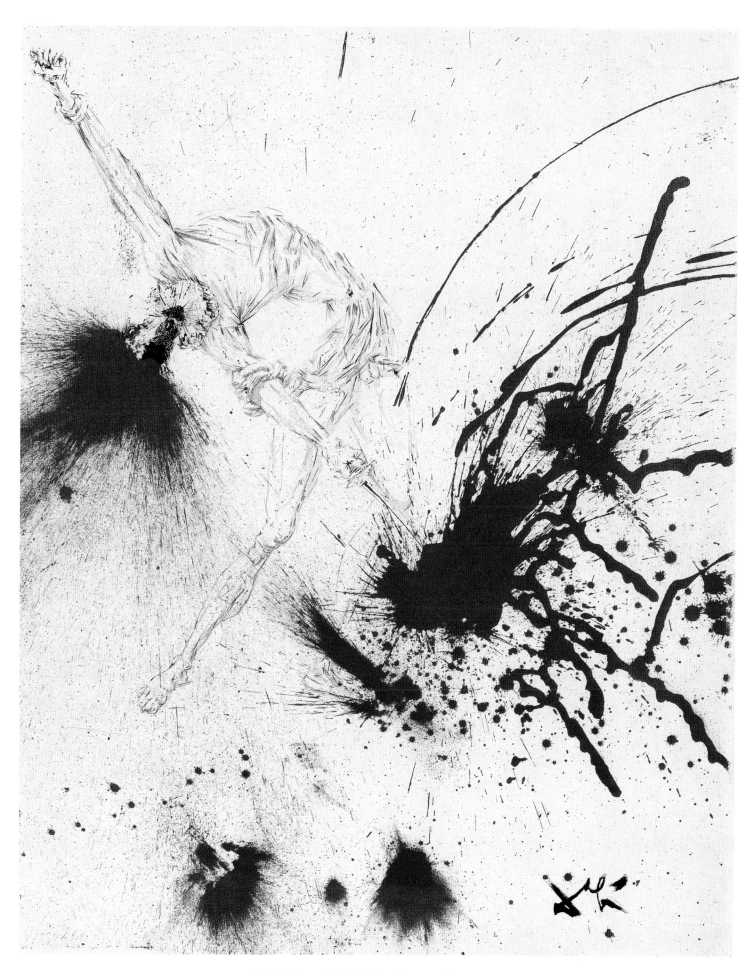

4 The Battle with the Wineskins, 1956/7 cat.1006

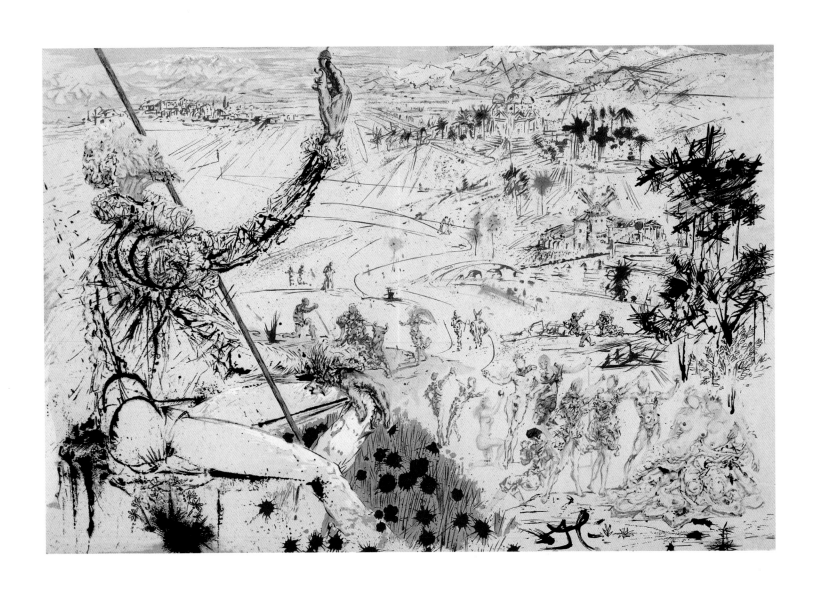

5 The Golden Age, 1956/7 cat.1012

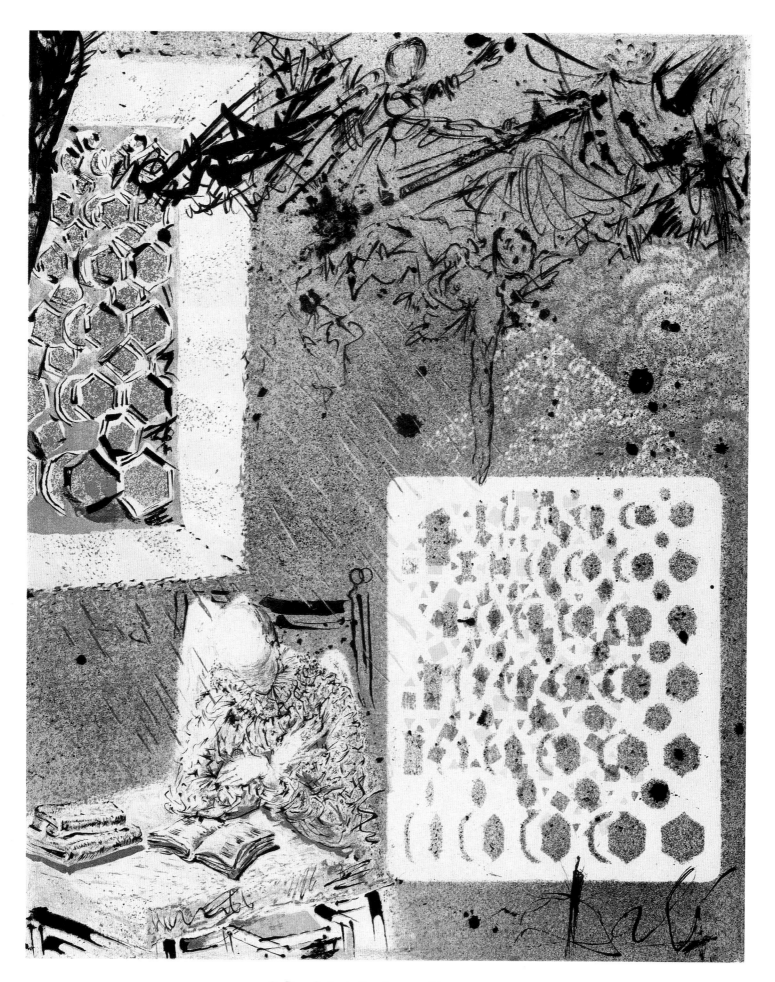

6 Don Quixote Reading, 1956/7 cat.1003

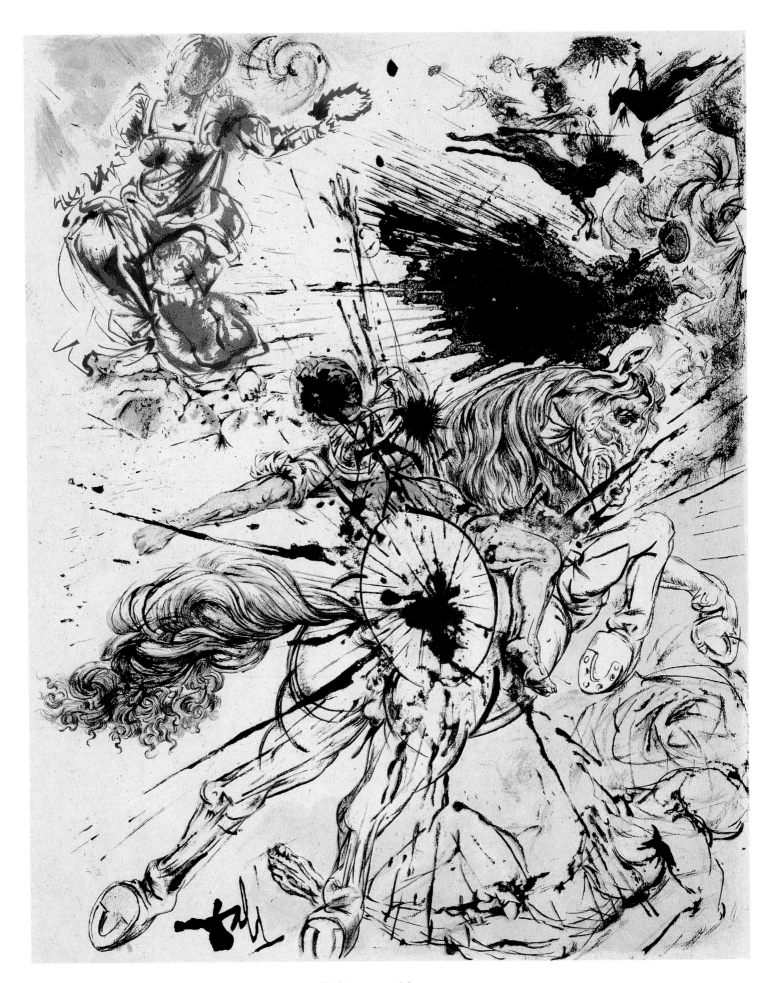

7 Dulcinea, 1956/7 cat.1002

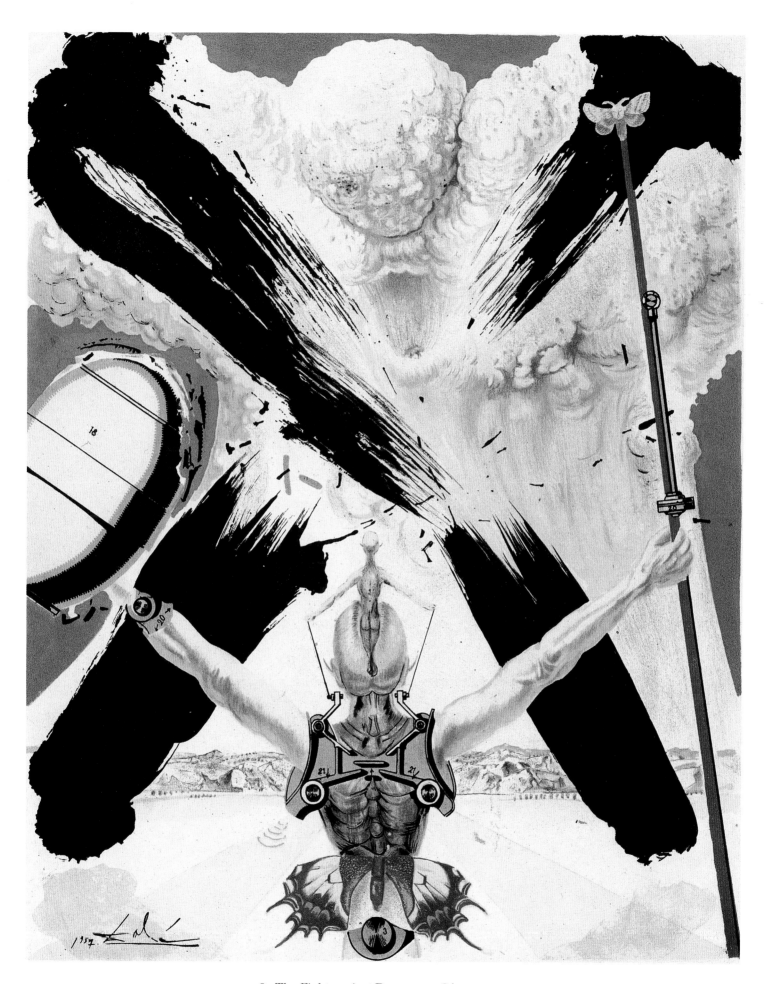

8 The Fight against Danger, 1956/7 cat.1009

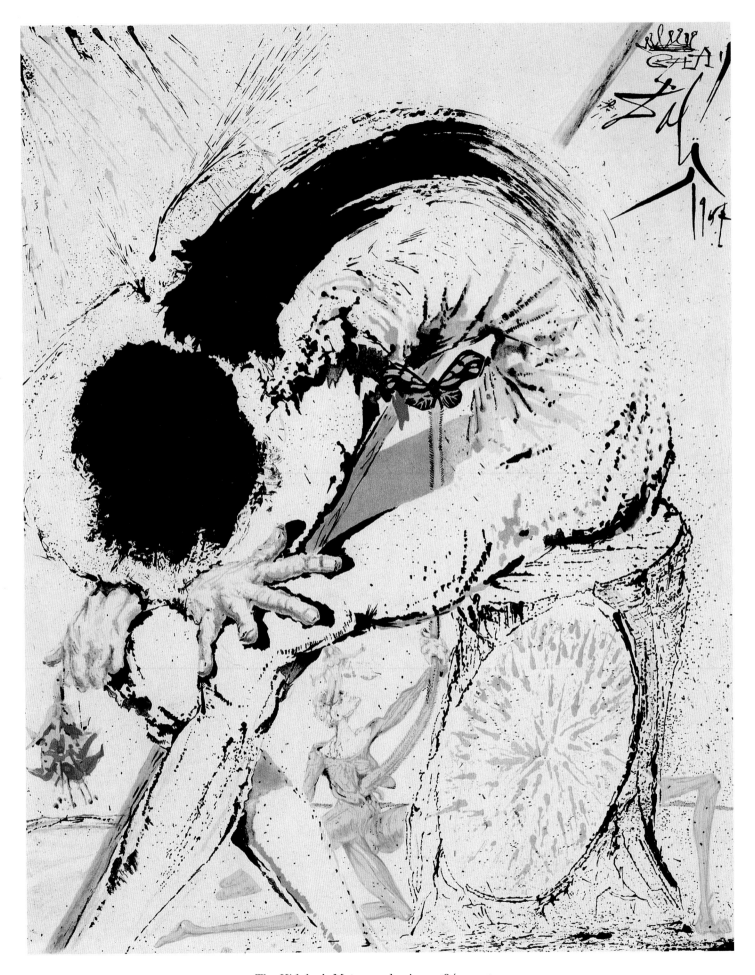

9 The Hidalgo's Metamorphosis, 1956/7 cat.1007

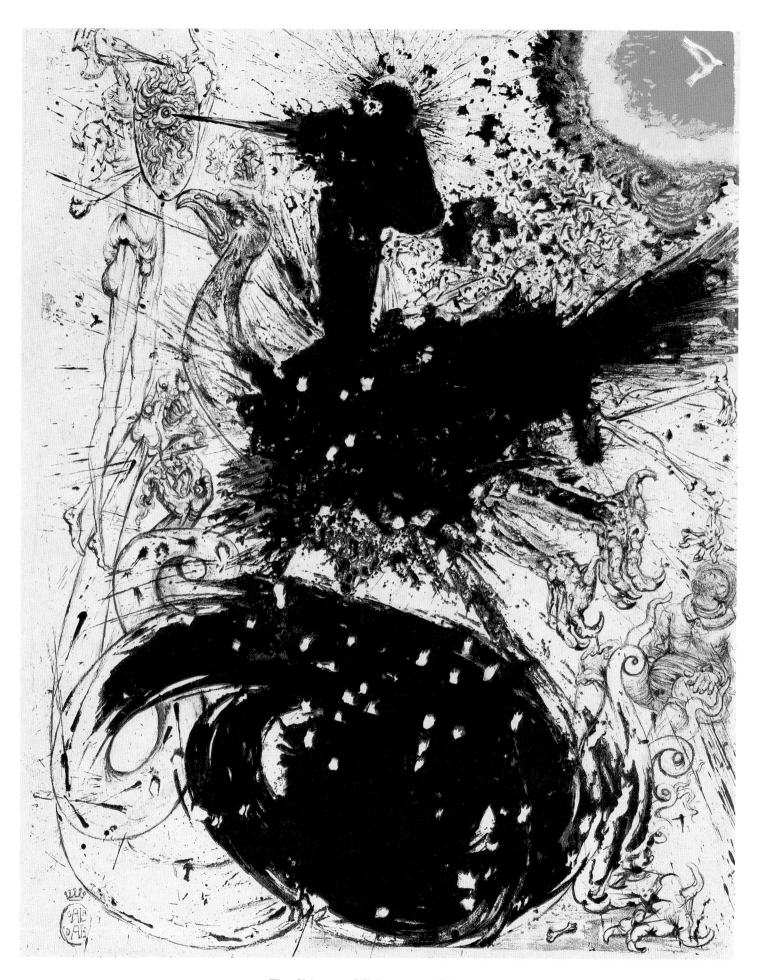

10 The Chimera of Chimeras, 1956/7 cat.1004

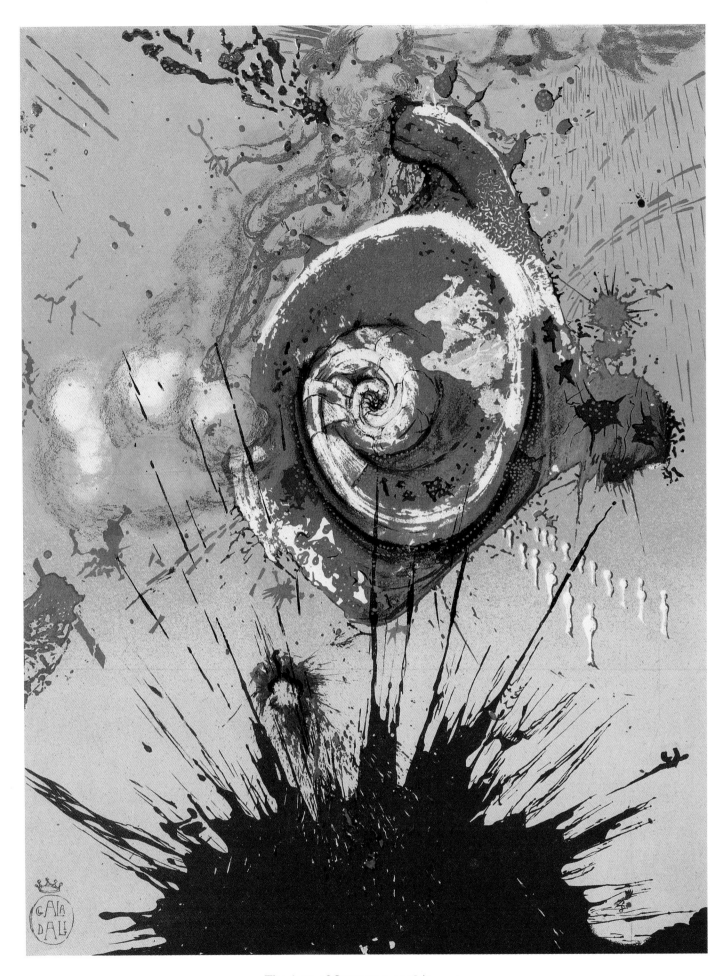

11 The Aura of Cervantes, 1956/7 cat.1005

12 Milky Way, 1956/7 cat.1008

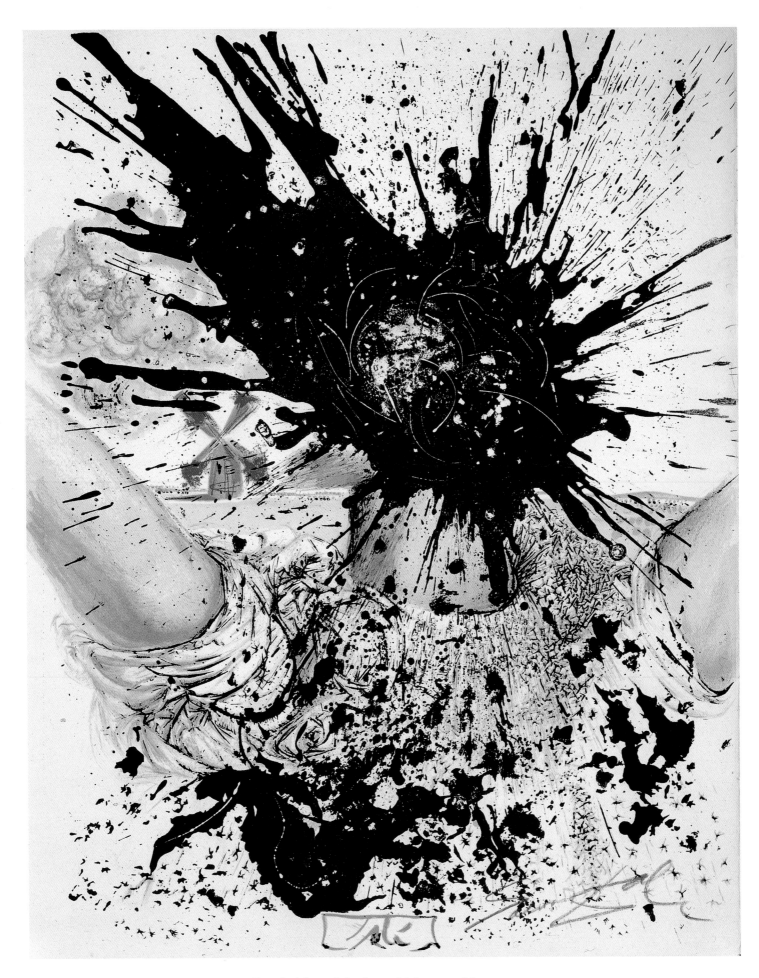

13 Don Quichotte à la tête qui éclate, 1956/7 cat.1013

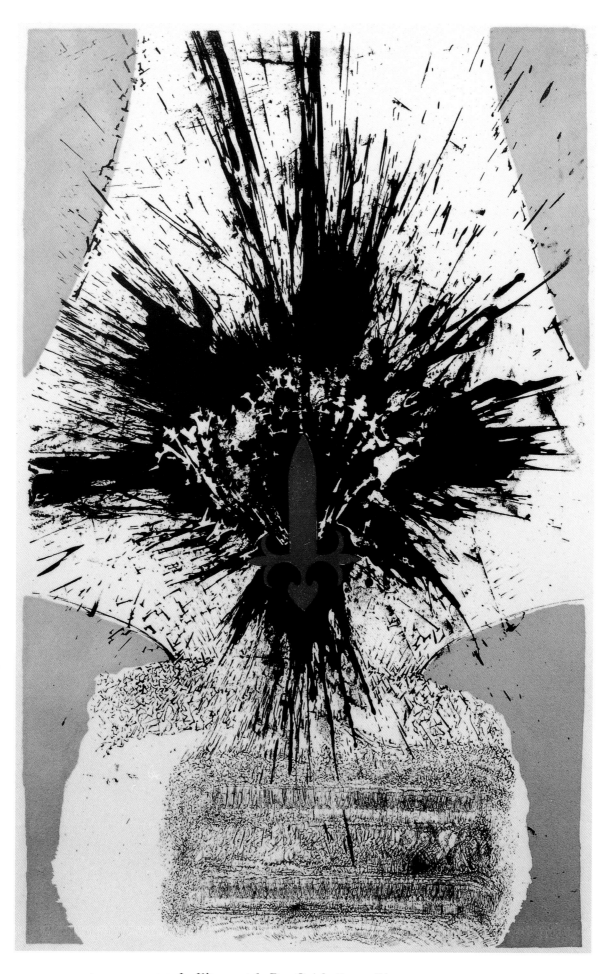

14 Le Vêtement de Don Quichotte, 1956/7 cat.1015

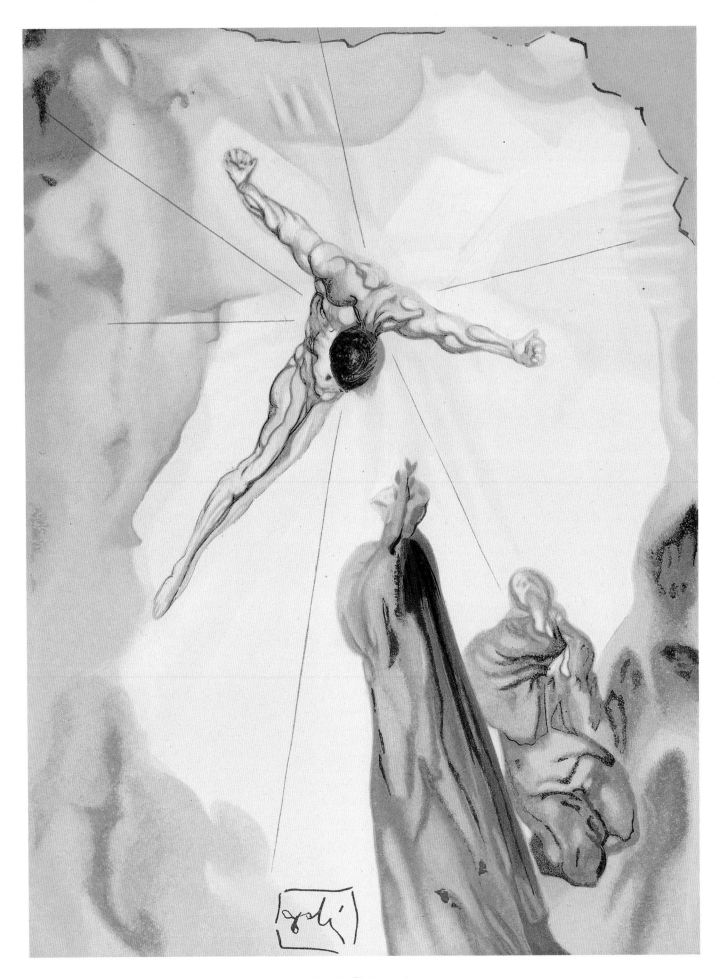

15 Apparition du Christ, 1960 cat.1119

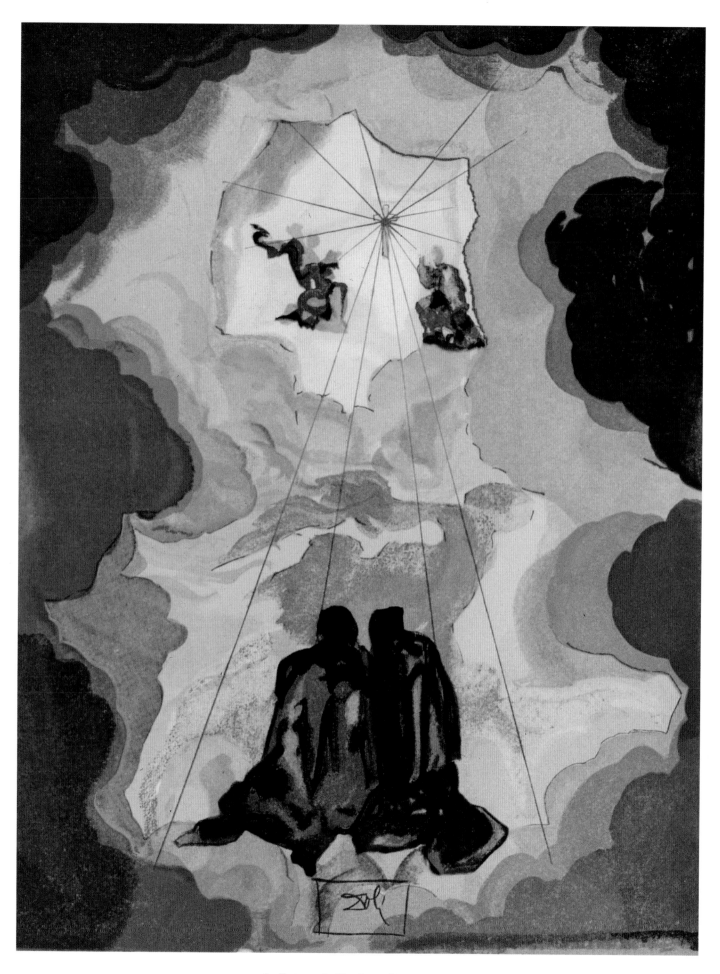

16 Extase de Dante, 1960 cat.1120

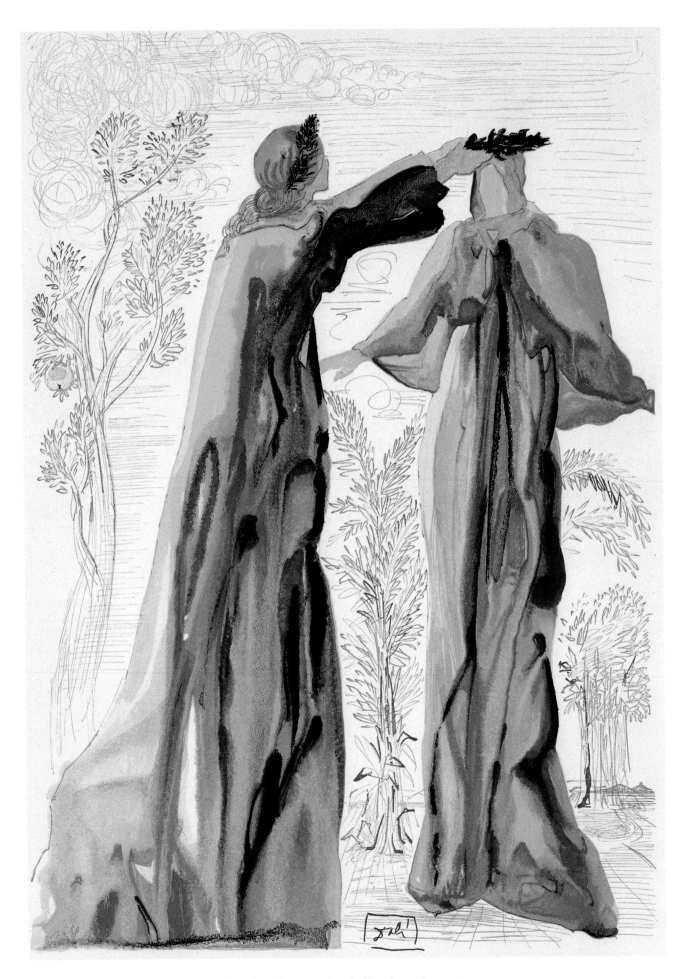

17 Les dernières paroles de Virgile, 1960 cat.1099

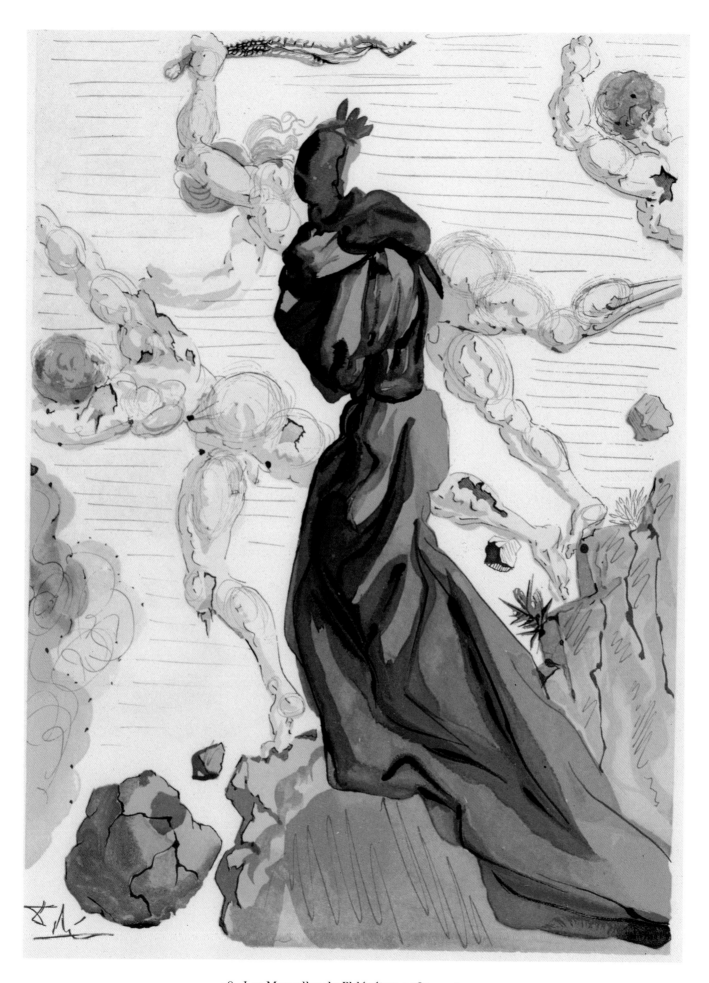

18 Les Margelles du Phlégéton, 1960 cat.1053

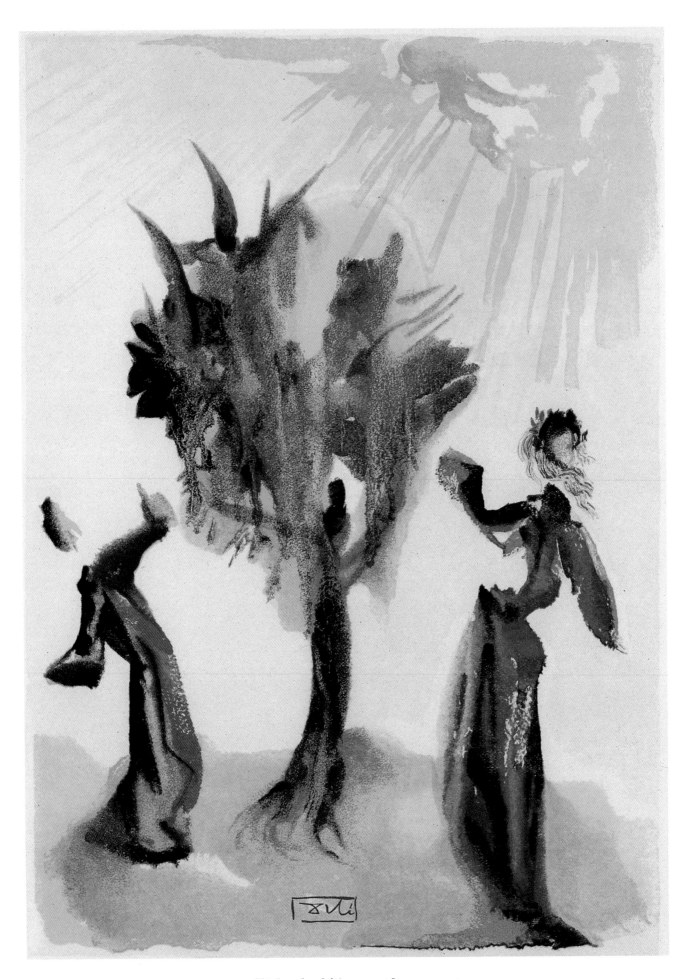

19 L'Arbre du châtiment, 1960 cat.1096

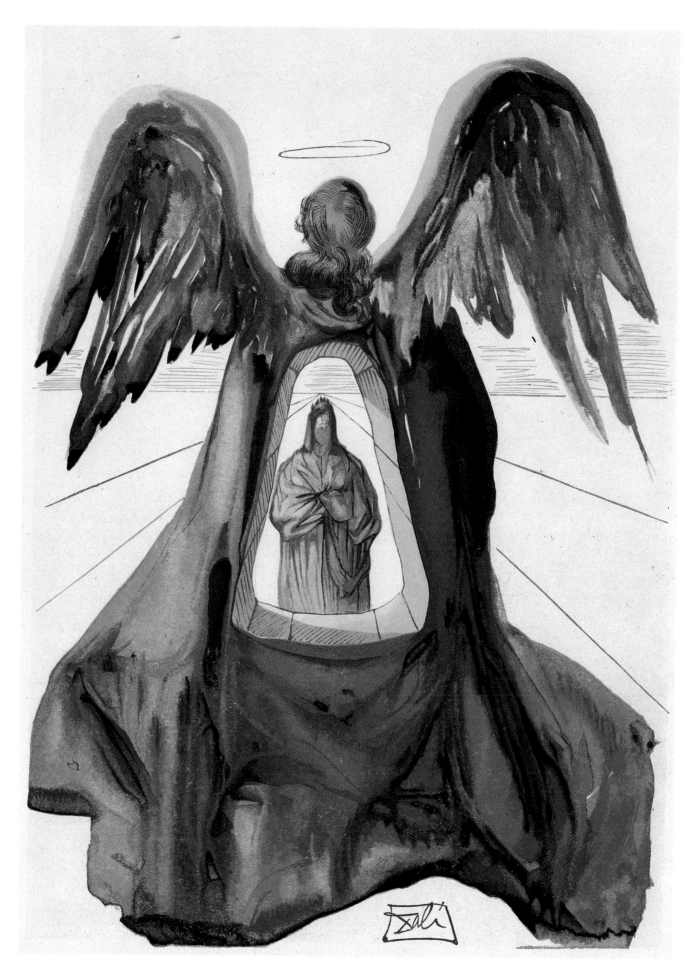

20 Dante purifié, 1960 cat. 1105

21 Dante, 1964 cat. 1141

22 Beatrice, 1964 cat.1142

24
Drawers of Memory
(Cité des tiroirs), 1965
cat.1145

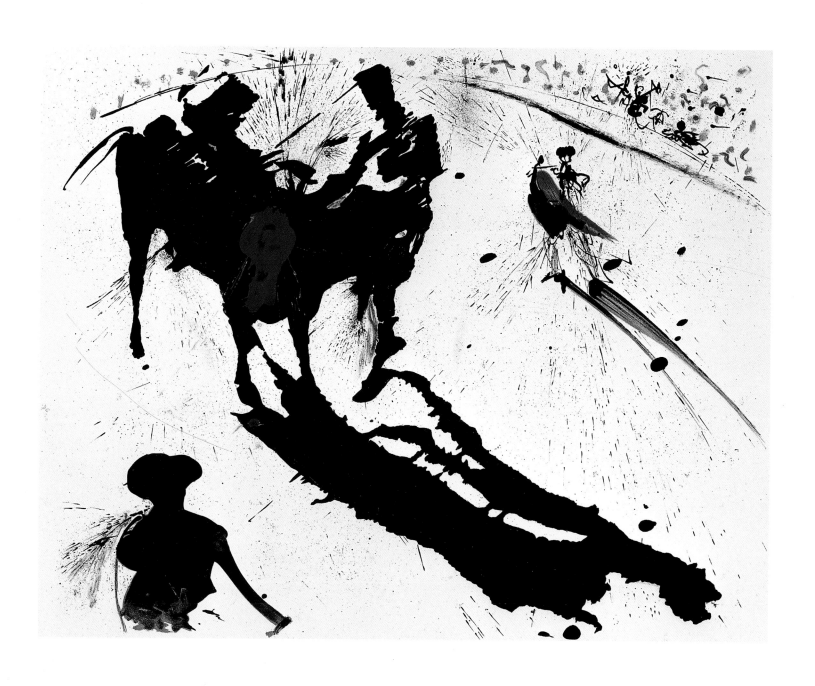

25 Bullfight No. 1, 1966 cat. 1152

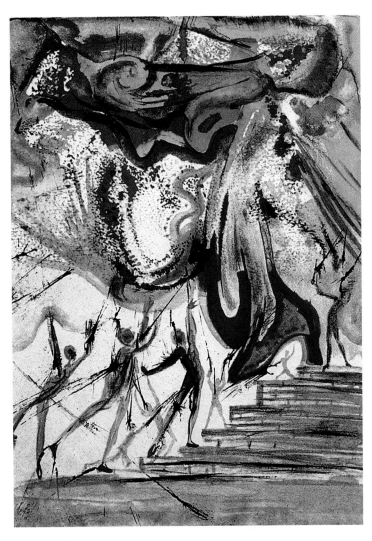

26 The Red Shoes, 1966 cat.1162

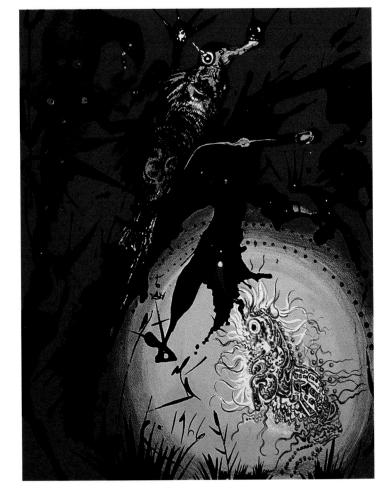

27 The Toad, 1966 cat.1167

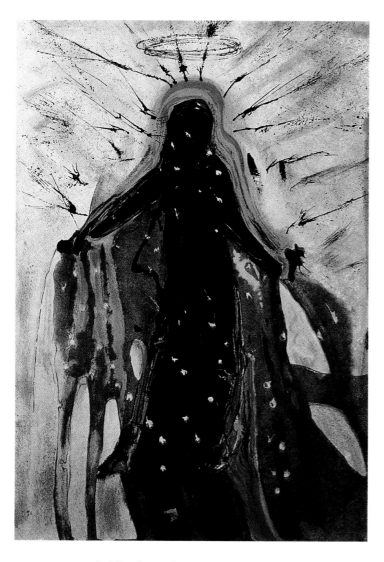

28　The Snow Queen, 1966　cat.1165

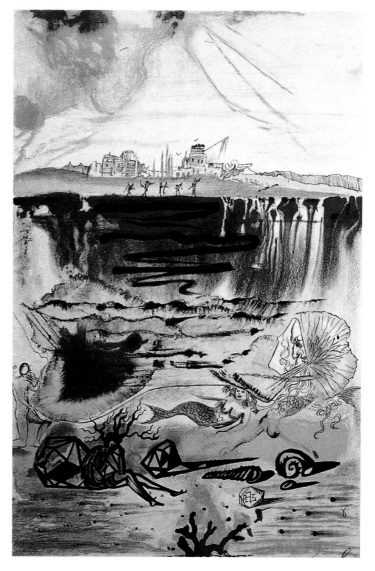

29　The Little Mermaid II, 1966　cat.1164

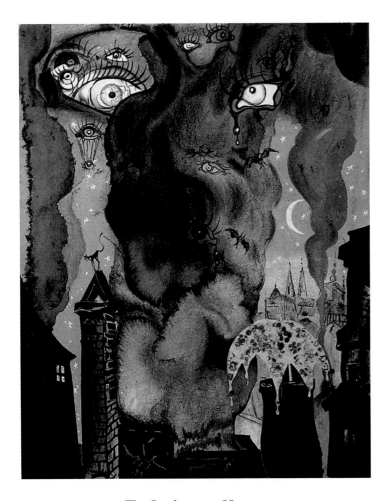

30 The Sandman, 1966 cat.1171

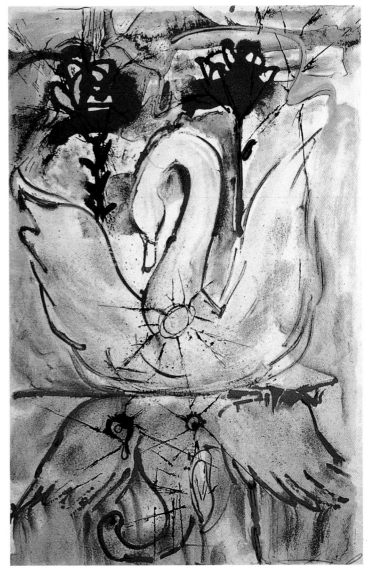

31 The Ugly Duckling, 1966 cat.1168

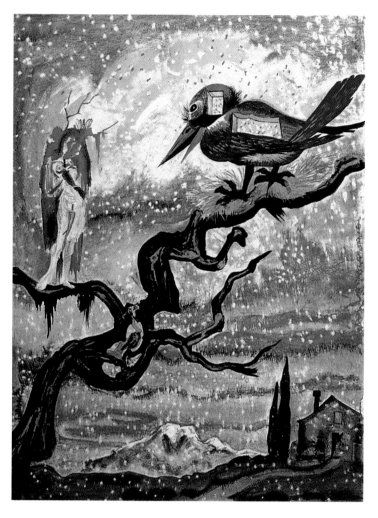

32 Prince and Princess, 1966 cat.1166

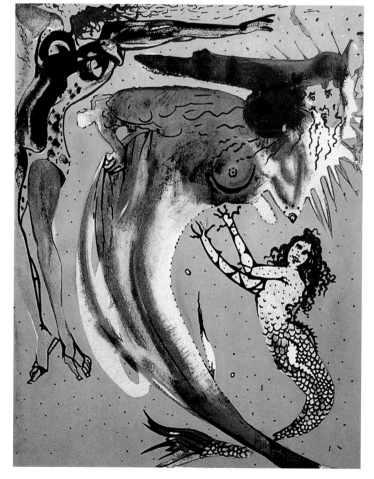

33 The Little Mermaid I, 1966 cat.1163

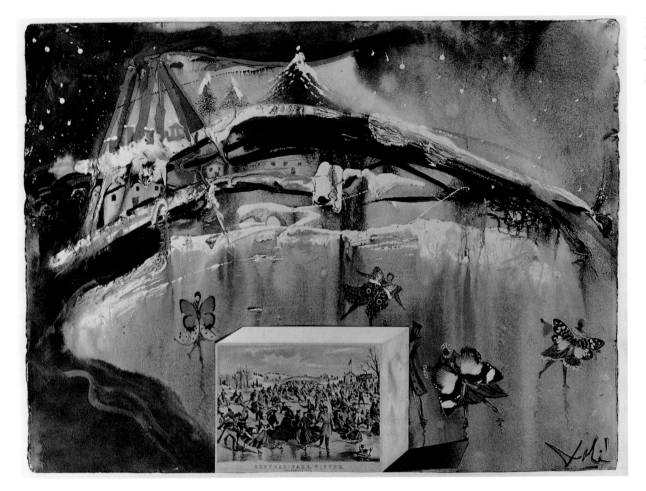

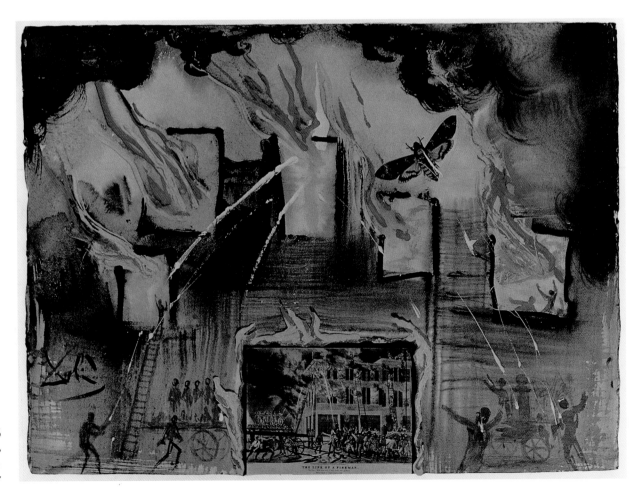

35
Fire, Fire,
Fire, 1971
cat.1347

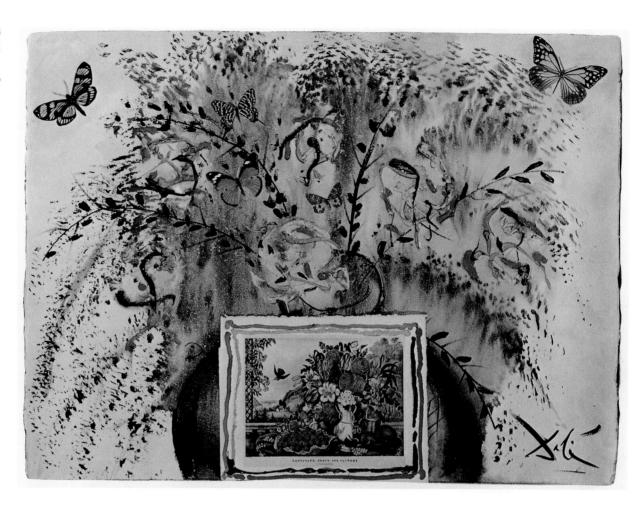

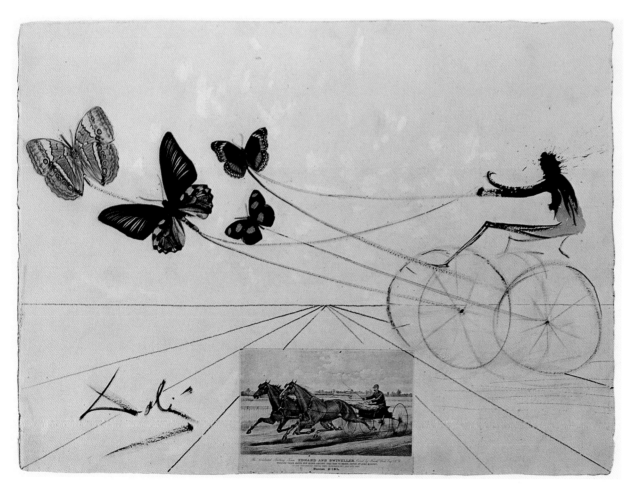

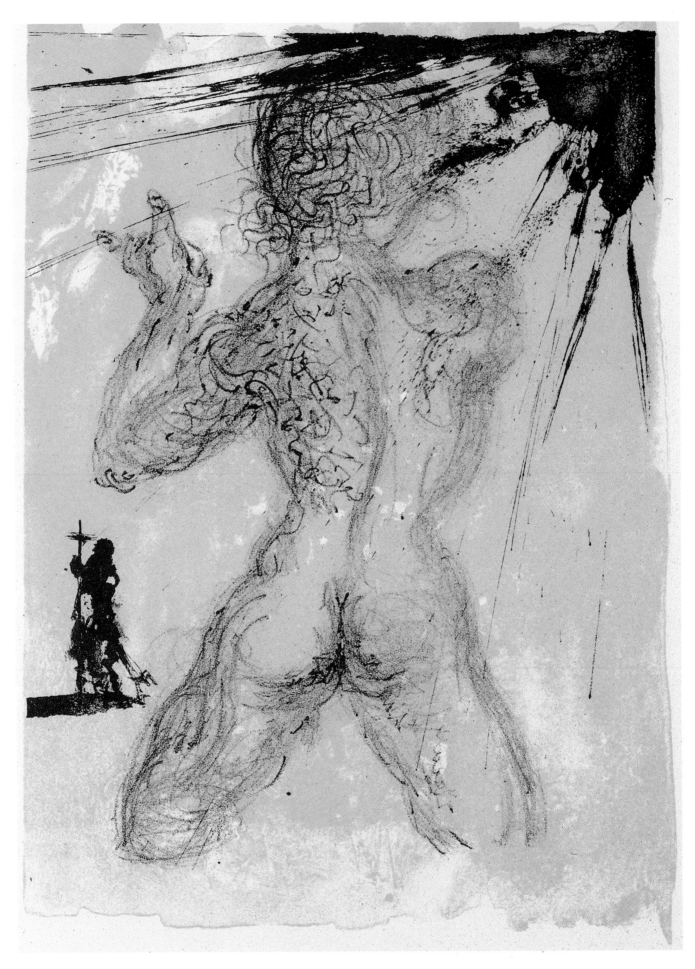

38 Nu gris, 1967 cat.1176

39 Le Pécheur, 1967 cat.1177

40 Gala, 1967 cat.1175

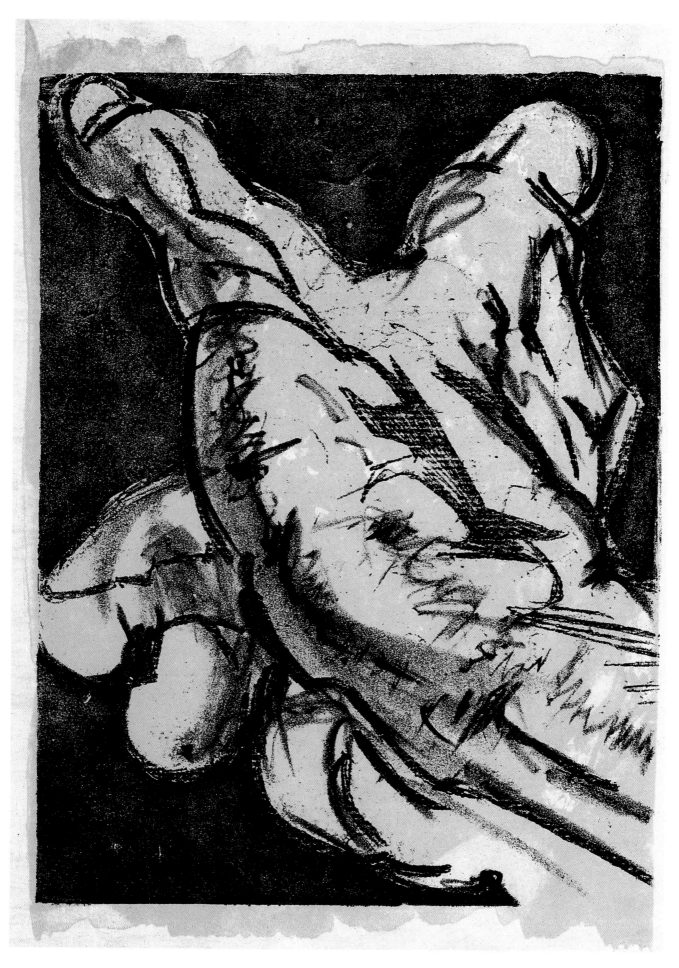

41 La Main, 1967 cat.1178

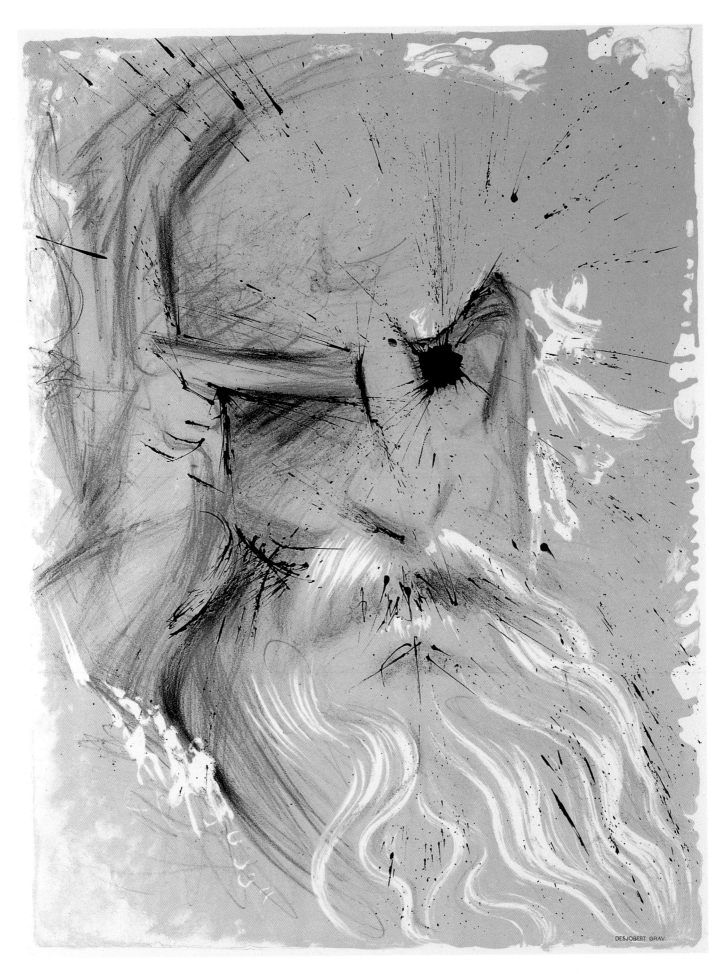

DESJOBERT GRAV.

42 Meissonier, 1967 cat. 1179

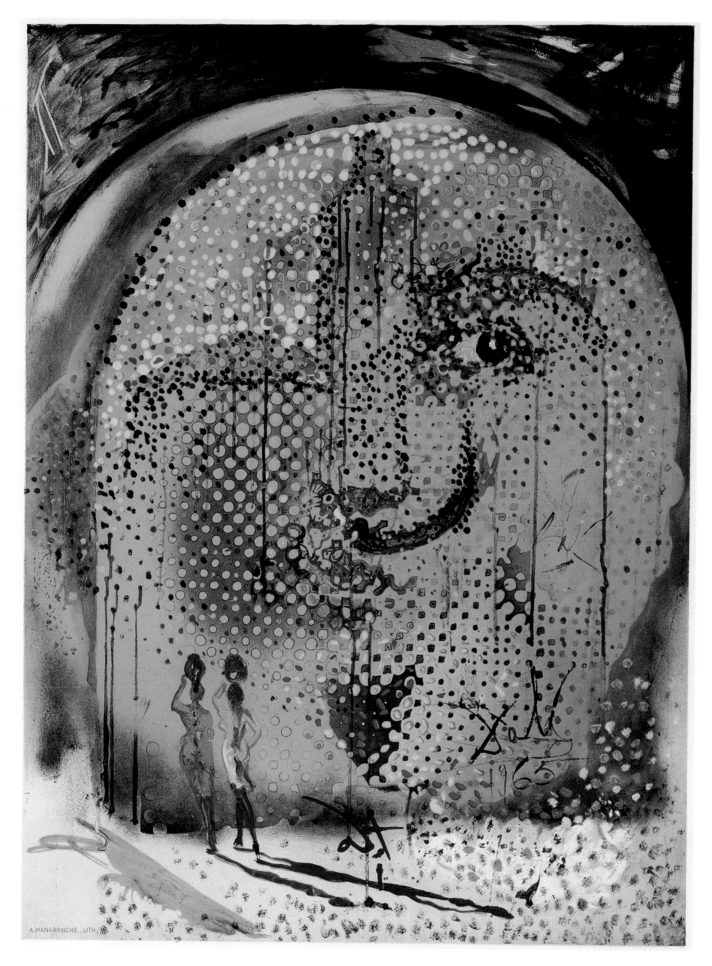

43 Sol y Dalí, 1967 cat.1173

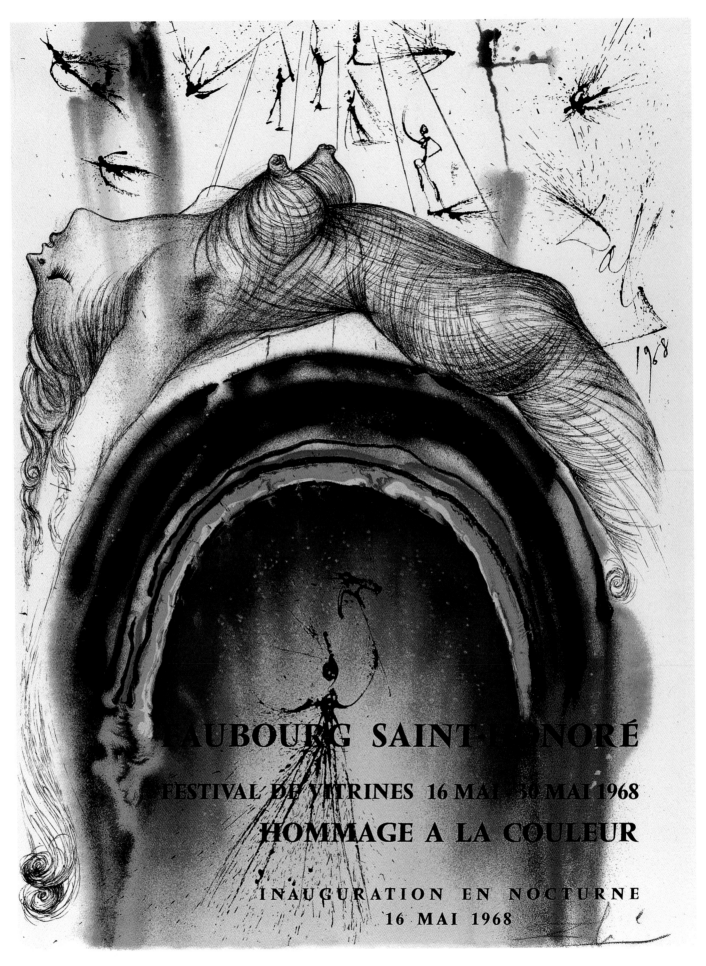

44 Faubourg Saint-Honoré, 1968 cat.1218

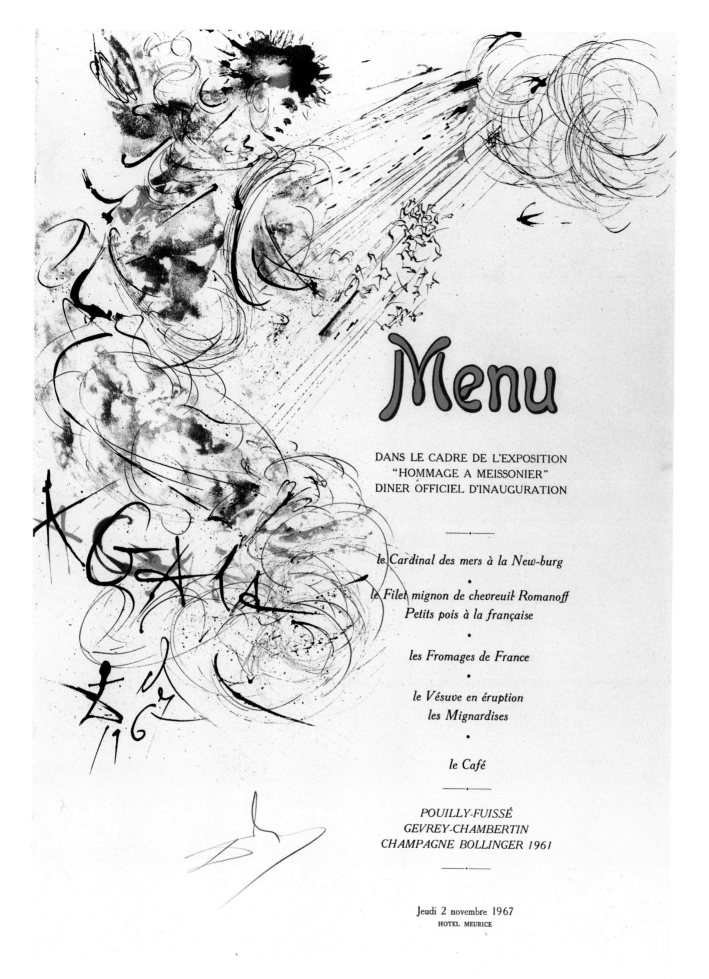

Menu

DANS LE CADRE DE L'EXPOSITION
"HOMMAGE A MEISSONIER"
DINER OFFICIEL D'INAUGURATION

———

le Cardinal des mers à la New-burg

·

le Filet mignon de chevreuil Romanoff
Petits pois à la française

·

les Fromages de France

·

le Vésuve en éruption
les Mignardises

·

le Café

———

POUILLY-FUISSÉ
GEVREY-CHAMBERTIN
CHAMPAGNE BOLLINGER 1961

———

Jeudi 2 novembre 1967
HOTEL MEURICE

45 Menu de Gala, 1967 cat.1180

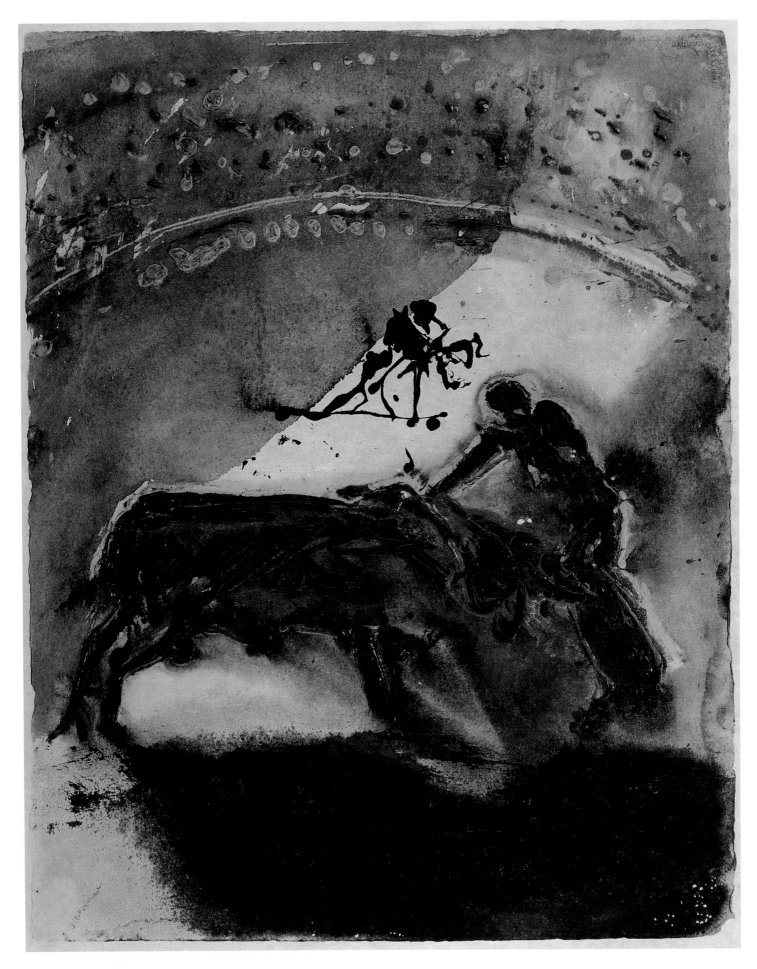

46 Tauromachie I, 1968 cat.1220

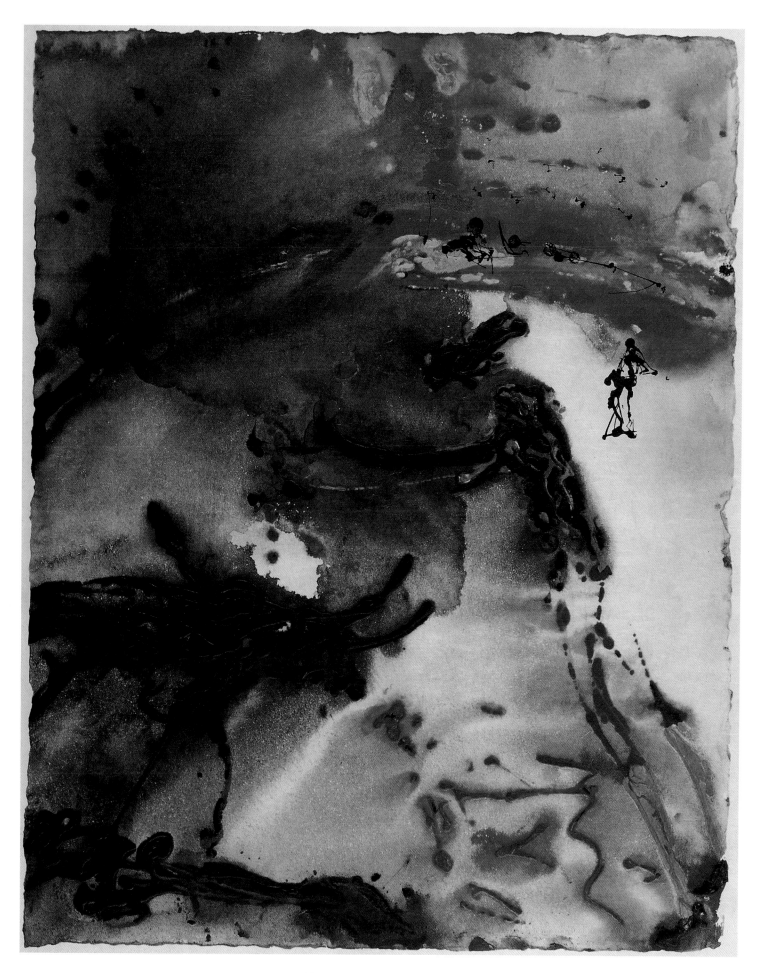

47 Tauromachie II, 1968 cat.1221

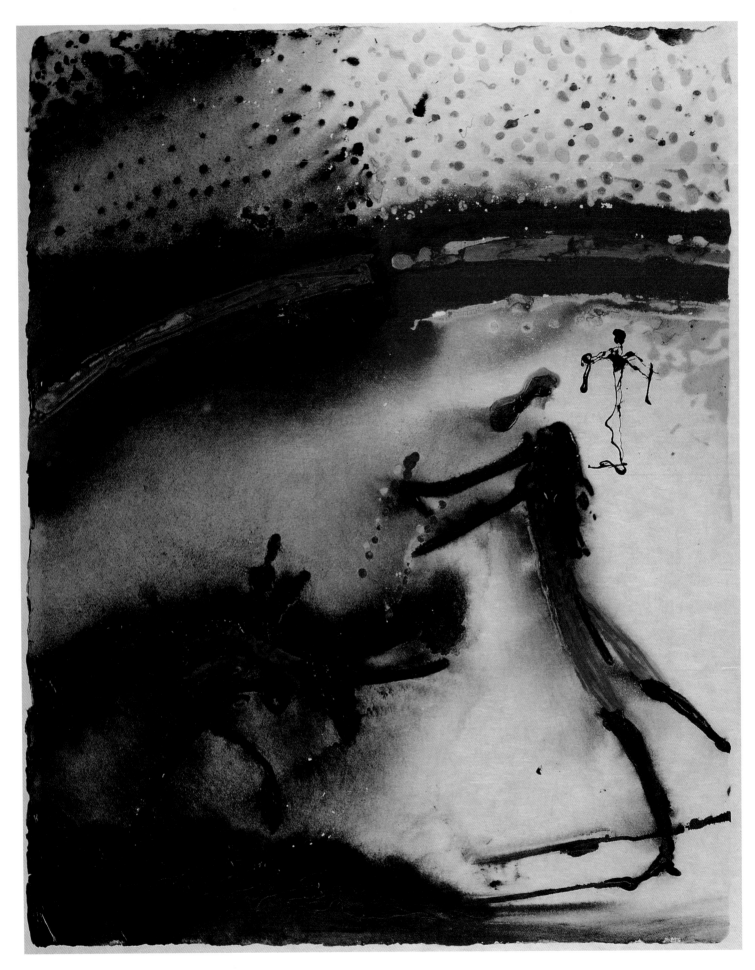

48 Tauromachie III, 1968 cat.1222

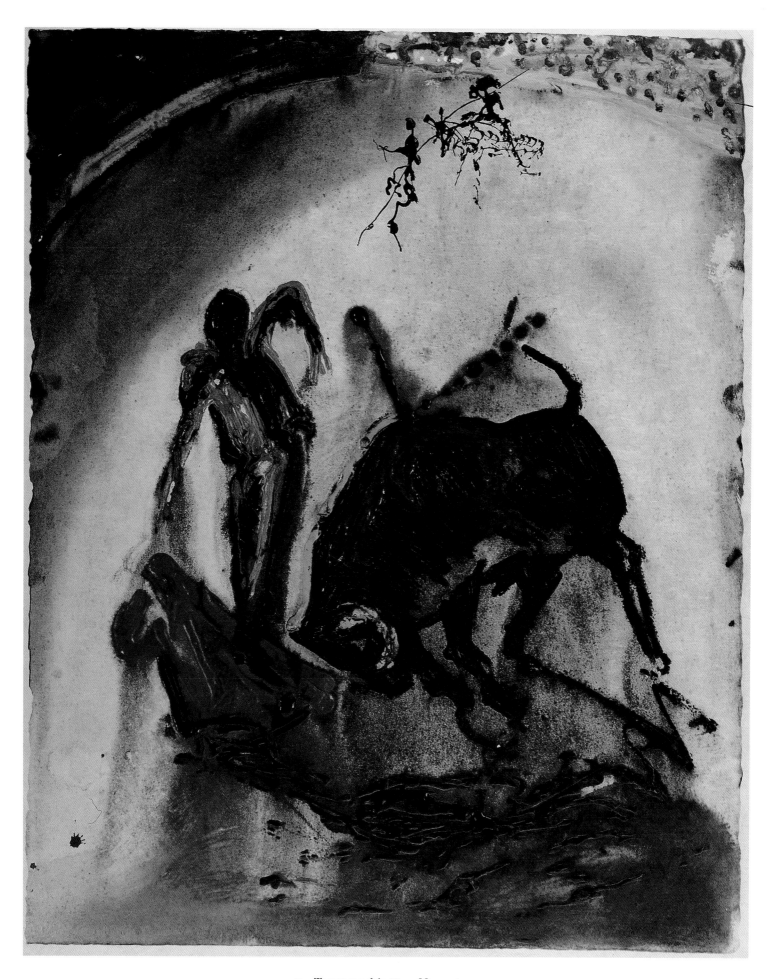

49 Tauromachie V, 1968 cat.1224

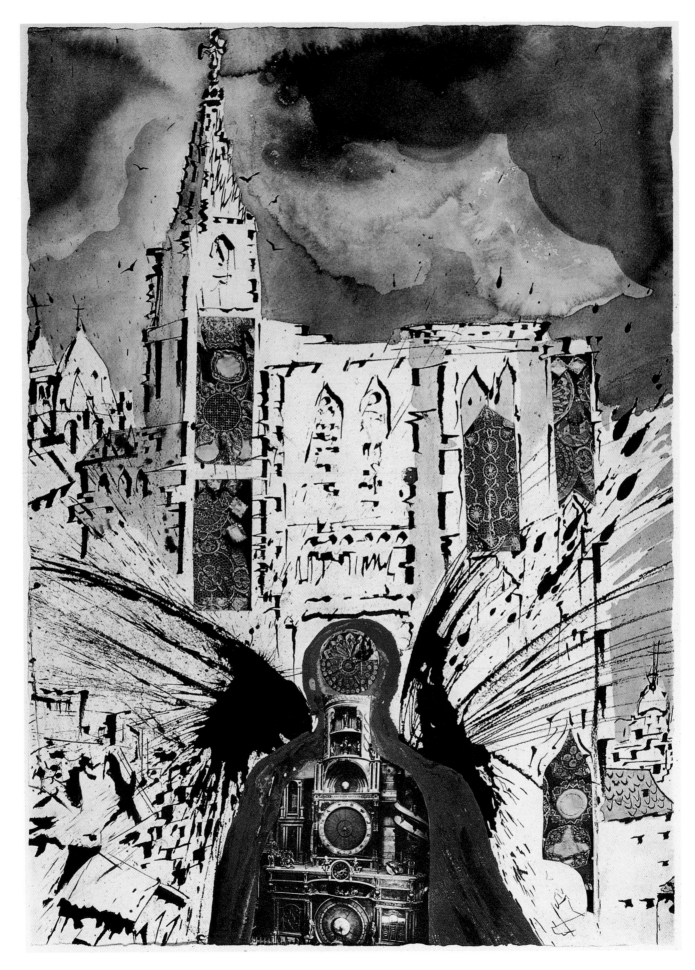

50 Alsace, 1969 cat.1229

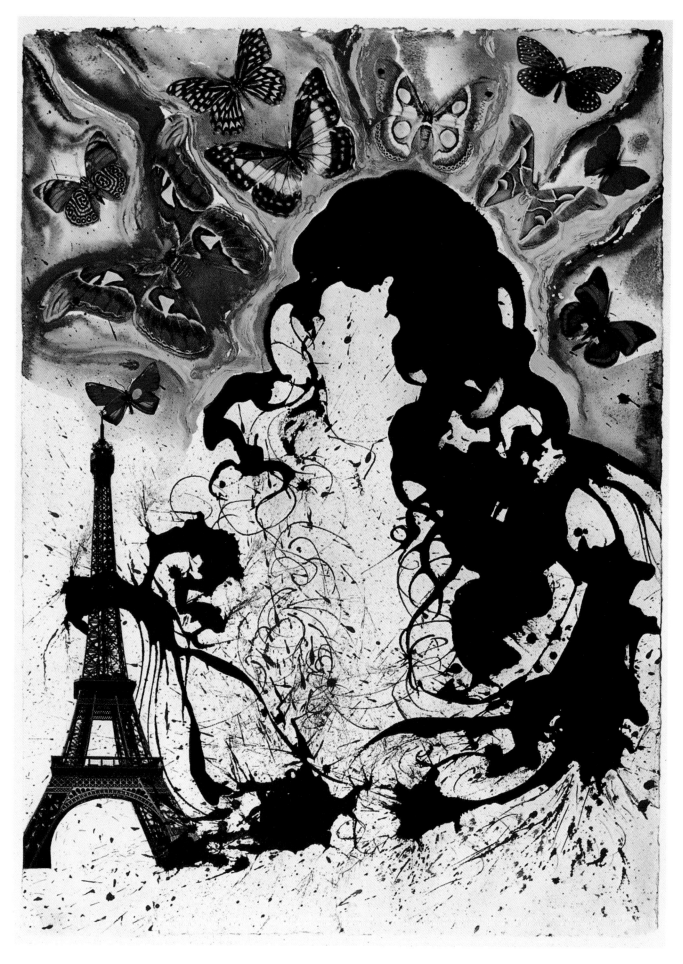

51 Paris, 1969 cat.1228

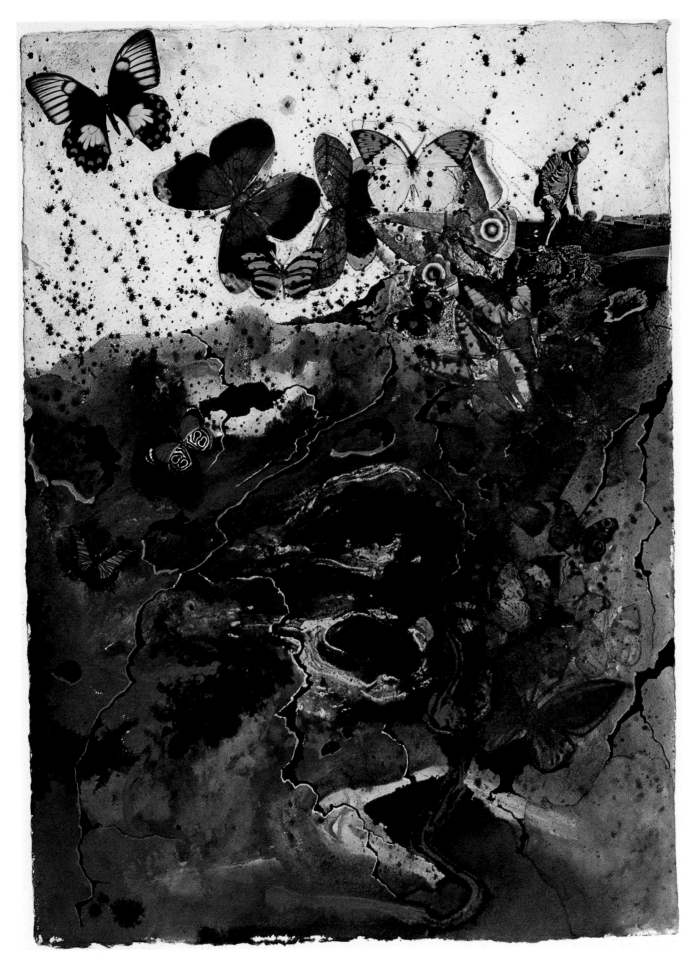

52 Auvergne, 1969 cat.1230

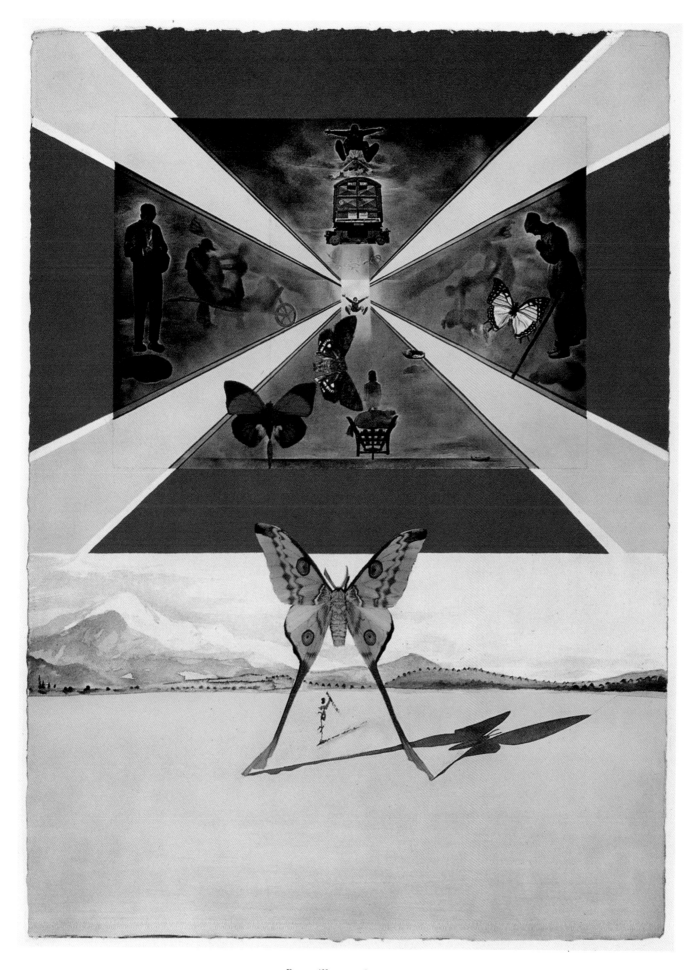

53 Roussillon, 1969 cat.1227

54 Alpes, 1969 cat.1225

55 Normandie, 1969 cat.1226

56 Nu, 1972 cat. 1374

57 Gala, 1973 cat.1397

58 Flower Magician, 1972 cat.1385

59 Sun Goddess Flower, 1972 cat.1386

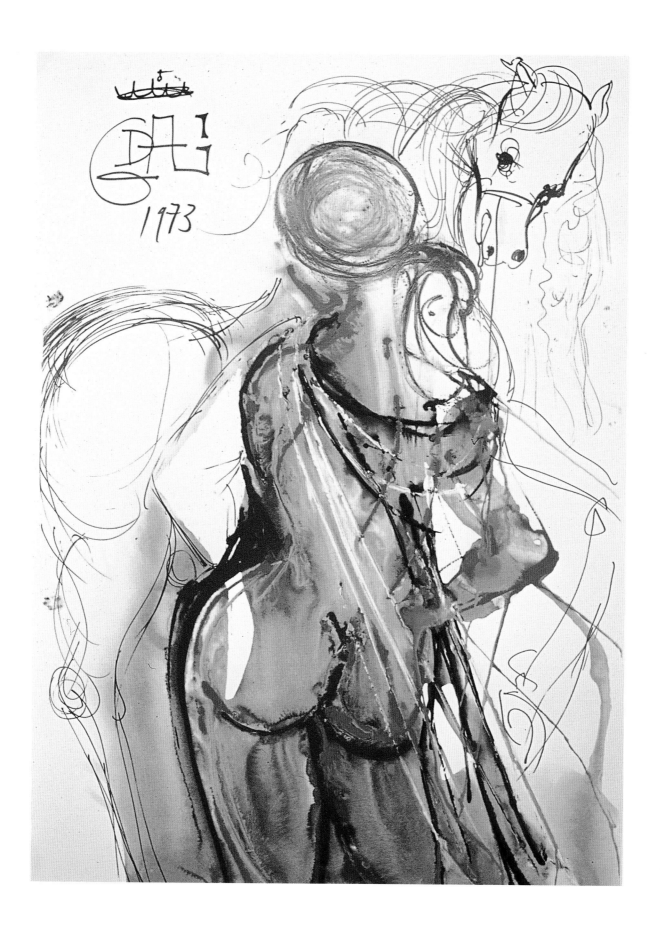

60 Ecuyère et cheval, 1973 cat.1438

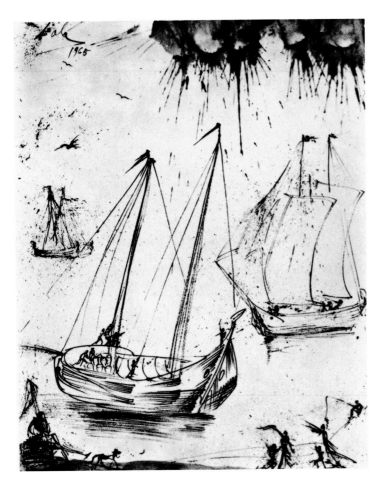

61 The Fishermen, 1965 cat.1147

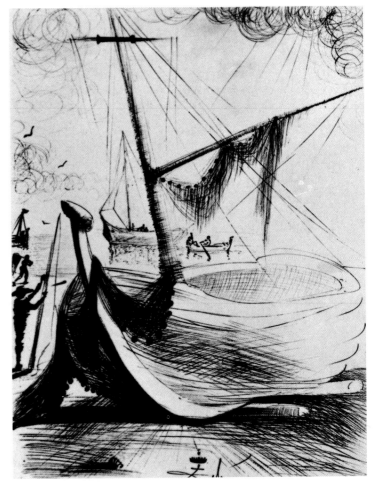

62 Departure of the Fishermen, 1965 cat.1148

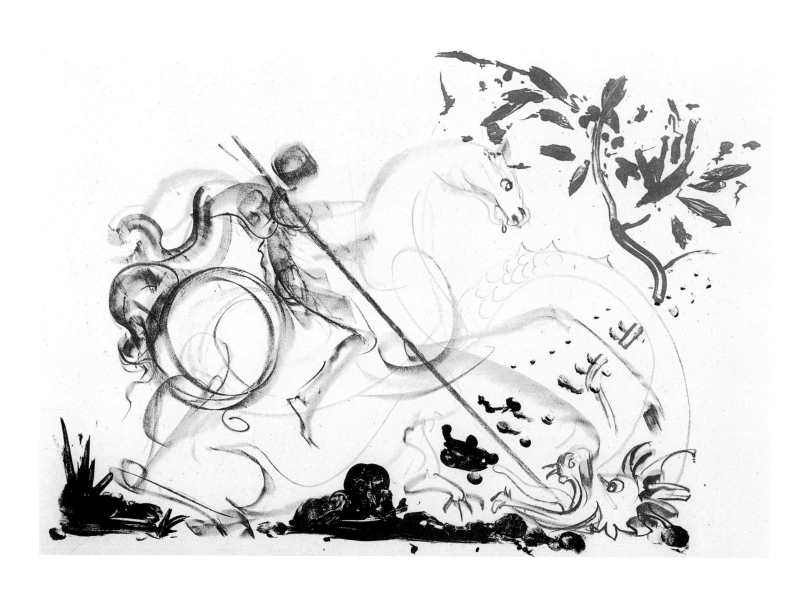

63 St George and the Dragon, 1973 cat.1437

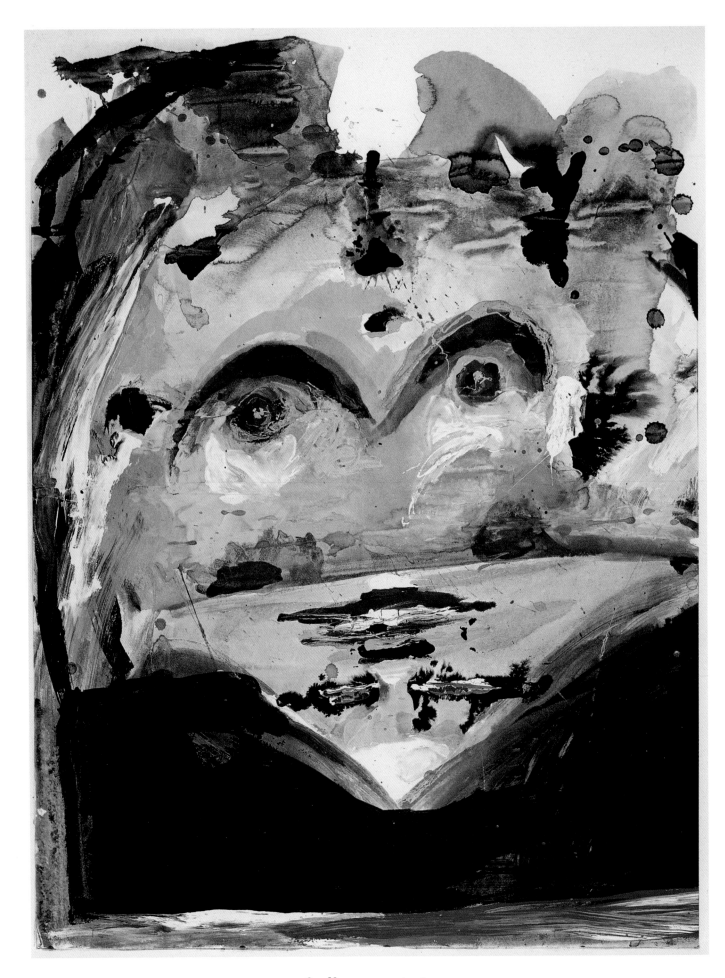

64 Nu, 1972 cat.1367

65 Arlequin, 1972 cat.1365

66 Chevalier aux papillons, 1972 cat.1363

67 Le Crâne, 1972 cat.1364

68 Lys, 1972 cat.1366

69 Puberty, 1973 cat.1431

70 Youth, 1973 cat.1432

71 Maturity, 1973 cat.1433

72 Old Age, 1973 cat.1434

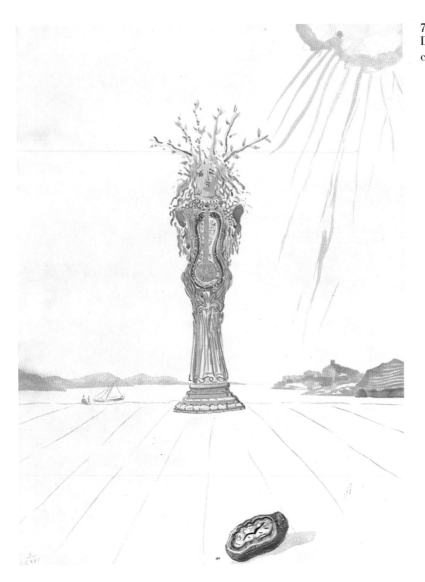

73
Daphne, 1975/6
cat.1480

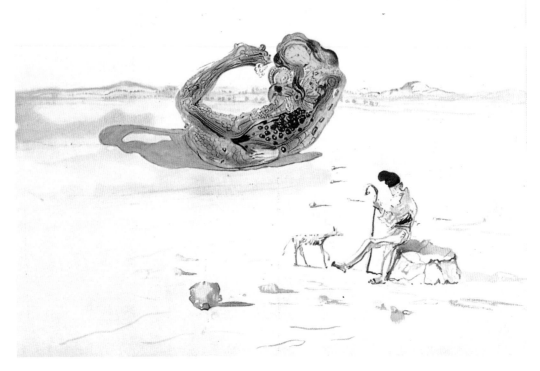

74
Desert Jewel,
1975/6
cat.1484

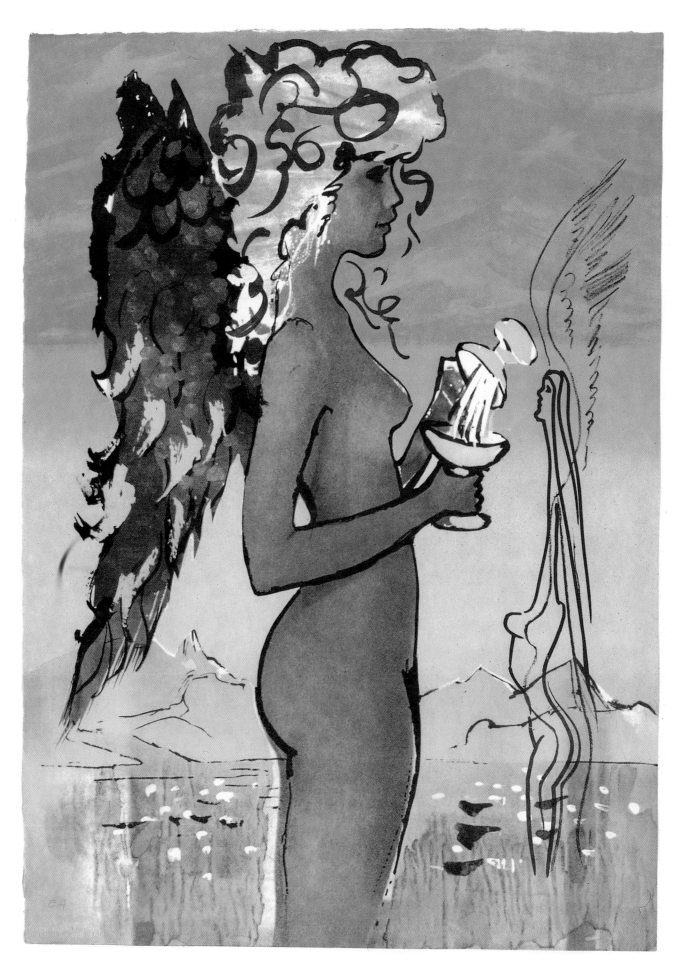

75 Love's Trilogy, 1977 cat.1501

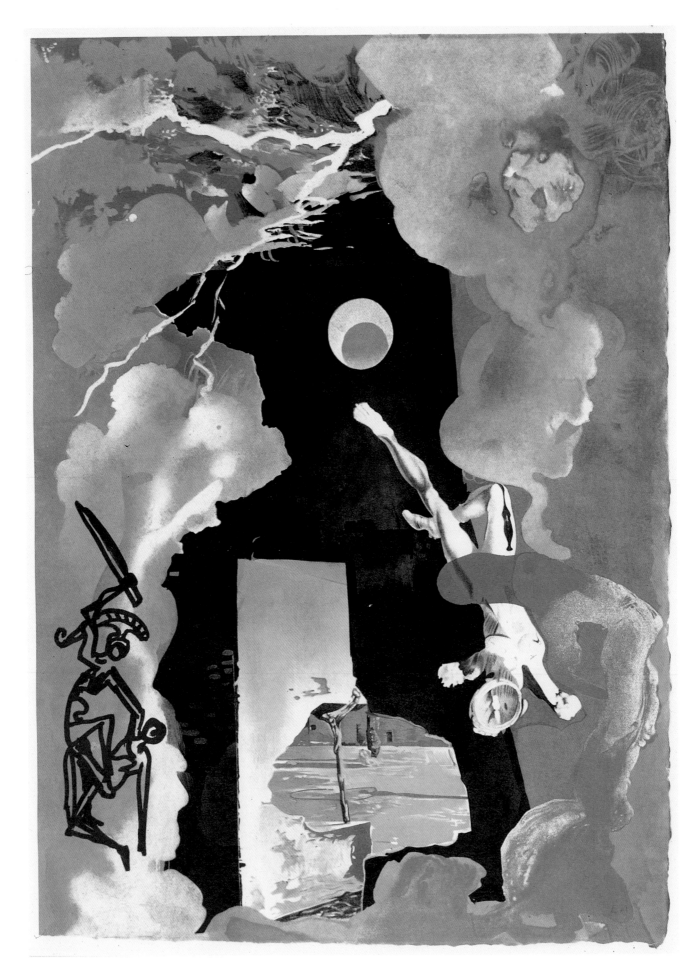

76 Love's Trilogy, 1977 cat.1502

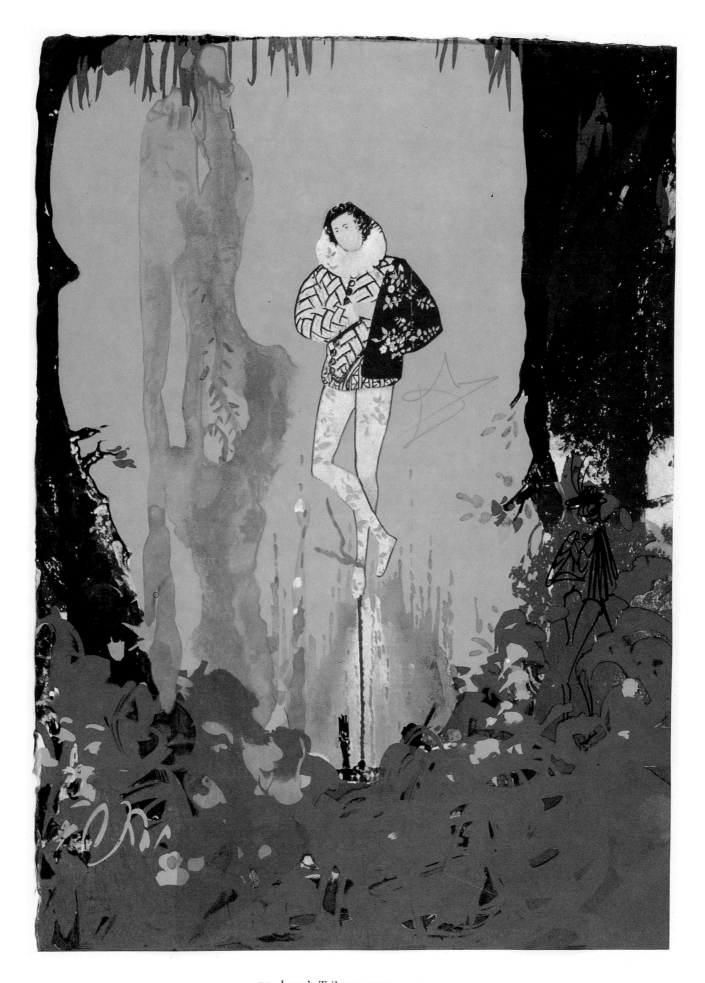

77 Love's Trilogy, 1977 cat.1503

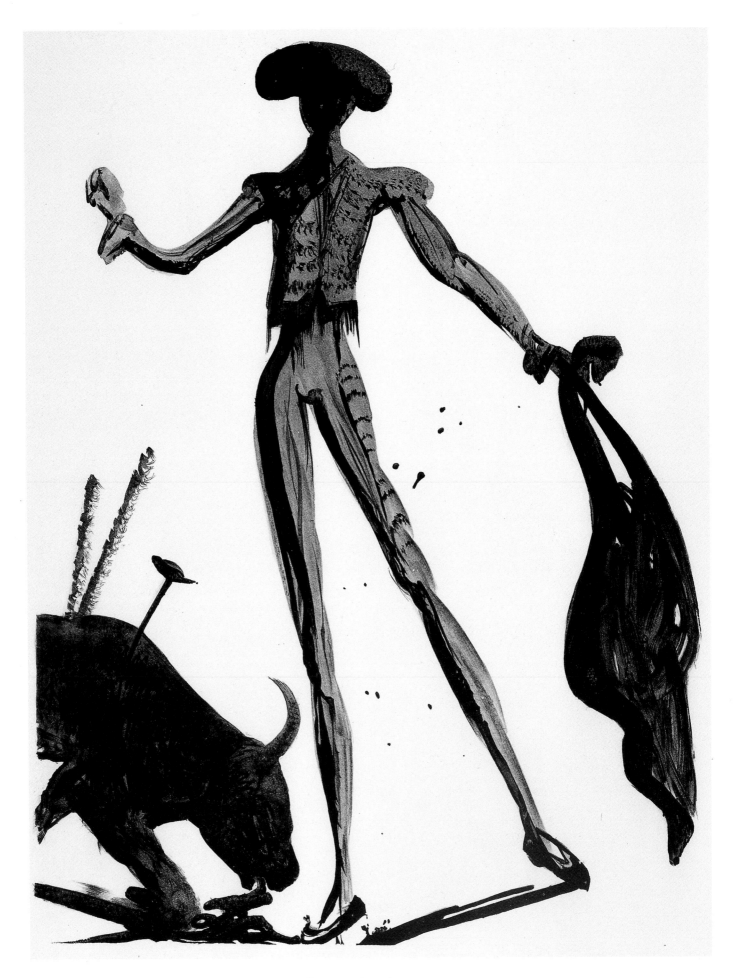

78 Torero noir, 1969 cat.1257

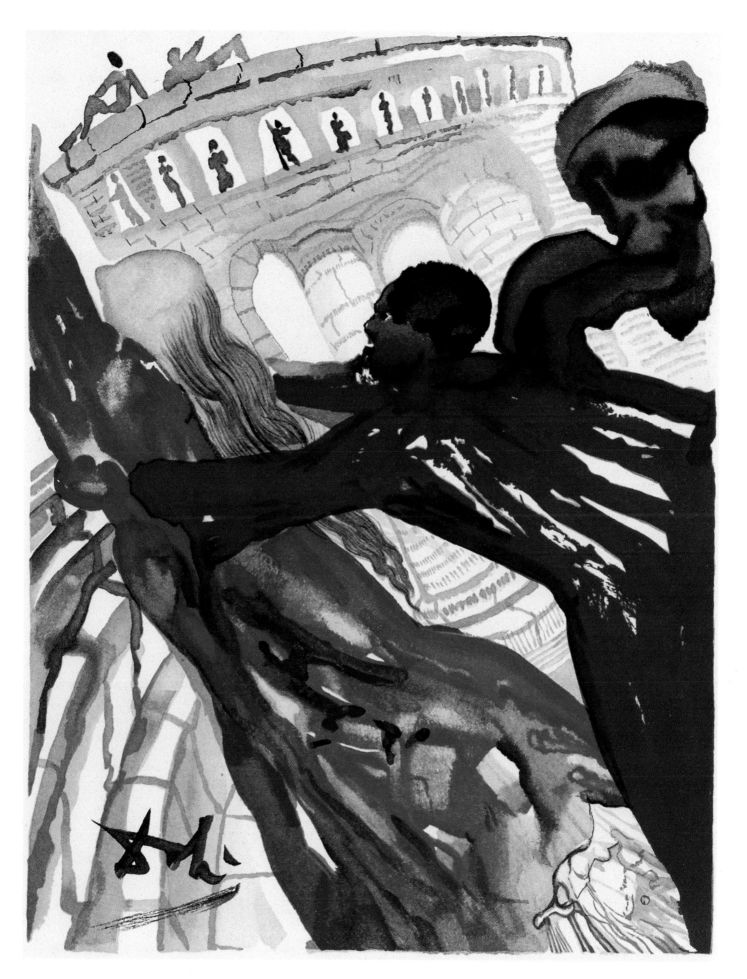

79 Mais ô belle Dionée, 1978 cat.1530

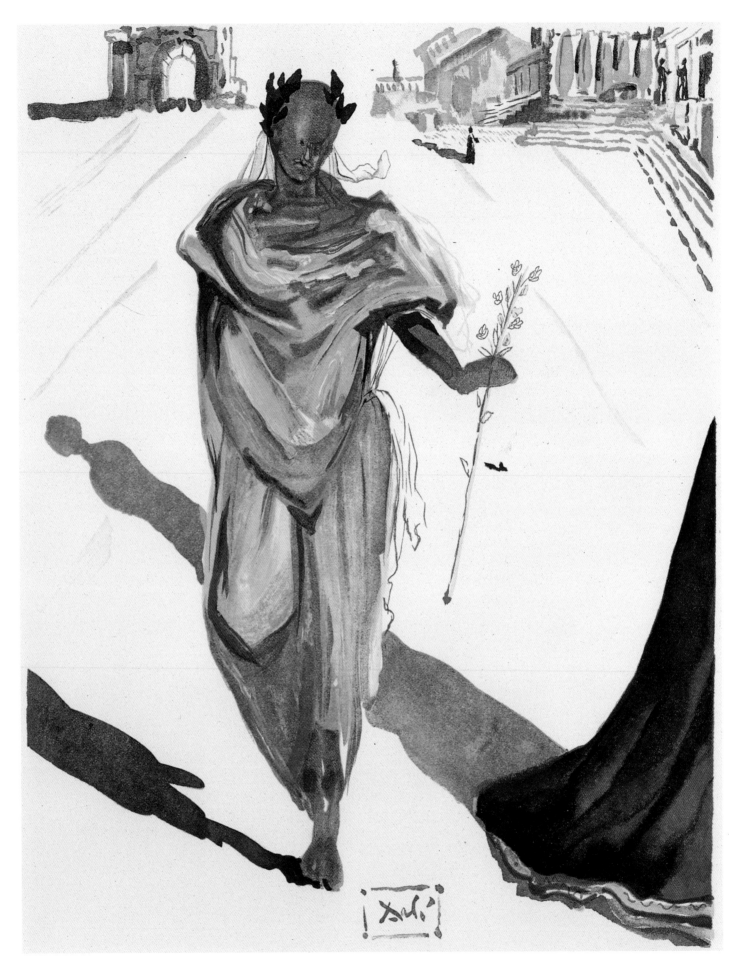

80 Apollon, 1978 cat.1528

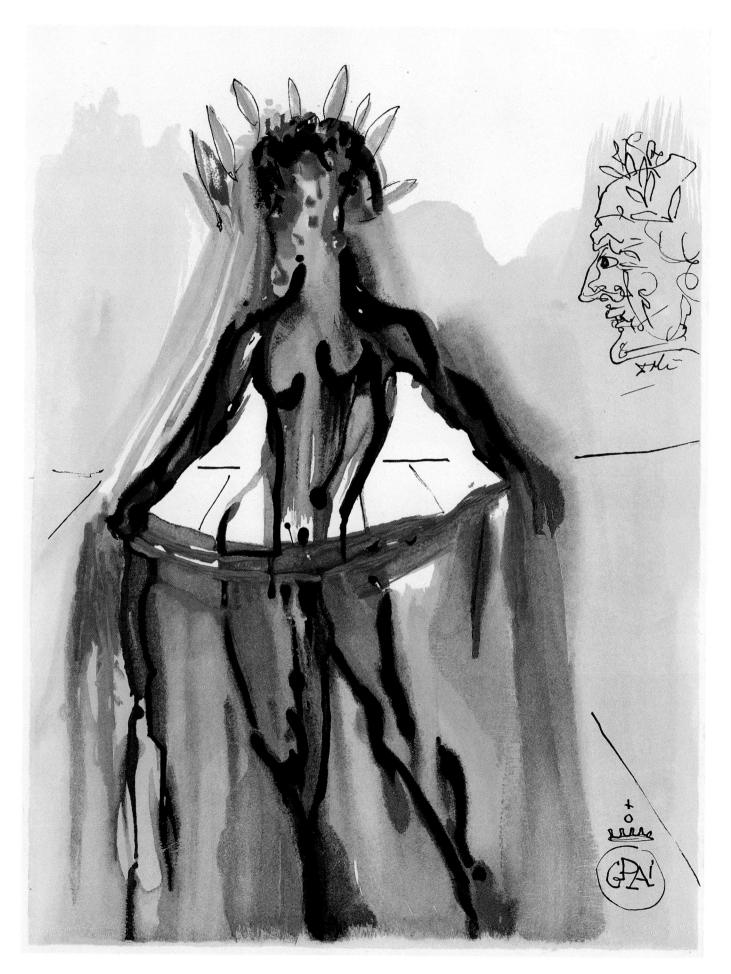

81 Vénus…, 1978 cat.1531

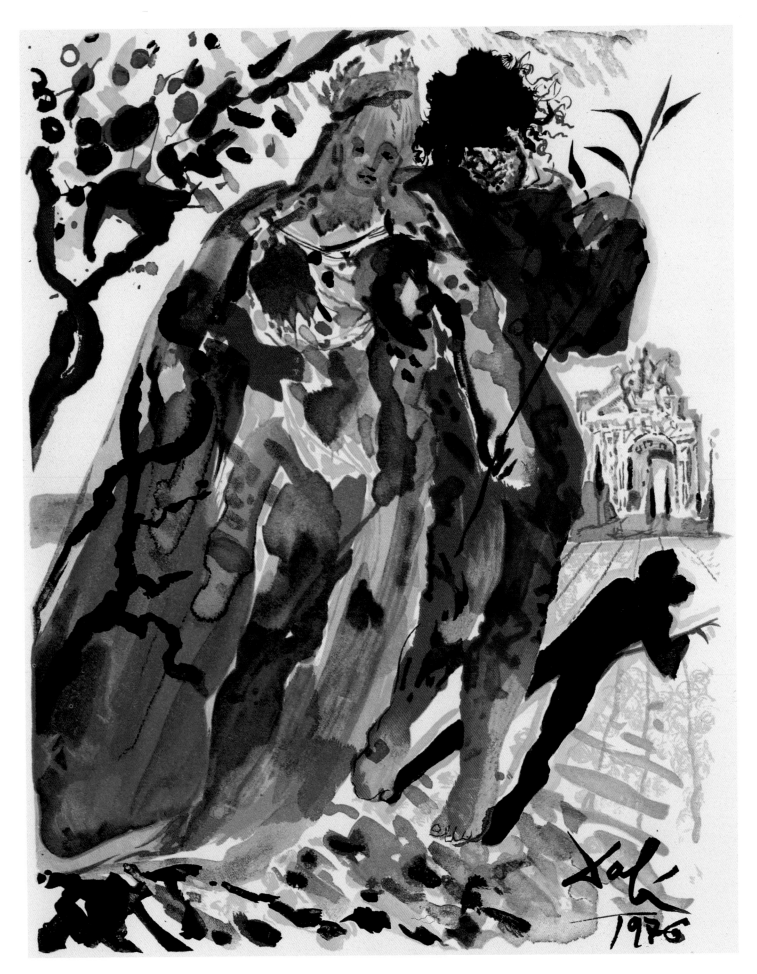

82 Fille de Minos, 1978 cat.1538

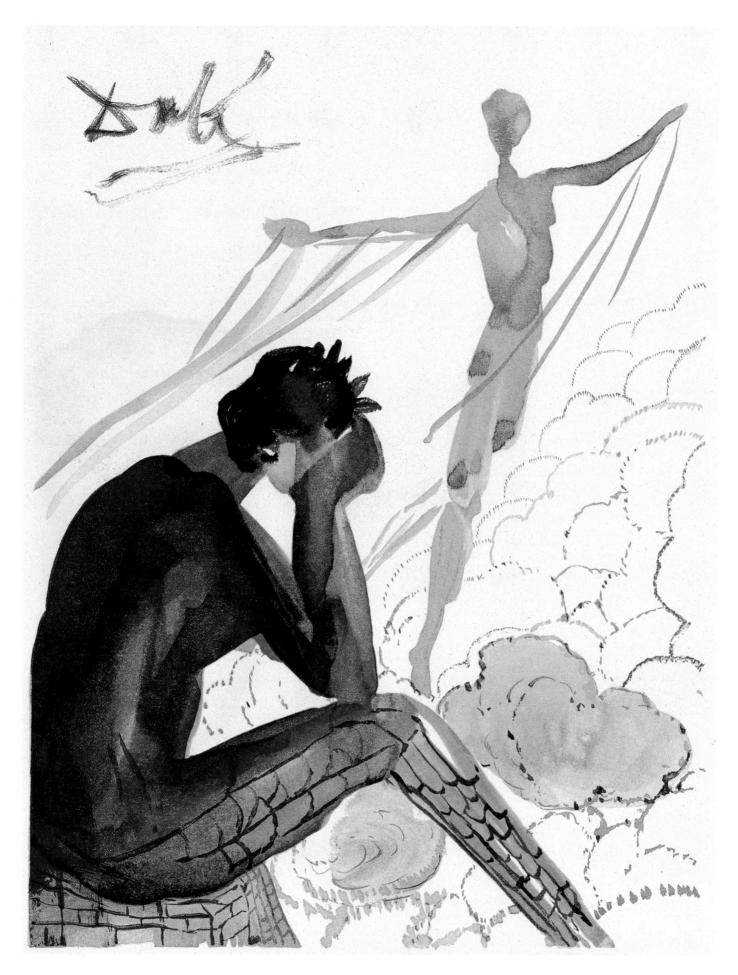

83 Le jeune Icare, 1978 cat. 1534

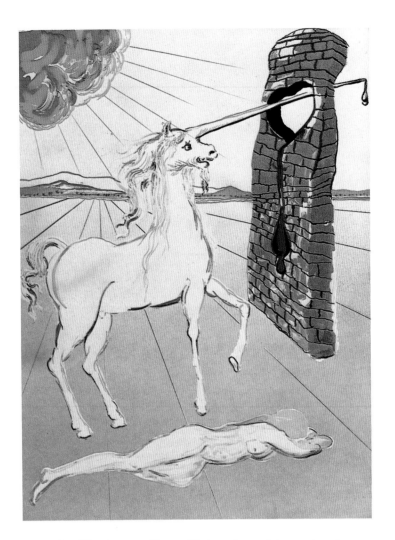

84 The Agony of Love (Unicorn), 1978/9 cat.1556

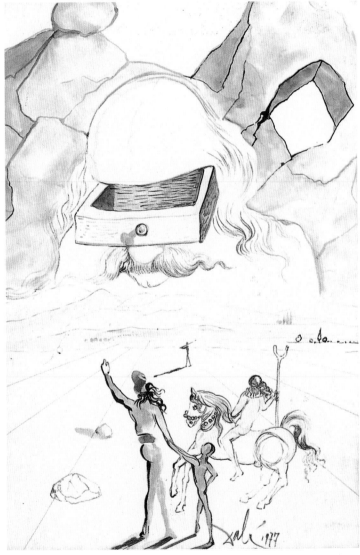

85 The Path to Wisdom (Drawer), 1978/9 cat.1554

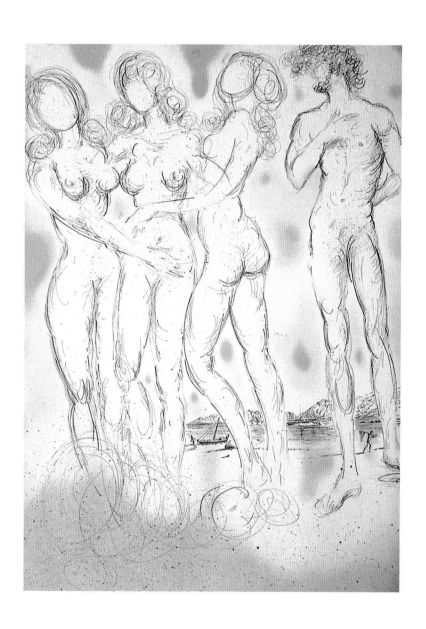

86 The Judgement of Paris, 1979 cat.1562

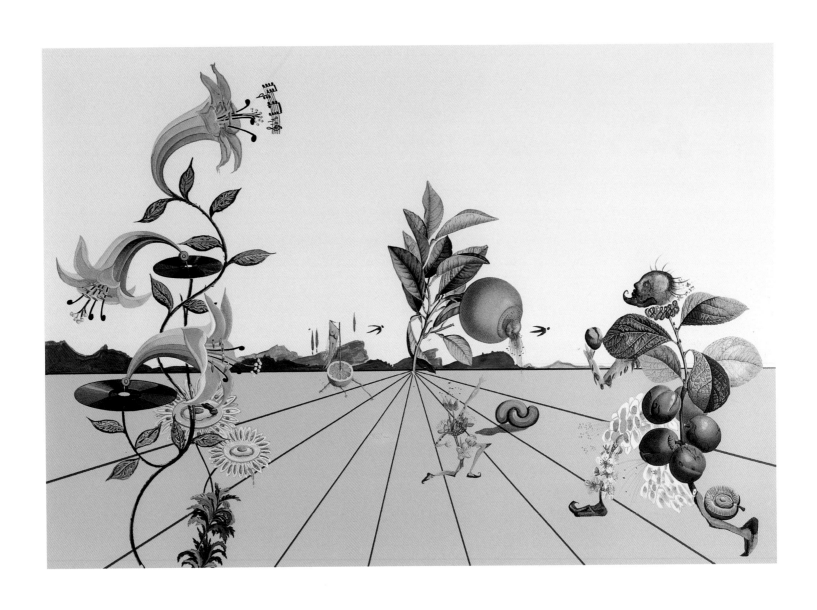

87 Flordali® I, 1981 cat.1586

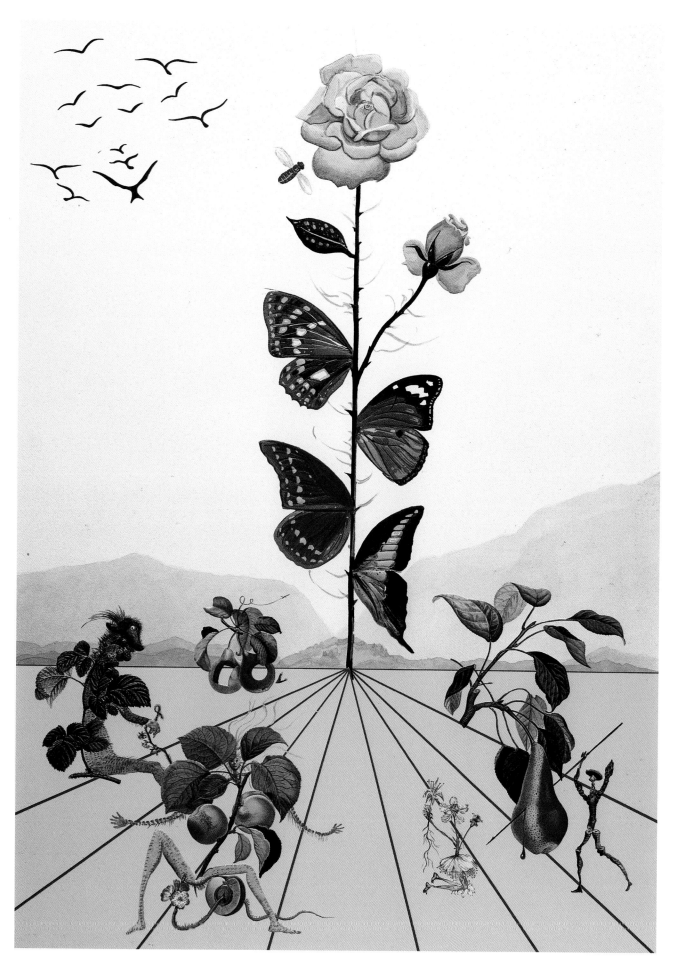

88 Flordali® II, 1981 cat.1587

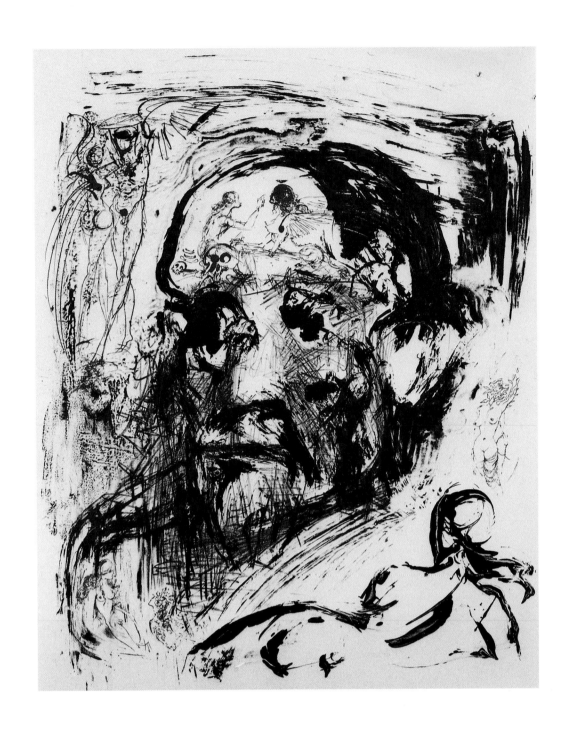

89 Freud, 1973 cat.1429

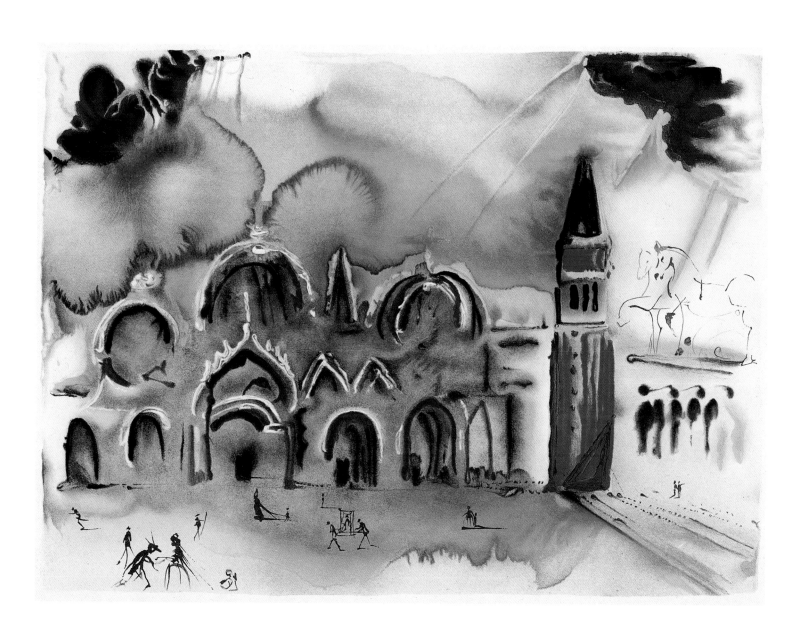

90 Venise (La Basilique et le Campanile), 1978 cat.1551

Catalogue Raisonné
Lithographs and Wood Engravings
1956–1980

The catalogue entries are made up of the following elements:

1. Title

The title refers either to a series (e.g. cat. 1001–1012) or to a single subject (e.g. cat. 1013). Wherever possible, the title is given in the language of the original edition (usually French), followed by the year of publication and, where appropriate, an English translation.

2. Printmaking technique

Lithographs are on stone, unless stated otherwise.

When the word 'original' is used (e.g., 'original lithograph') Dalí played a substantial part in the execution of the print. When the technique ('lithograph', 'wood engraving' or 'silk-screen print') is given on its own, the print was specially made from a design (gouache, watercolour, etc.) executed by Dalí himself.

3. Dimensions

Dimensions are given in centimetres, height first, and refer to the size of the printed area, the sheet size being given in parentheses. The sheet sizes can vary widely, of course, and can therefore only serve as a rough guide.

4. Publisher

The publisher is not necessarily the same as the distributor or the copyright holder. Copublishers are not listed. Abbreviations used include EGI (Editions Graphiques Internationales) and WUCUA (Werbungs- und Commerz Union Anstalt).

5. Printer

6. Titles of prints within a series

Titles of individual prints within a series are given only if authentic.

7. Editions and types of paper

In a few cases, edition details are incomplete. The total edition is then cited wherever possible.

In cases where a handmade paper cannot be precisely identified, the term 'wove paper' has been used.

In a very few instances, painstaking research has failed to ascertain whether an edition bore roman or arabic numerals. In doubtful cases, arabic numerals are given.

Editions numbered in roman numerals follow the form in which they were recorded by the publisher.

Copies designated as 'EA' (épreuve d'artiste) 'PP' (printer's proof), 'PC' (printer's copy), 'AP' (artist's proof) and 'HC' (hors commerce, for restricted sale) are mentioned only when they are numbered or display another state, or when their exact quantity has been definitely established.

Unless otherwise stated, all prints were signed by hand.

Edition details are given in an abbreviated form, i.e. '1–250' means '1/250–250/250'.

8. Descriptive notes

Where prints were published in a book or as a portfolio, reference to the accompanying texts is included.

9. Abbreviated references

The full reference for Charles Sahli (catalogue, 1985) is: Charles Sahli, *Salvador Dalí: 257 Editions Originales, 1964–1985*, Werbungs- und Commerz Union Anstalt catalogue (J. P. Schneider: Vaduz, 1985).

10. Forgeries and reproductions

Information on forgeries, unauthorized editions and reproductions can be found in the Appendix (p. 181), although the absence of any reference to forgeries in the Catalogue itself should not be taken to mean that none exists of the print, or series, in question.

High-quality photomechanical reproductions of Dalí's prints are often confused with the authentic originals, hence their inclusion here, although neither their authorization nor the signatures they bear can be discussed in detail.

For further details on printing techniques, Dalí's signature, papers and editions, readers are referred to Lutz Löpsinger's essay *Dalí's Graphic Development* in Volume I (pp. 15–28).

1001–1012 (plates 1–12)

Don Quichotte de la Manche, 1956/7

12 original coloured lithographs
For dimensions see individual titles
Foret
For printers (where known) see
individual titles

1001 **Don Quixote and Sancho Panza**,
 41 x 32.5 (Manequin)
1002 **Dulcinea**, 40 x 31.8
1003 **Don Quixote Reading**, 41 x 32.5
 (Detruit)
1004 **The Chimera of Chimeras**,
 41 x 32.5
1005 **The Aura of Cervantes**, 41.7 x 32
 (Guillard)
1006 **The Battle with the Wineskins**,
 41 x 32.5 (Delorme)
1007 **The Hidalgo's Metamorphosis**,
 41 x 32.5 (Manequin)
1008 **Milky Way**, 41 x 32.5
1009 **The Fight against Danger**,
 40.5 x 32.5 (Ravel)
1010 **Gala, My Sistine Madonna**,
 55 x 40.5 (Ballon)
1011 **Tilting at the Windmills**,
 64.5 x 40.5
1012 **The Golden Age**, 41.2 x 64.2
 (Ballon)

(a) 1 designated 'A' on parchment, plus
 8 watercolours and 1 suite on Japan
 nacré with watercoloured remarques,
 1 suite on Japan impérial, 1 suite on
 Arches, and colour separations of the
 lithographs
(b) 3 designated B–D on Japan nacré,
 plus 1 watercolour and 1 suite on
 Japan impérial with watercoloured
 remarques, 1 suite on Rives, and
 colour separations of the lithographs
(c) I–XXV on Arches, plus 1 suite on
 Japan nacré and 1 on Rives
(d) 1–50 on Rives, plus 1 suite on Japan
 impérial
(e) 51–168 on Rives
(f) HC1–HC10

Published in the portfolio of the same name
with texts by Miguel de Cervantes (1547–1616).
No sheets hand-signed. The lithographs are on
stone or zinc and printed on transfer paper,
nearly all with photomechanical help. For
further details, see Appendix (p.181).

1001

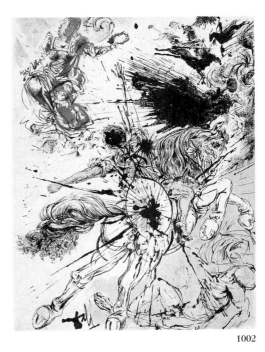

1002

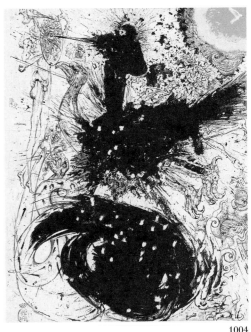

1003

1004

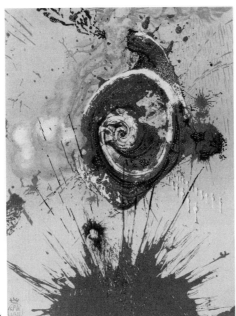

1005

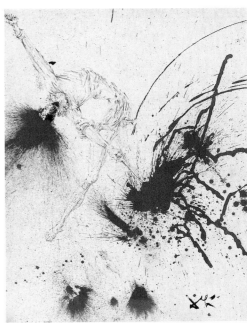

1006

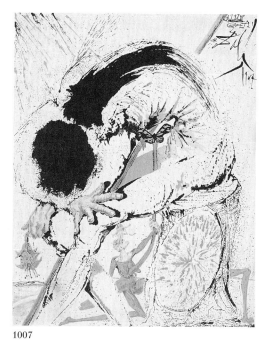

1007

1008

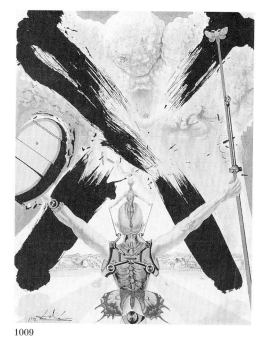

1009

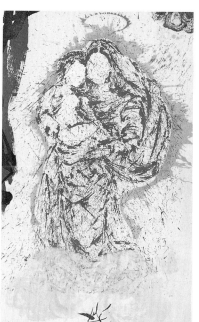

1010

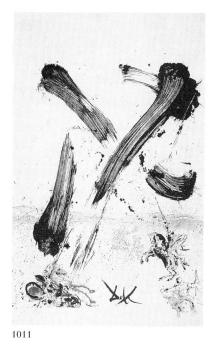

1011

1012

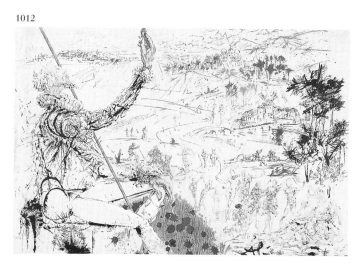

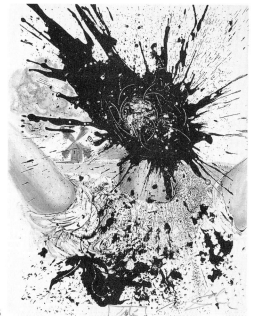

1013

1013 (plate 15)
**Don Quichotte à la tête qui éclate,
1956/7**
Don Quixote with Exploding Head
Original coloured lithograph
41 x 32.5 (sheet and printed area)
Foret
Ballon

(a) 1–25 plus 1 pull on Japan nacré, 1 on
Japan impérial, and 1 on Arches
(b) 26–75 plus 1 pull on Japan impérial
and 1 on Rives
(c) 76–197 plus 1 pull on Rives

Contained in the portfolio *Histoire d'un grand
livre: Don Quichotte* by Michel Déon. In 1966
Dalí hand-signed 60 numbered copies of the
above edition for Edition Michèle Broutta.
All other impressions in the portfolio are un-
signed. For further details, see Appendix
(p.181).

1014

Don Quichotte considéré comme ficelle masochiste, contredite par l'ennoblissement de la lapidation, 1956/7

Don Quixote Seen as a Masochistic Fellow Ennobled by Stoning

Original lithograph

41.5 x 32.6 (sheet and printed area)

Foret

Mourlot

(a) *c.* 7–10 on Arches, unsigned in the plate
(b) 1 on Japan nacré, heightened with gold-dust and signed in the plate (see illus.)

This is a lithograph not included in the *Don Quichotte* series.

1015 (plate 14)

Le Vêtement de Don Quichotte, 1956/7

Don Quixote's Clothing

Original lithograph

65 x 50 (sheet)

Foret

Printer unknown

(a) 1 in black on Rives, designated '1/1'
(b) 1 in black on Rives with red overpainting, designated '1/3'
(c) 1 in black on Rives with white overpainting, designated '2/3'

This is a lithograph not included in the *Don Quichotte* cycle. It was planned as an envelope. The ruff borrows a motif depicted in an old engraving of a procession at Versailles on 4 May 1789.

1016

Femme avec béquille, 1957

Woman with Crutch

Original coloured lithograph

27 x 21.5 (44 x 28.5)

Atelier 53 (?)

Mourlot

(a) 150 on Japan nacré
(b) 100 on handmade paper

In our opinion this is photo-engraver's work. We do, however, have a handwritten statement from Fernand Mourlot expressly pronouncing it to be an original lithograph.

1017

Saint-Jacques de Compostelle, 1958

Santiago de Compostela

Coloured lithograph

58 x 43.7 (76 x 56)

Foret

Manequin

(a) I–XXV on Japan nacré with water-coloured remarques
(b) 1–50 on Arches with remarques
(c) 51–172 on Rives

For further details, see Appendix (p.181).

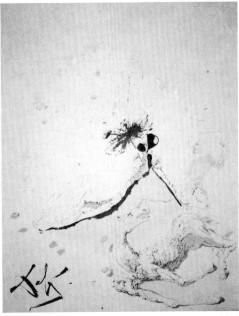

1014

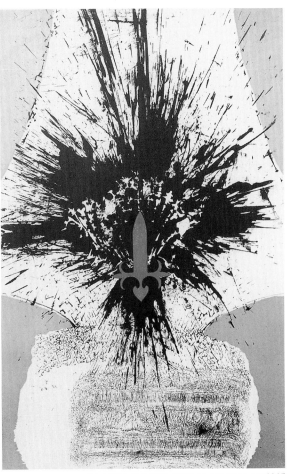

1015

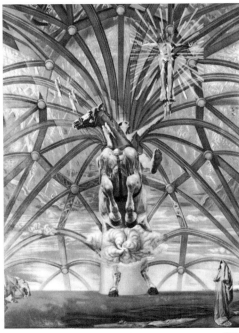

1017

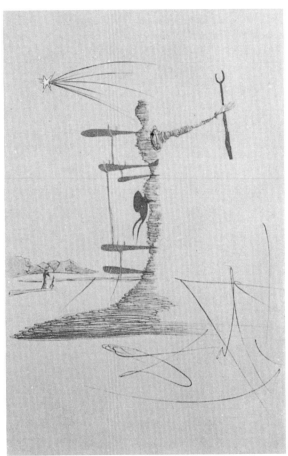

1016

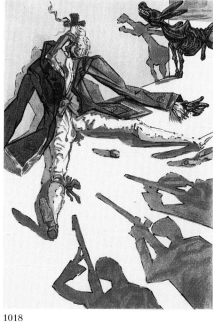

1018

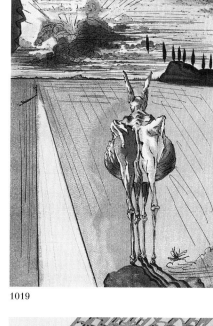

1019

1018–1037
Le Tricorne (El Sombrero de tres picos), 1959
The Three-Cornered Hat
20 coloured wood engravings
32 x 25 (sheet)
Edition du Rocher/Nouveau Cercle
Parisien du Livre
Vibert

(a) 120 portfolios numbered 1–120 on
 Richard de Bas, the first 30 contain-
 ing various suites adorned with cop-
 perplate engravings (see Volume I,
 cat. 68–80)
(b) 140 portfolios numbered I–CXL on
 Richard de Bas, reserved for mem-
 bers of the Nouveau Cercle Parisien
 du Livre
(c) 30 portfolios designated HC1–HC30
(d) 60 suites on Chinese paper, Hollande,
 and Richard de Bas, some with
 copperplate engravings and colour
 separations

Published in the portfolio of the same name
with texts by Pedro Antonio de Alarcón y Ariza
(1833–91). With the exception of a few signed
as a personal favour, the coloured wood en-
gravings bear no signature.

1020

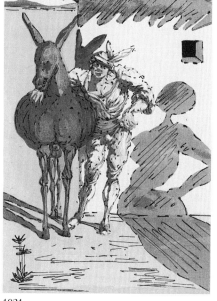

1021

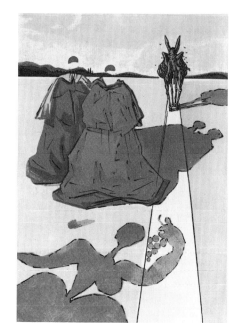

1022

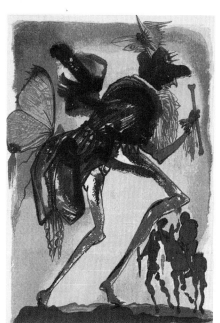

1023

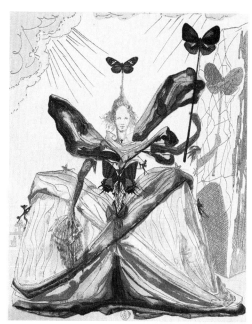

1024

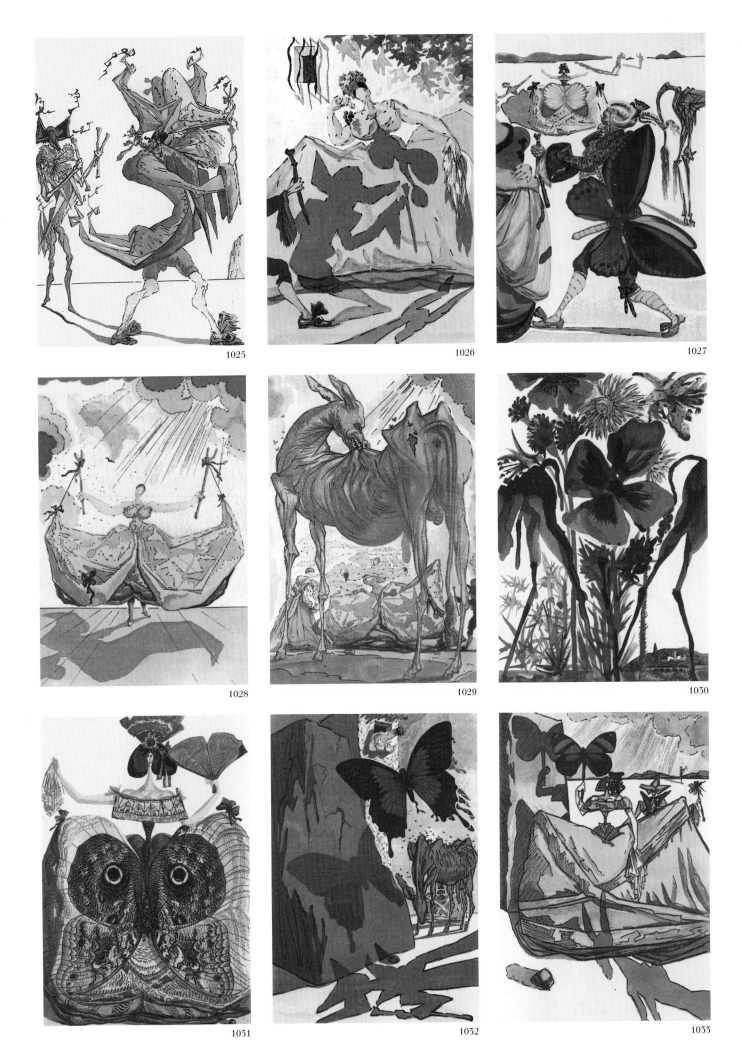

1025

1026

1027

1028

1029

1030

1031

1032

1033

1034

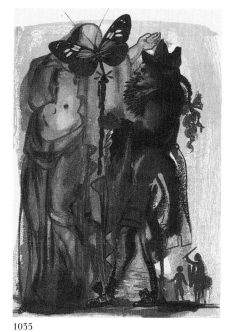

1035

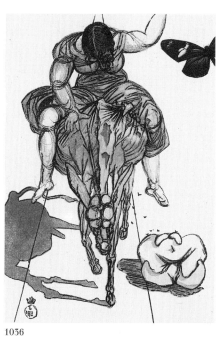

1036

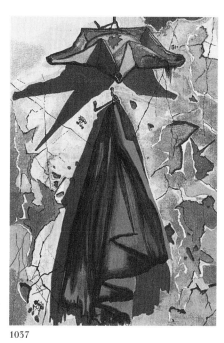

1037

1038

1038

Combat, 1960
Original lithograph
36.2 x 45.7 (sheet and printed area)
Publisher unknown
Printer unknown

1 impression with a superimposed
drawing by Dalí

Like the *Don Quichotte* series, this is a 'boule-
tiste' lithograph. The printing surface was shot
at with bullets dipped in lithographic ink and
fired from a fifteenth-century arquebus.

1039–1138 (plates 15–20)

La Divine Comédie, 1960

100 coloured wood engravings in
6 volumes
33 x 26.2 (sheet)
Foret/Les Heures Claires
Ateliers Jacquet/Taricco

Edition for Foret:

(a) I on Japan nacré, plus 9 watercolours
 and 3 copperplates, 1 suite of copper-
 plates on silk, 1 suite of copperplates
 on Rives, 1 coloured suite of wood en-
 gravings, and colour separations of
 1 subject

(b) II and III on Japan nacré, plus
 6 watercolours and 1 copperplate,
 1 suite of copperplates on silk,
 1 coloured suite of wood engravings,
 and colour separations of 1 subject

(c) IV–VIII on Japan nacré, plus 3 water-
 colours and 1 copperplate, 1 suite of
 copperplates on silk, 1 coloured suite
 of wood engravings, and colour
 separations of 1 subject

(d) IX–XXI on Japan nacré, plus 1 water-
 colour, 1 suite of copperplates on silk,
 1 coloured suite of wood engravings,
 and colour separations of 1 subject

Edition for Les Heures Claires:

(e) 1–15 on Rives, plus 1 copperplate,
 1 suite of copperplates, 1 coloured
 suite of wood engravings, and colour
 separations of 1 subject

(f) 16–165 on Rives, plus 1 suite of cop-
 perplates, 1 coloured suite of wood
 engravings, and colour separations of
 1 subject

(g) 166–515 on Rives, plus 1 coloured
 suite of wood engravings and colour
 separations of 1 subject

(h) 516–865 on Rives, plus colour separ-
 ations of 1 subject

(i) 866–4765 on Rives

With a few exceptions, all examples of
editions (a) to (i) bear engraved signa-
tures in the design itself. Only a few of
the prints were hand-signed for friends
and associates. Editions (j) and (k) bear
no engraved signatures but were hand-
signed by Dalí in crayon.

(j) 150 on Rives, hand-signed for
 Editions Orangerie-Reinz, 1964

(k) I–III on Rives, hand-signed for
 Editions Orangerie-Reinz, 1964

All 100 subjects were also executed as copper-
plate engravings for incorporation in a few
suites. The Rome State Press executed litho-
graphs of 7 subjects prior to the Foret edition.
They are now in the Reynold-Morse Collection
(40.6 x 29.3). For further details, see Appendix
(p. 181).

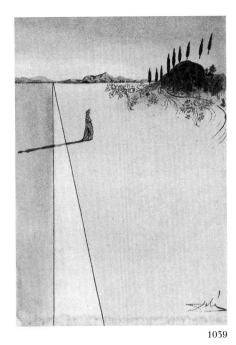

1039

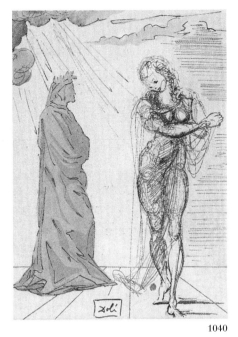

1040

1041

1042

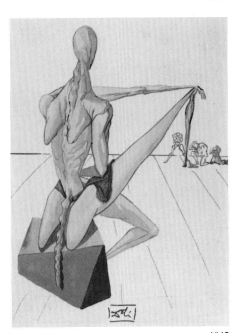

1043

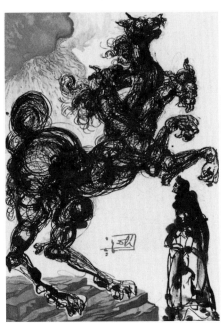

1044

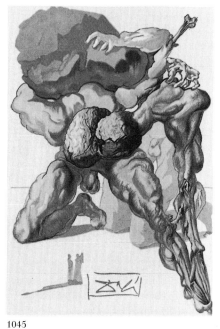

1045

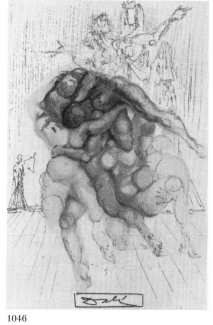

1046

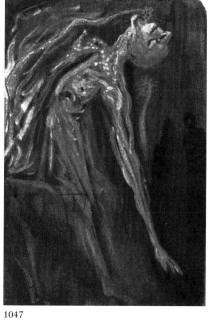

1047

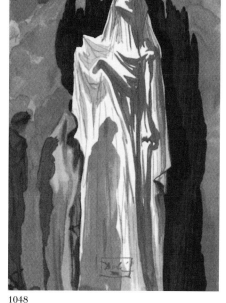

1048

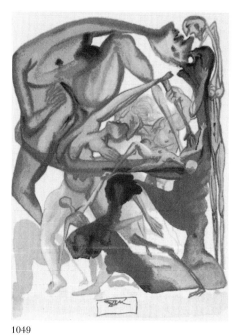

1049

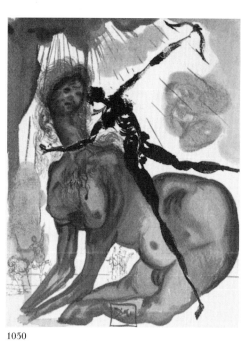

1050

1051

1052

1053

1054

1055

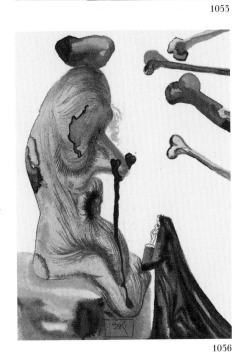

1056

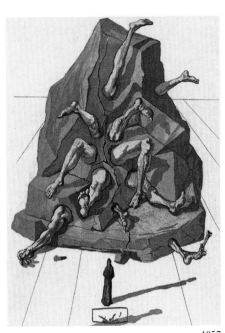

1057

1058

1059

1060

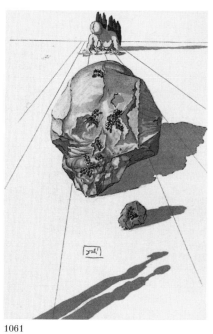

1061

1062

1063

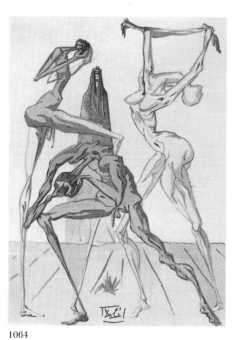

1064

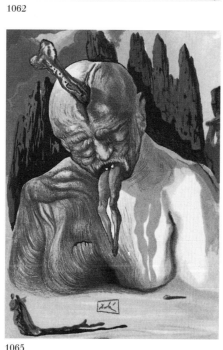

1065

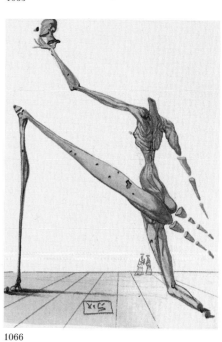

1066

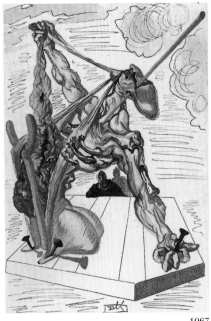

1067

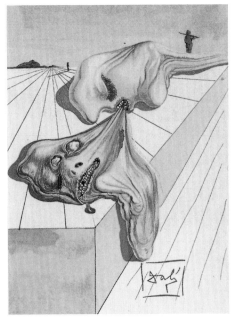

1068

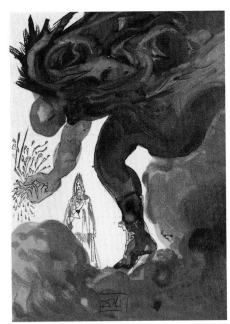

1069

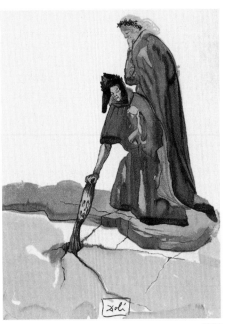

1070

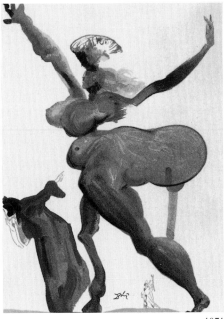

1071

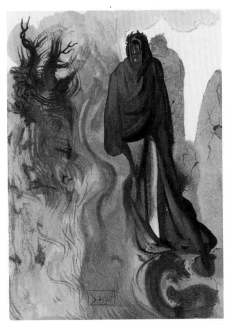

1072

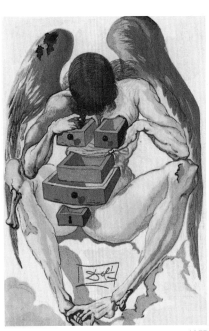

1073

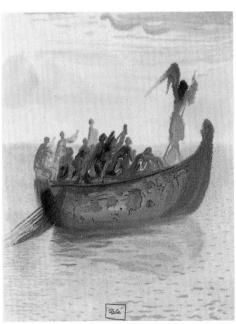

1074

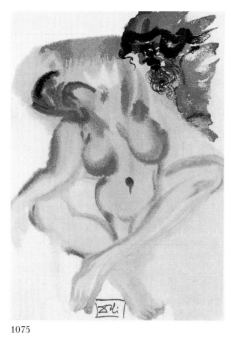

1075

1076

1077

1078

1079

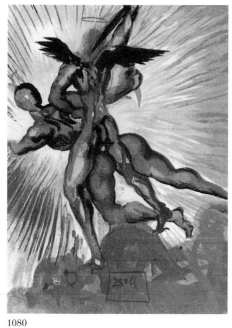

1080

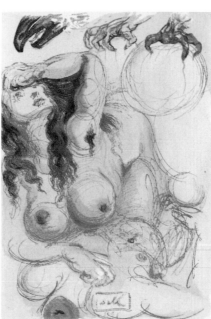

1081

1082

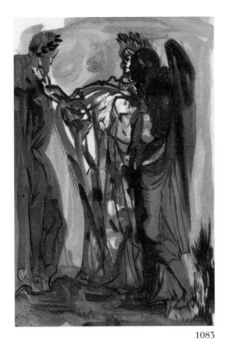

1083

1084

1085

1086

1087

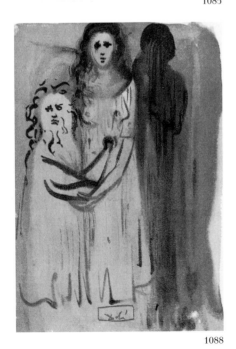

1088

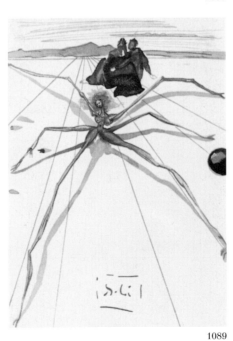

1089

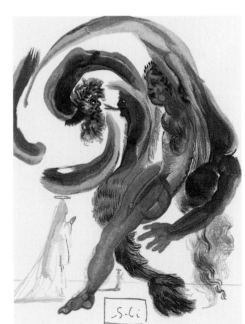

1090

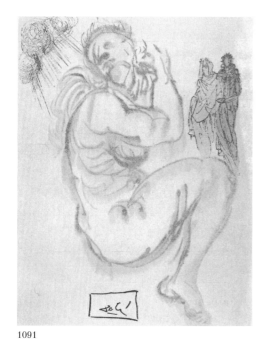

1091

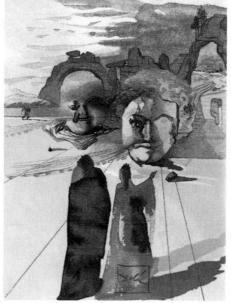

1092

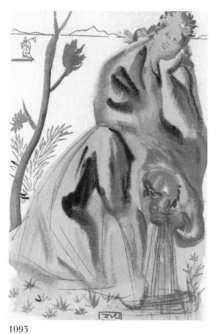

1093

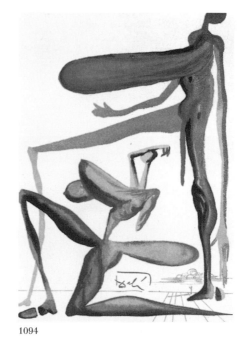

1094

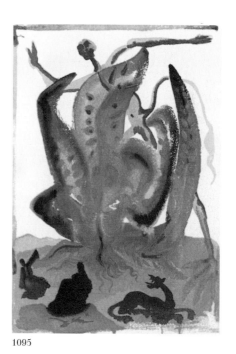

1095

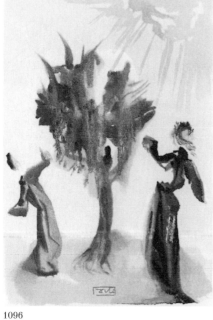

1096

1097

1098

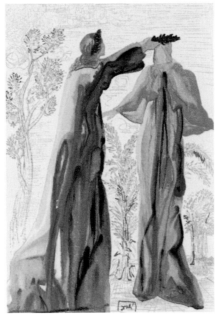

1099

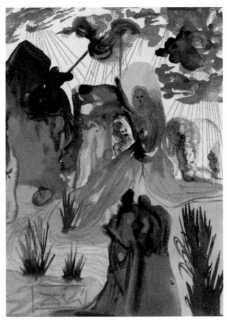

1100

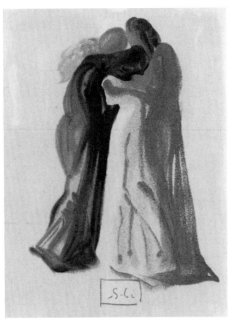

1101

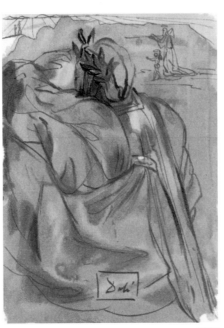

1102

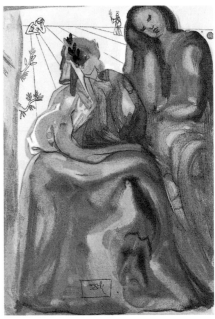

1103

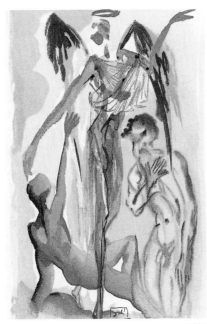

1104

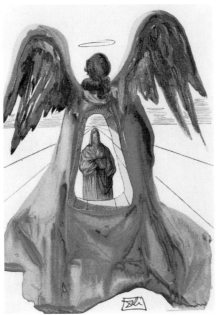

1105

1106

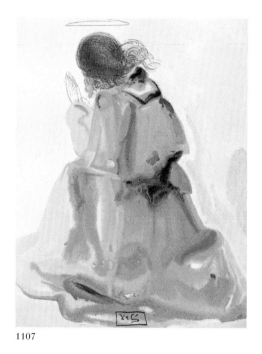

1107

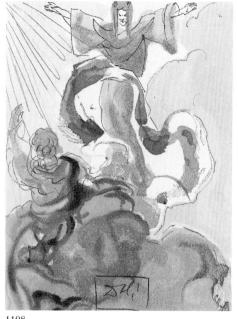

1108

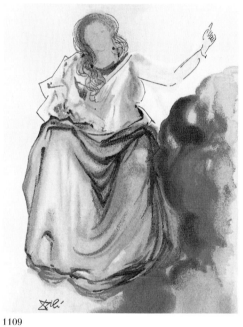

1109

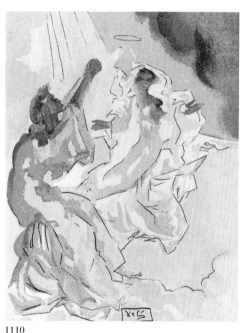

1110

1111

1112

1113

1114

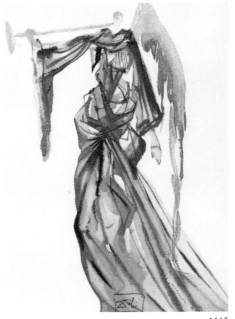

1115

1116

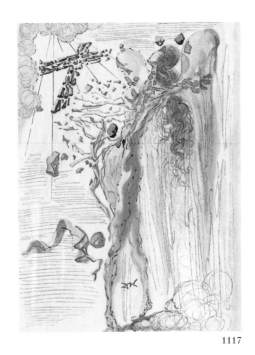

1117

1118

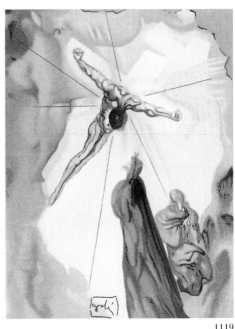

1119

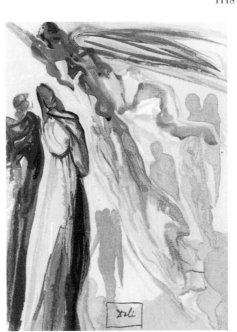

1120

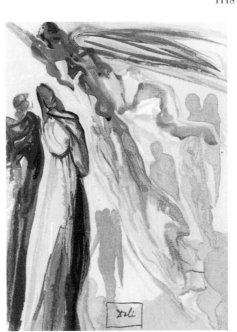

1121

1122

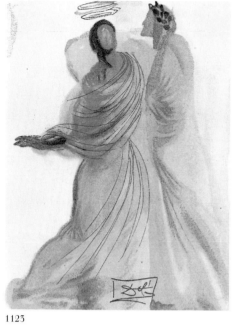

1123

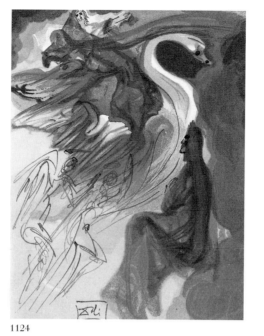

1124

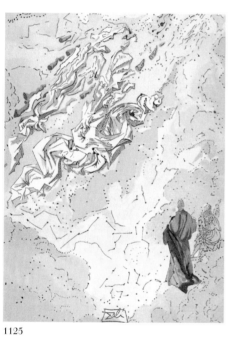

1125

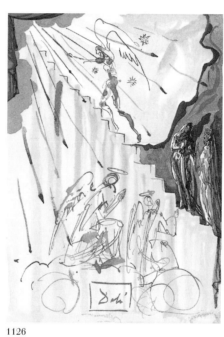

1126

1127

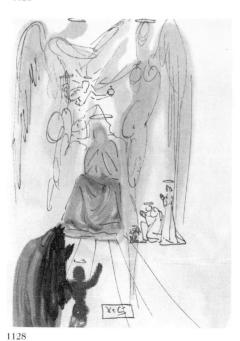

1128

1129

1130

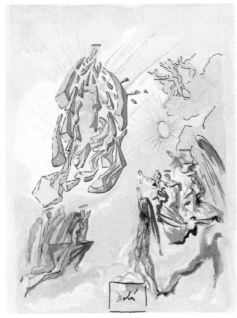
1131

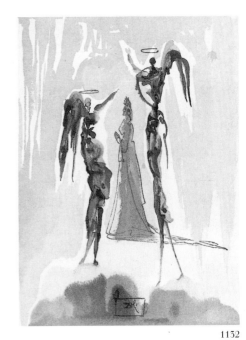
1132

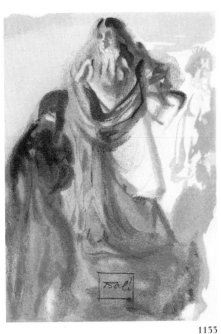
1133

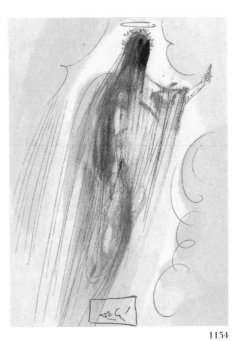
1134

1135

1136

1137

1138

114 Catalogue Raisonné 1960

1139

1139
La Danse, 1960
The Dance
Coloured wood engraving
72 x 50 (100 x 65)
Foret
Printer unknown

(a) 100 on handmade paper

A further edition with different print area
and sheet dimensions was printed for
Edition Les Heures Claires:

(b) 1–147 on wove paper
(c) I–L on Japanese paper

For further details, see Appendix (p. 181).

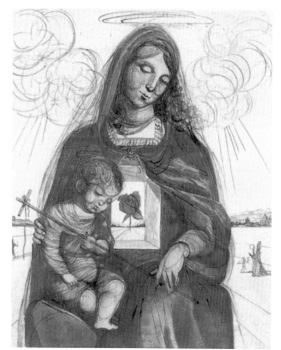

1140

1140
Mystical Rose Madonna, 1964
Coloured lithograph
45.5 x 46 (48.6 x 47.3)
Sears Roebuck Commission
Printer unknown

1–300 on Arches *teinté*

For further details, see Appendix (p. 181).

1141 (plate 21)
Dante, 1964
Original zinc lithograph
59 x 47 (76 x 55)
WUCUA
Desjobert

(a) 1–125 on Rives
(b) 1–25 on Japan nacré
(c) I–X on Auvergne
(d) a few proofs on red paper

Our information derives from Charles Sahli
(catalogue, 1985), no. 8.

1141

1142 (plate 22)
Beatrice, 1964
Original zinc lithograph
59 x 51 (76 x 55)
WUCUA
Desjobert

(a) 1–125 on Rives
(b) 1–25 on Japan nacré
(c) I–X on Auvergne
(d) a few proofs on red paper

Our information derives from Charles Sahli
(catalogue, 1985), no. 7.

1142

1143

Triumph of the Sea, 1965
Coloured lithograph
65 x 78.7 (sheet)
Sidney Z. Lucas
Printer unknown

1–150 on handmade paper

The imprint of an octopus served as a background.

1144 (plate 23)

The Cosmic Rays Resuscitating the Soft Watches, 1965
Original coloured lithograph
54 x 75 (63.5 x 96.5)
Sidney Z. Lucas
Printer unknown

(a) 1–150 on Rives
(b) 10 on handmade paper, designated 'A–J'

1145 (plate 24)

Drawers of Memory (Cité des tiroirs), 1965
Original lithograph
51 x 78 (63.5 x 96.5)
Sidney Z. Lucas
Printer unknown

(a) 1–150 on handmade paper
(b) 10 on handmade paper, designated 'A–J'

For further details, see Appendix (p.181).

1146

The Face in the Windmill, 1965
Original coloured lithograph
51 x 67.8 (63 x 96.5)
Sidney Z. Lucas
Printer unknown

(a) 1–150 on handmade paper
(b) 10 on handmade paper, designated 'A–J'

The technique employed here was probably 'litho mezzotinto'. The plate signature was applied by a photo-engraver.

1147 (plate 61)

The Fishermen, 1965
Lithograph
68.5 x 53.4 (96 x 65)
Sidney Z. Lucas
Printer unknown

(a) 1–150 on handmade paper
(b) 10 on handmade paper, designated 'A–J'

1143

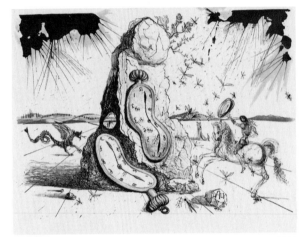

1144

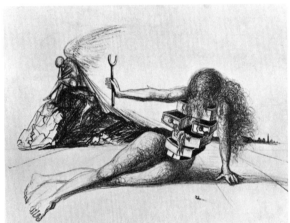

1145

1147

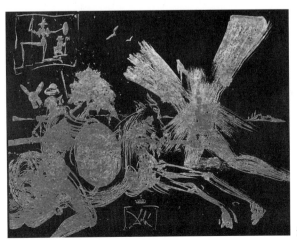

1146

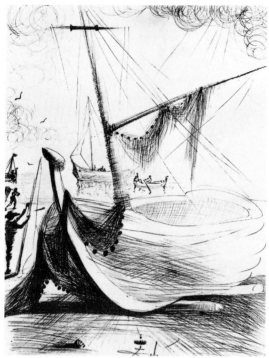

1148

1149

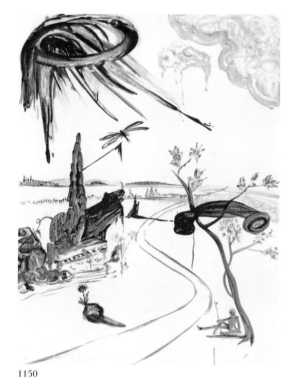

1150

1148 (plate 62)
Departure of the Fishermen, 1965
Lithograph
68.5 x 53.4 (96 x 65)
Sidney Z. Lucas
Printer unknown

(a) 1–150 on Rives
(b) 10 on handmade paper, designated
 'A–J'

1149
Spring Explosive, 1965
Coloured lithograph
67.2 x 50.8 (78.5 x 60.5)
Sidney Z. Lucas
Printer unknown

(a) 1–300 on handmade paper
(b) 10 on handmade paper, designated
 'A–J'

1150
Studio of Dalí, 1965
Coloured lithograph
48.5 x 65 (55 x 65)
Sidney Z. Lucas
Printer unknown

(a) 1–300 on Rives
(b) 10 on handmade paper, designated
 'A–J'

1151
Fantastic Voyage, 1965
Coloured lithograph
57 x 46 (76 x 55)
Sidney Z. Lucas
Printer unknown

(a) 1–300 on Rives
(b) 10 on handmade paper, designated
 'A–J'

1151

1152–1156 (plate 25)
Bullfight Series, 1966
5 coloured lithographs
For dimensions see individual titles
Sidney Z. Lucas
Printer unknown

1152 **Bullfight No. 1**, 50 x 65
1153 **Bullfight No. 2**, 76 x 55
1154 **Bullfight No. 3**, 56 x 76
1155 **Bullfight No. 4**, 76 x 56
1156 **Picador**, 67 x 53

(a) 1–300 on handmade paper
(b) EA1–EA10 on handmade paper

The lithograph *Picador* was not published until
1967.

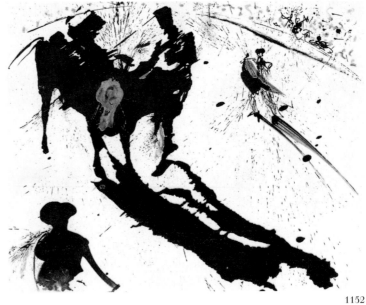

1152

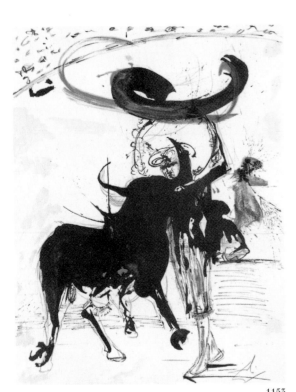

1155

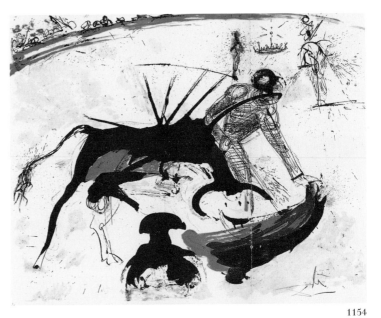

1154

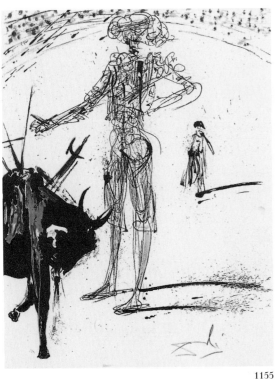

1155

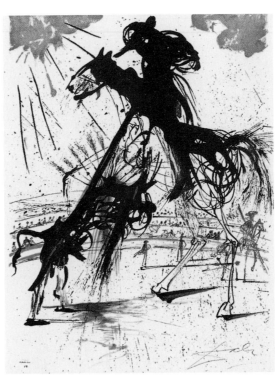

1156

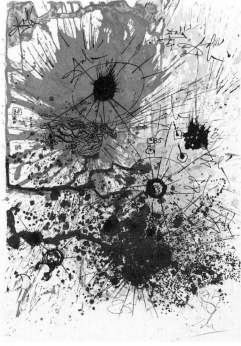

1157

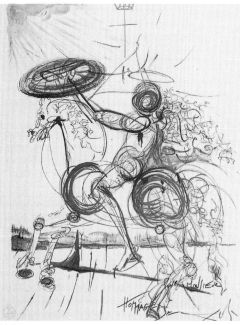

1158

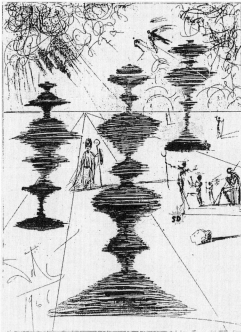

1159

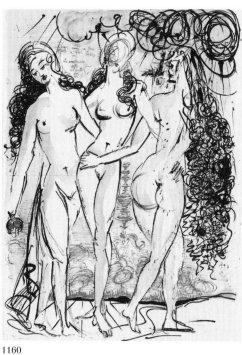

1160

1161

1157

The Lucky Number of Dalí, 1966
Coloured lithograph
76 x 55.8 (sheet)
Sidney Z. Lucas
Printer unknown

(a) 1–300 on Rives
(b) 10 on handmade paper, designated 'A–J'

1158

The Crazy Horse Saloon, 1966
Original coloured lithograph
72 x 52 (76 x 55)
Yamet-Art
Mourlot (?)

(a) 1–250 on Rives
(b) I–XXV on Rives

1159

Fables de La Fontaine, 1966
Lithograph
Dimensions unknown
La Croix-Rouge Française
René Guillard

(a) 1–20 on Japan nacré, each portfolio containing 1 original, 1 original fleuron, 3 suites on Japan impérial, Arches, and silk, and 1 set of colour separations on Arches
(b) 21–70 on Arches, each portfolio containing 2 suites on Arches and Lana and 1 set of colour separations on Arches
(c) 71–399 on Lana, plus 1 suite on Lana
(d) HC1–HC41 on Arches, plus 1 suite on Lana, 1 print on silk, and 1 set of colour separations on Arches

Contained in the portfolio of the same name with lithographs by various artists. Volume II of this work was produced by René Guillard.

1160

Three Graces, 1966
Original coloured lithograph
63 x 47 (76 x 55)
Sidney Z. Lucas
Printer unknown

1–300 on Rives

1161

Sundial, 1966
Coloured lithograph
32 x 42 (45.5 x 55.5)
EGI
Mourlot

(a) 1–150 on wove paper
(b) I–XXXV on Japanese paper
(c) 25 *épreuves d'artiste*

The watercolour also served as a design for a sundial.

1162–1171 (plates 26–33)
Contes d'Andersen, 1966
Andersen's Fairy-Tales
10 coloured lithographs
c. 65.5 x *c.* 50.5 (sheet)
Gerschman
Desjobert

1162 **The Red Shoes**
1163 **The Little Mermaid I**
1164 **The Little Mermaid II**
1165 **The Snow Queen**
1166 **Prince and Princess**
1167 **The Toad**
1168 **The Ugly Duckling**
1169 **The Will-o'-the-Wisps Are in Town**
1170 **The Girl Who Trod on the Loaf**
1171 **The Sandman**

(a) 1–75 on Japanese paper
(b) I–XXXXV on Arches
(c) EA1–EA10 on Japanese paper
(d) EA1–EA10 on Arches

Contained in the portfolio of the same name.

1162

1163

1164

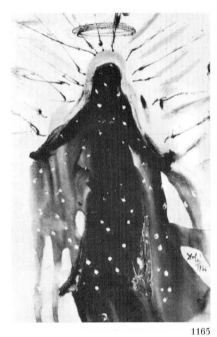

1165

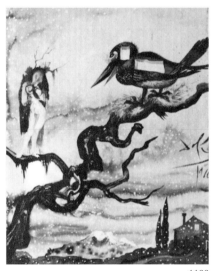

1166

1167

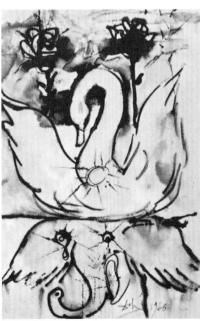

1168

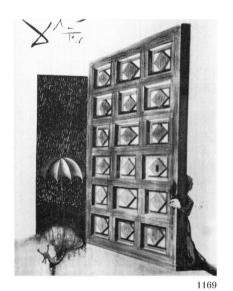

1169

1171

1170

1172

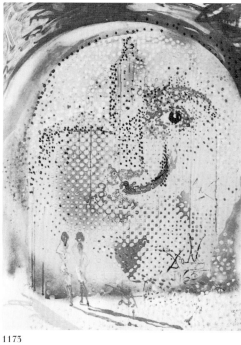

1173

1172
Cartel Unicef, 1966/7
Coloured lithograph
60.2 x 45.2 (sheet)
World Federation of the United Nations
Associations/EGI
Desjobert

(a) 300 on handmade paper
(b) 50 on Japanese paper
(c) 25 designated 'Musée'

Design for an envelope.

1173 (plate 43)
Sol y Dalí, 1967
Sun and Dalí
Coloured lithograph
55.7 x 41.9
WUCUA
Mourlot

(a) 1–200 on Arches
(b) I–C on Arches
(c) 1720 posters with text, unsigned

Our information derives from Charles Sahli
(catalogue, 1985), no. 42.

1174
Casino de Beirut – Searching, 1967
Coloured lithograph
37.5 x 55.7 (50 x 65)
EGI
Desjobert

Details of edition unknown

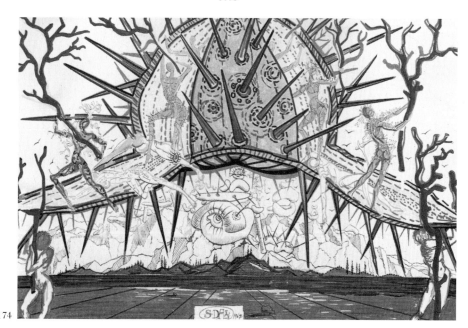

1174

1175–1178 (plates 38–41)
Hommage à Meissonier, 1967
Tribute to Meissonier
4 original coloured lithographs
31 X 23
WUCUA
Desjobert

1175 **Gala**
1176 **Nu gris** *(Grey Nude)*
1177 **Le Pécheur** *(The Sinner)*
1178 **La Main** *(The Hand)*

(a) 1–150 on Rives
(b) 1–150 on Japan nacré
(c) 2000 unsigned impressions, minus
 margins, are embodied in the book of
 the same name.

Our information derives from Charles Sahli
(catalogue, 1985), nos. 44–47.

1179 (plate 42)
Meissonier, 1967
Coloured lithograph
56 X 43
WUCUA
Desjobert

(a) 1–300 on Rives
(b) 1500 posters with text, unsigned

Our information derives from Charles Sahli
(catalogue, 1985), no. 43.

1180 (plate 45)
Menu de Gala, 1967
Coloured lithograph after an original
sketch
46 X 32.5
WUCUA
Draeger

(a) Menu card for an official dinner on
 2 November 1967 to inaugurate the
 'Hommage à Meissonier' Exhibition
(b) Menu card for a dinner on 11 Novem-
 ber 1967
(c) a few pulls designated 'HC' and
 signed

Our information derives from Charles Sahli
(catalogue, 1985), no. 48.

1175

1176

1177

1178

1179

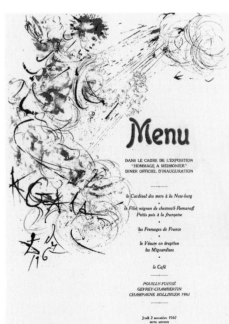

1180

1181

1182

1181–1192
Signes du Zodiaque, 1968
Signs of the Zodiac
12 coloured lithographs
64 x 47.6 (73 x 52)
Léon Amiel
Mourlot

(a) 1–250 on Arches *teinté*
(b) I–L on Japanese paper
(c) 15 *hors commerce* designated 'A–O'

Published in the portfolio of the same name
with texts by Nicolas Sokoloff. For further
details, see Appendix (p.181).

1183

1184

1185

1186

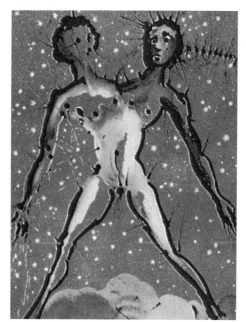

1187

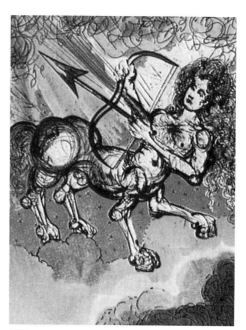

1188

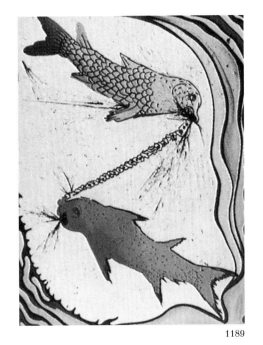

1189

1190

1191

1192

1193–1217
Aliyah, 1968
Elijah
25 coloured lithographs
65 x 50 (sheet)
Shorewood
Wolfensberger/Mourlot

1193 **Aliyah**
1194 **Thou Hast Laid Me in the Deeps**

1193

1194

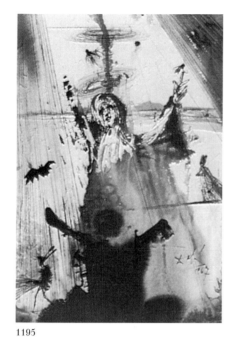

1195

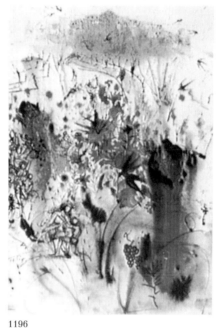

1196

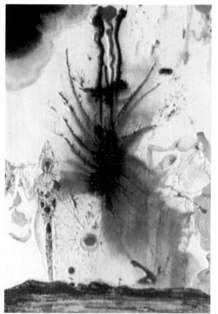

1197

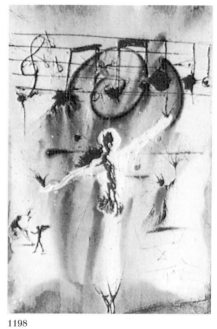

1198

1199

1200

1201

1202

1203

1204

1205

1206

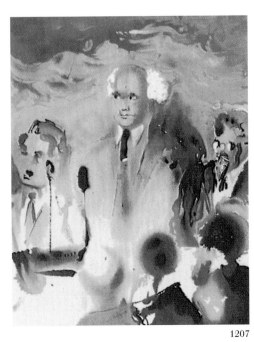

1207

1208

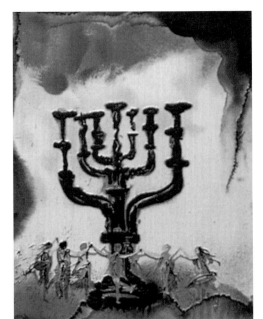

1209

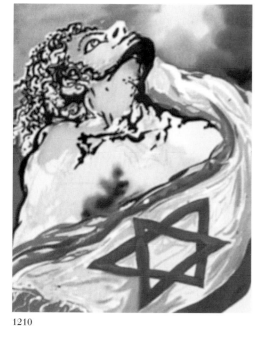

1210

1211

(a) 1–250 on Arches
(b) 15 *hors commerce*
(c) 25 on Japanese paper, designated
 'a–y'

Contained in the portfolio of the same name.
For further details, see Appendix (p. 181).

1212

1213

1214

1215

1216

1217

1218 (plate 44)
Faubourg Saint-Honoré, 1968
Silk-screen print
63 x 45
WUCUA
Editions de l'Oiselet

(a) 300 posters with text, numbered
 1–300
(b) 1 copy (158 x 110) with text,
 dedicated
(c) Posters (63 x 45), unsigned
(d) Posters (158 x 110), unsigned

Our information derives from Charles Sahli
(catalogue, 1985), no. 77.

1219
El Caballero, 1968
The Horseman
Coloured lithograph
77 x 56 (102 x 73)
Shorewood
Wolfensberger

(a) 1–175 on Arches
(b) 1–25 on Japanese paper
(c) I–XXV on Japanese paper
(d) EA1–EA15 on Arches
(e) I–LXXV on Arches

1220–1224 (plates 46–49)
Tauromachie, 1968
Bullfight
5 coloured lithographs after 5 embossed
gouaches
54.5 x 43.5
WUCUA
Matthieu

1220 **Tauromachie I**
1221 **Tauromachie II**
1222 **Tauromachie III**
1223 **Tauromachie IV**
1224 **Tauromachie V**

(a) 1–150 on Rives
(b) I–XXV on Japan nacré

1218

1219

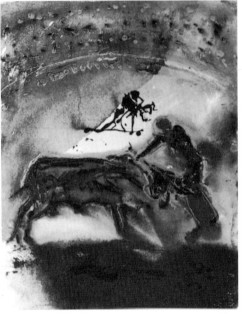

1220

1221

1222

1223

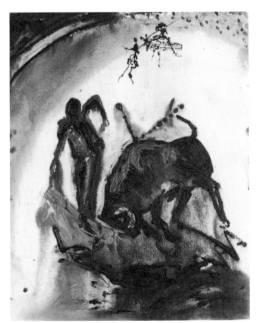

1224

1225

1226

Executed by a photo-engraver after a work specially created for this edition and lithographically reworked and corrected by Dalí himself. Our information derives from Charles Sahli (catalogue, 1985), nos. 121–125.

1225–1230 (plates 50–55)
S. N. C. F., 1969
6 coloured lithographs
WUCUA
Draeger/Matthieu

1225 **Alpes,** 74 x 53.5
1226 **Normandie,** 73 x 56.5
1227 **Roussillon,** 73 x 56.5
1228 **Paris,** 77.5 x 56
1229 **Alsace,** 74 x 53.5
1230 **Auvergne,** 73 x 56.5

(a) 1–300 without text
(b) 1700 posters (46.5 x 34), with die stamp and unsigned
(c) 700 posters on cardboard with text, unsigned
(d) Posters in both formats for the Société Nationale des Chemins de Fer Français, printed on poster paper and unsigned

Our information derives from Charles Sahli (catalogue, 1985), nos. 130–135.

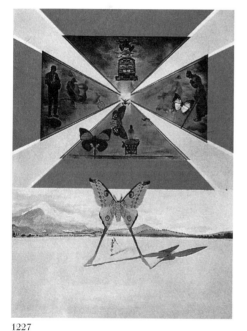

1227

1228

1231
The Spring at Evian (Perrier), 1969
Coloured silk-screen print
53.5 x 37.5 (sheet)
Perrier
Printer unknown

(a) 25 on cardboard
(b) countless examples on poster paper with offset impressions of crown corks

1229

1230

1231

1232–1256

**Three Plays by the Marquis de Sade,
1969**
25 coloured lithographs
65.5 x 50.2 (sheet)
Shorewood
Wolfensberger

1232 **Marianne and the Chevalier,**
 50.5 x 39.5
1233 **As Pure as Her Heart,** 51 x 39.5
1234 **The Chevalier's Proposal,** 51 x 39
1235 **Cécile's Chastity,** 50.5 x 40
1236 **The Twins Outwit Damis,**
 53 x 42.5
1237 **Damis and Durval,** 53 x 42.5
1238 **All's Well that Ends Well,** 53 x 42.5
1239 **The Prison,** 51 x 39.5
1240 **A Miserable Flat,** 50.5 x 39.5
1241 **Adelaide's Promise,** 53 x 42.5
1242 **The Obsequies for Clorinda,**
 53 x 42.5
1243 **The Crime,** 51 x 39.5
1244 **The Arrival of Dumont,** 53 x 42
1245 **Cécile Receives Germeuil's**
 Letter, 53 x 42.5
1246 **The Death of Clorinda,** 53 x 42.5
1247 **Merville and His Sons Reunited,**
 50.5 x 40
1248 **Brave Cécile,** 47.5 x 35
1249 **The Siege of Jerusalem,** 53 x 42.5
1250 **The Chevalier's Dream of Cécile,**
 50.5 x 40
1251 **Tancred's Oath,** 53 x 42.5
1252 **Without Hope,** 50.5 x 40
1253 **Damis's Dilemma,** 53 x 42.5
1254 **Dumont and Marton,** 53 x 42.5
1255 **Tancred's Choice,** 53 x 42.5
1256 **Protect Her from Misfortune's**
 Mistakes, 53 x 42.5

(a) 1–160 on Arches (for the USA)
(b) I–XC on Arches *teinté*
(c) EAI–EAIV on wove paper
(d) 26 *hors commerce* on Japanese paper,
 designated 'A–Z'
(e) EA1–EA6 on Rives

Contained in the portfolio of the same name.
For further details, see Appendix (p.181).

1232

1233

1234

1235

1236

1237

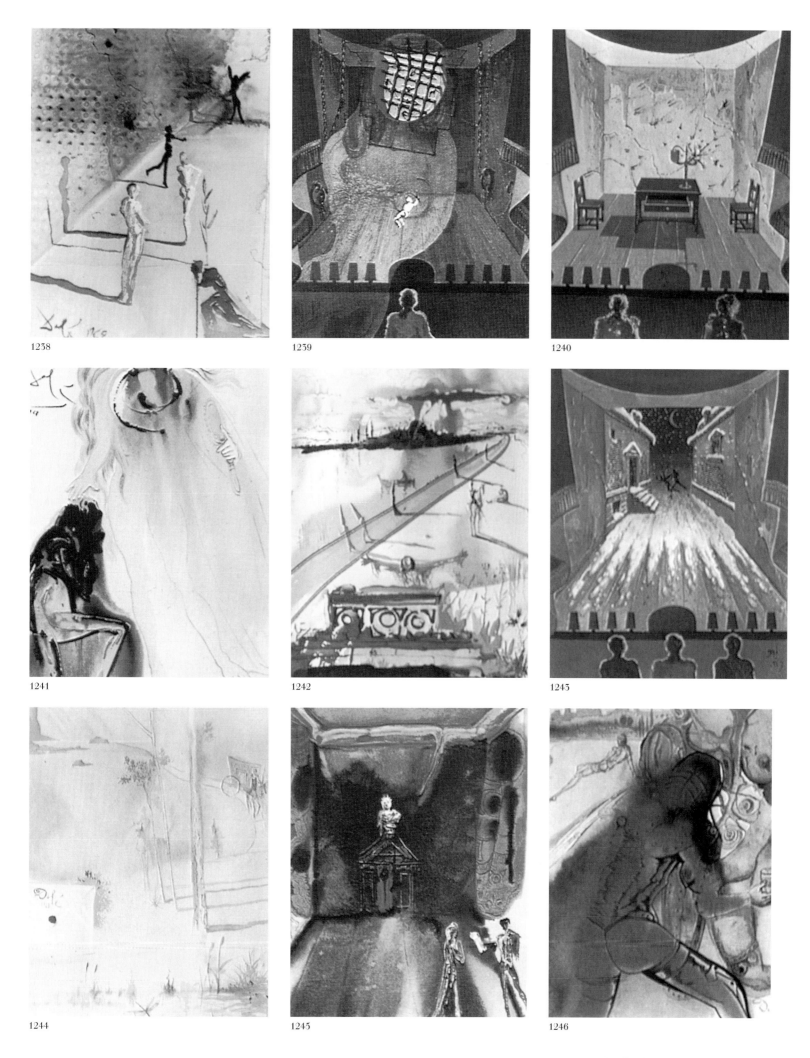

1238

1239

1240

1241

1242

1243

1244

1245

1246

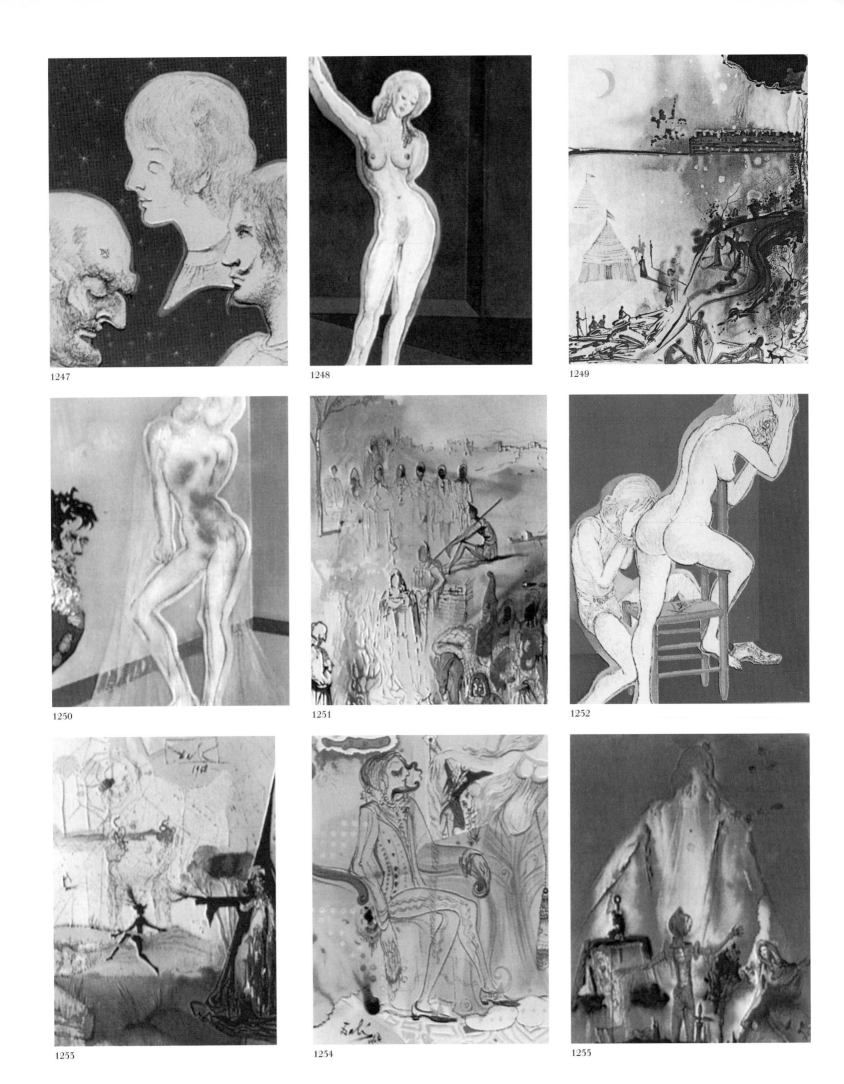

1247

1248

1249

1250

1251

1252

1253

1254

1255

1257 (plate 78)
Torero noir, 1969
Black Bullfighter
Original lithograph
65 x 43 (76 x 56)
WUCUA
Wolfensberger

(a) I–LXXV on Japan nacré
(b) 1–150 on Rives
(c) 4 states, hand-coloured by Dalí

Our information derives from Charles Sahli
(catalogue, 1985), no. 128.

1256

1257

1258

1259

1260

1261

1258–1282
Les Chevaux Daliniens, 1970/2
Dalinesque Horses
25 coloured lithographs with embossing
65 x 50 or 50 x 65 (sheet)
Carpentier/Waintrop
Wolfensberger

1258 **La Licorne** *(The Unicorn)*
1259 **Le Cheval marin** *(The Sea-Horse)*
1260 **Le Cheval de course** *(The Race-horse)*
1261 **Pégase** *(Pegasus)*
1262 **Le Chevalier romain** *(Roman Knight)*
1263 **Le Cheval du printemps** *(The Horse of Spring)*
1264 **Caligula**
1265 **Lady Godiva**
1266 **Neptune**
1267 **Bucéphale** *(Bucephalus)*
1268 **Le Cheval de la mort** *(The Horse of Death)*
1269 **Le Cheval de triomphe** *(The Horse of Triumph)*
1270 **La Chimère d'Horace** *(Horace's Chimera)*
1271 **Le Cheval de Troie** *(The Trojan Horse)*
1272 **Le Centaure de Crête** *(Cretan Centaur)*
1273 **Saint-Georges** *(St George)*
1274 **La Femme-cheval** *(Woman-Horse)*
1275 **Le Chevalier moyenâgeux** *(Medieval Knight)*
1276 **Le Picador**
1277 **Le Chevalier chrétien** *(Christian Knight)*
1278 **Le Centurion**
1279 **Don Quichotte** *(Don Quixote)*
1280 **La Victime de la fête** *(The Victim of the Festivity)*
1281 **Clauilegnio**
1282 **Le Cheval de labeur** *(Workhorse)*

(a) 1–250 on Arches
(b) EA1–EA48 on Arches

Contained in the portfolio of the same name.
For further details, see Appendix (p. 181).

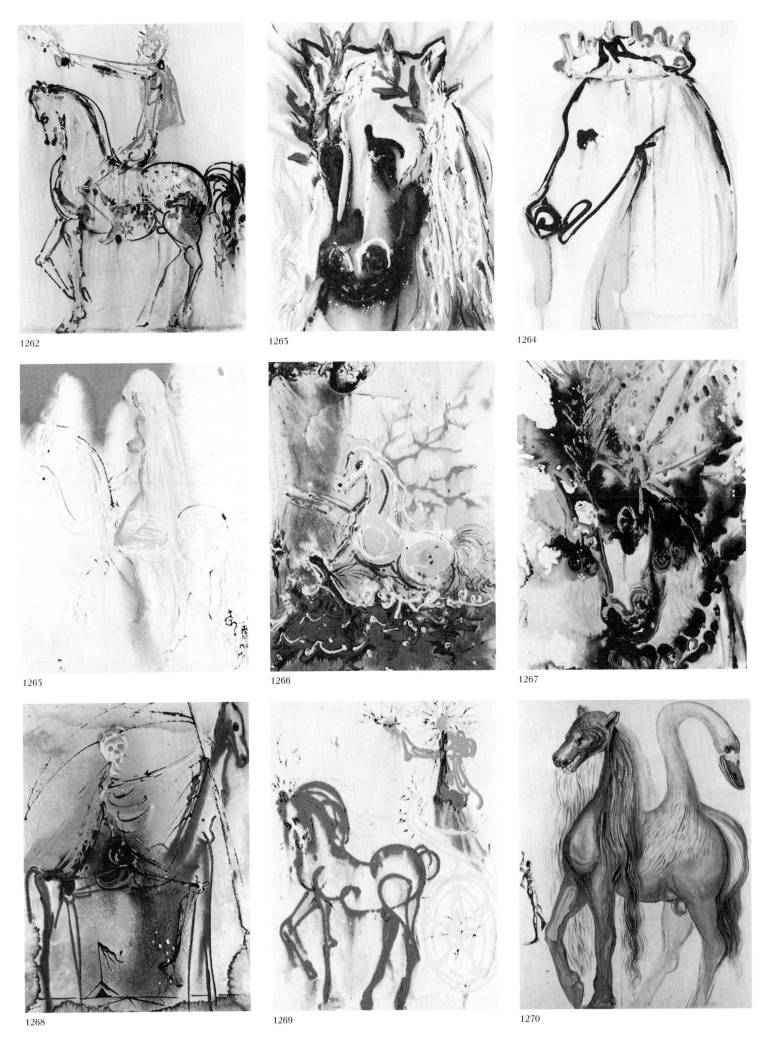

1262

1263

1264

1265

1266

1267

1268

1269

1270

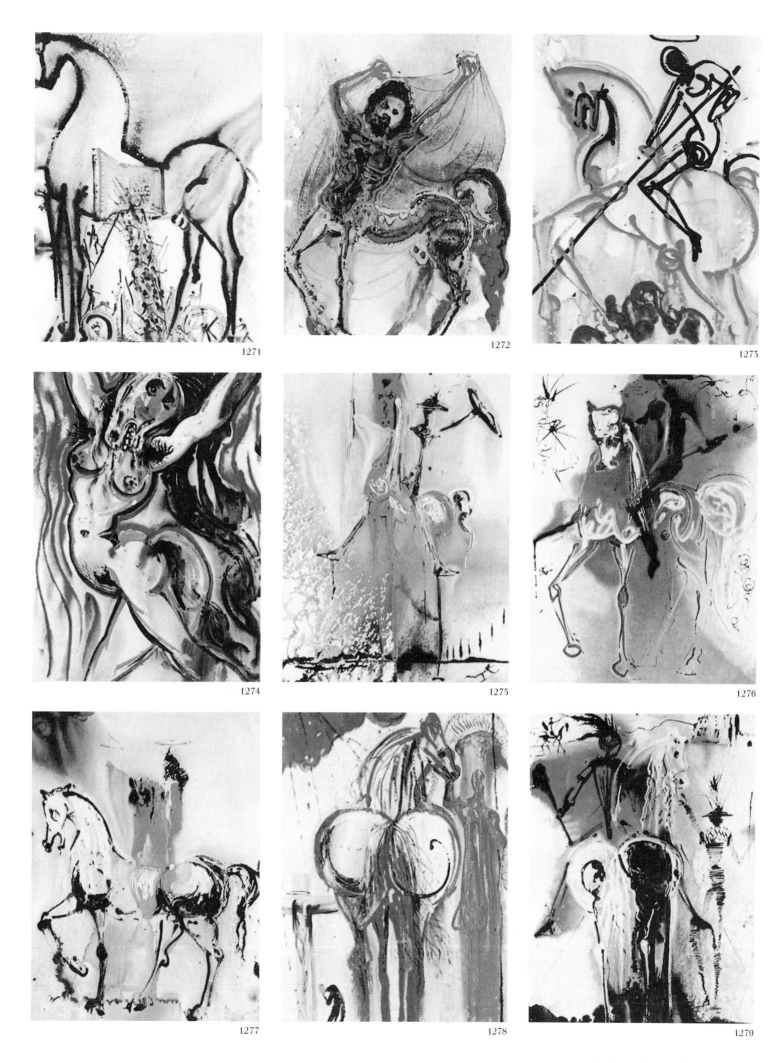

1271

1272

1273

1274

1275

1276

1277

1278

1279

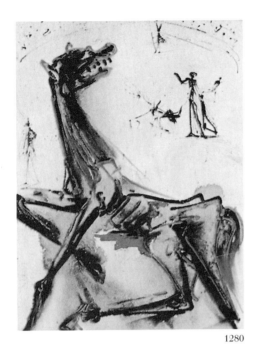

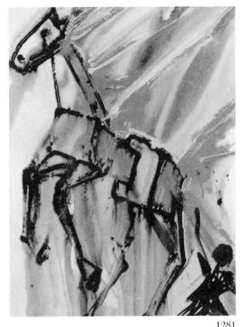

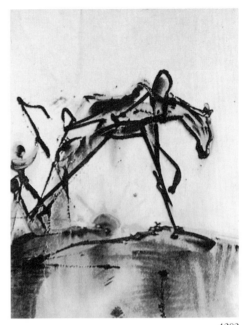

1280

1281

1282

1283
The Creation of Eve, 1970
Original coloured lithograph
49 x 48 (52 x 48)
Matabosh
Torrents (?)

1000 on wove paper

Contained in the portfolio *Del calendario 5 art-
istes catalans*. Executed by a photo-engraver
after a work specially created for this edition
and lithographically reworked and corrected
by Dalí himself.

1284
Port Lligat (Vénus aux tiroirs), 1970
Port Lligat (Venus with Drawers)
Coloured lithograph
76 x 56 (96 x 70)
TWA
Jobin

(a) Edition A: 250 on handmade paper
 plus 25 *épreuves d'artiste*
(b) Edition B: 500 on handmade paper,
 unsigned, signed on the stone and
 gilded
(c) 2000 as posters on poster paper, un-
 signed

1285
Deux nus (Gémeaux), 1970
Two Nudes (Gemini)
Coloured lithograph
72.5 x 33.3 (76 x 56)
Musée de l'Athénée, Geneva
Desjobert

175 on Rives

1286
Langouste, 1970
Crayfish
Coloured lithograph
75.5 x 49.3 (79 x 53)
EGI
Desjobert

I–L on Japanese paper

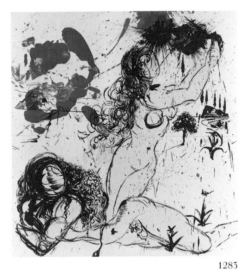

1283

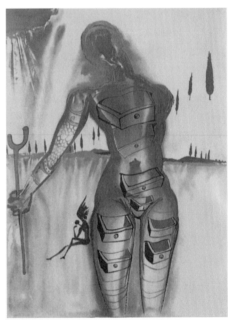

1284

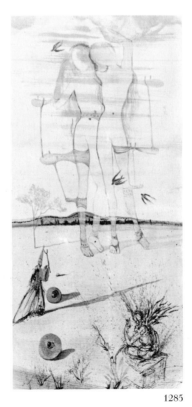

1285

1286

1287

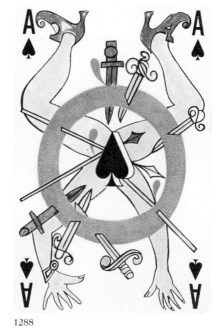

1288

1287–1303
Playing-Cards, 1970
17 coloured lithographs
65 x 50 (sheet)
Reiss/EGI
Printer unknown

(a) 150 on handmade paper
(b) 125 on wove paper
(c) 50 on Japanese paper

All these lithographs were made after playing-card designs. In 1969 two subjects were used as details for the portfolio *Alice in Wonderland* (see Volume I, cat. 329, on p.172). For further details, see Appendix (p.181).

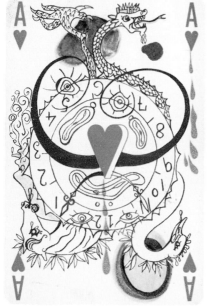

1289

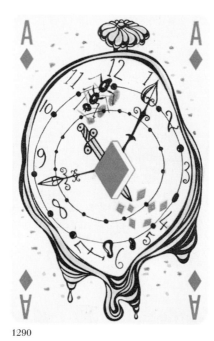

1290

1291

1292

1293

1294

1295

1296

1297

1298

1299

1300

1301

1302

1303

1304

1305

Contained in the portfolio of the same name.
For further details, see Appendix (p.181).

1306

1307

1308

1309

1310

1311

1312

1313

1314

1315

1316

1317

1318

1319

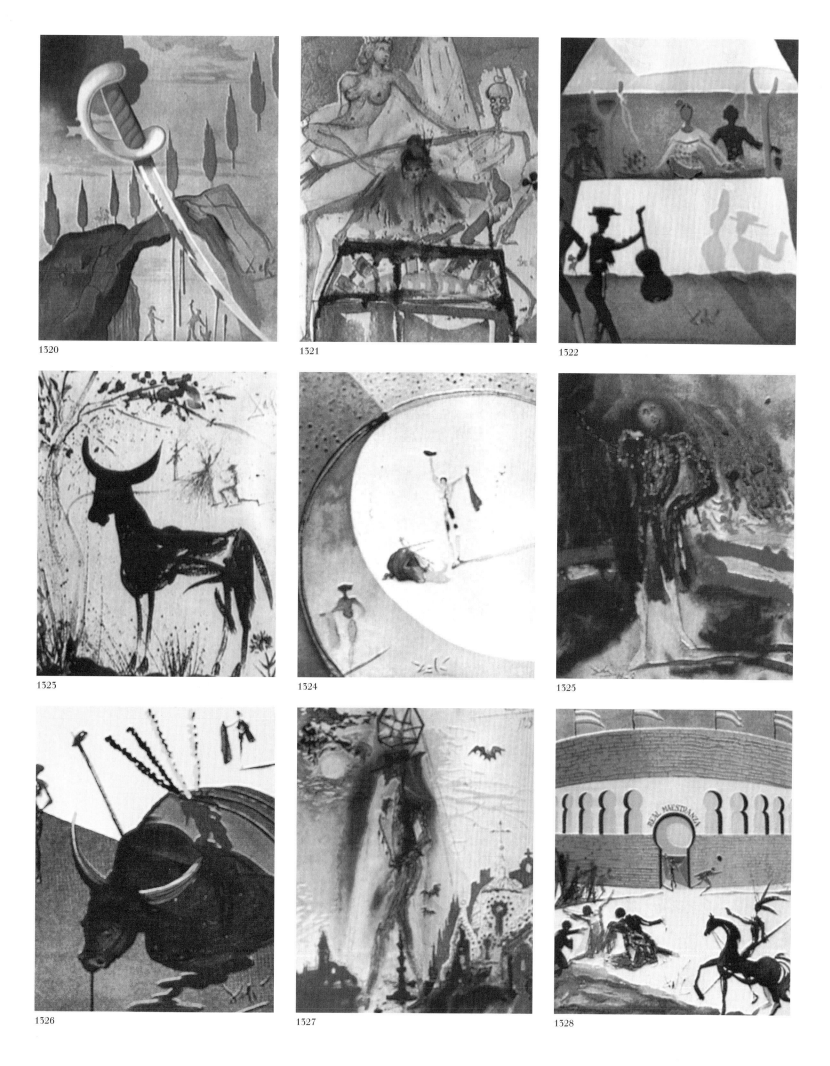

1320

1321

1322

1323

1324

1325

1326

1327

1328

1329

Femmes fleurs, 1970
Flower Women
Coloured lithograph
51.5 x 66 (57 x 76)
Musée de l'Athénée, Geneva/Broutta
Desjobert

(a) 1–150 on Arches
(b) I–XXV on Japanese paper
(c) 175 on wove paper
(d) 150 on wove paper

This lithograph was prompted by an exhibition at the Musée de l'Athénée, Geneva.

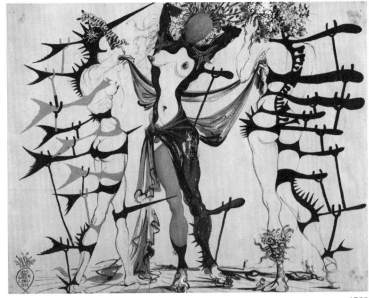

1329

1330

The Ram, after Gerrit Dou, 1971
Coloured lithograph
48.9 x 70 (56 x 76)
EGI
Desjobert

200 on wove paper

Dalí revered Gerrit Dou (1613–75) as the pioneer of stereoscopic painting.

1331

Spring, 1971
Coloured lithograph
75 x 56 (sheet)
Publisher unknown
Bellini

150 on wove paper

1332

Hommage à Dürer, 1971
Tribute to Dürer
Coloured lithograph
72 x 57 (sheet)
Vision Nouvelle
Mourlot

(a) 1–250 on Arches
(b) Some examples bearing text as posters for the exhibition of the same name at the Galerie Vision Nouvelle, Paris.

1330

1331

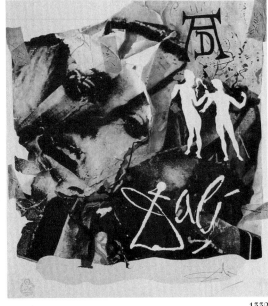

1332

1333

1334

1335

1336

1337

1338

1339

1340

1341

1342

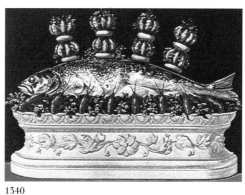

1343

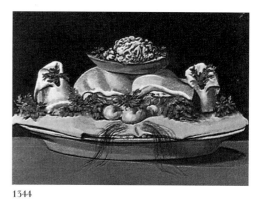

1344

1333–1344
Les Dîners de Gala, 1971
Gala's Dinners
12 coloured lithographs
48 x 57
Lavigne (Loup)
Draeger/Bellini

1333 **L'Atavisme** *(Atavism)*
1334 **Les Cannibalismes de l'automne** *(Autumn Cannibalisms)*
1335 **Les Montres molles 1/2 sommeil** *(Soft Watches Half Asleep)*
1336 **Les Chairs monarchiques** *(Monarchical Flesh Tones)*
1337 **Les 'Je mange Gala'** *(The 'I eat Gala's)*
1338 **Les Spoutniks astiqués d'asticots statistiques** *(Sputniks Polished by Statistical Maggots)*
1339 **Les Pios nonoches** *(Nocturnal Cravings)*
1340 **Les Panaches panachés** *(Variegated Plumes)*
1341 **Les Délices petits martyrs** *(Little Martyr Delights)*
1342 **Les Caprices pinces princiers** *(Princely Pliers Caprices)*
1343 **Les Entre-plats sodomisés** *(Sodomized Entrées)*
1344 **Les Suprêmes de malaises lilliputiens** *(Supremes of Lilliputian Malaises)*

(a) 1–195 on Rives
(b) I–CXXXXV on Japanese paper
(c) EA1–EA35 on Rives
(d) EA1–EA15 on Japanese paper

Each lithograph bears a small etching on the lower margin (see Volume I, cat. 509: *La Cuillère molle*). Contained in the portfolio of the same name.

1345–1350 (plates 34–37)
Currier & Ives, 1971
6 coloured lithographs with collages
56 x 76 (sheet)
Sidney Z. Lucas
Printer unknown

1345 **American Trotting Horses No. 1**
1346 **American Trotting Horses No. 2**
1347 **Fire, Fire, Fire**
1348 **American Yachting Scene**
1349 **New York Central Park Winter**
1350 **Flowers and Fruit**

(a) 1–250 on Rives
(b) 1–50 on Japanese paper

These lithographs were produced as a tribute
to the old American firm of lithographers and
print publishers, Currier & Ives.

1345

1346

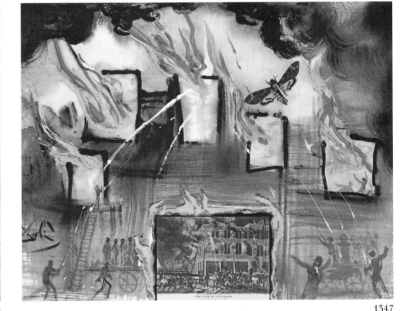

1347

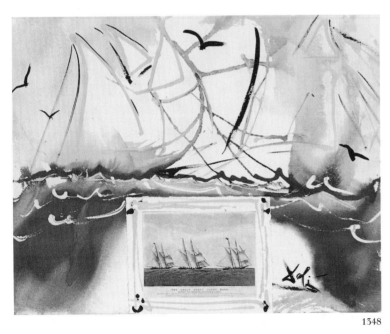

1348

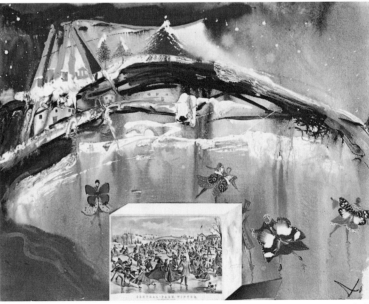

1349

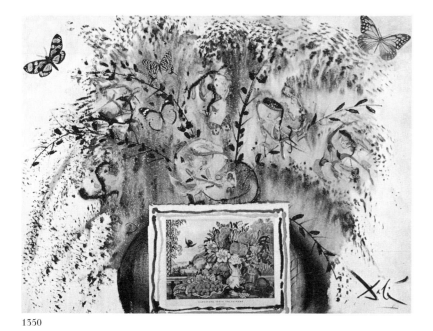

1350

1351

Rocas sobre el mar, 1971

Rocks Overlooking the Sea

Original coloured lithograph

43 x 56 (52.8 x 63.5)

Edition Cric S.L.

Torrents

1000 on wove paper

Executed by a photo-engraver after a work specially created for this edition and lithographically reworked and corrected by Dalí himself. For further details, see Appendix (p.181).

1352

Bataille de Tétouan, 1971

The Battle of Tetuán

Coloured lithograph

39 x 48.5 (54.3 x 61.3)

Les Heures Claires

Printer unknown

1–145 on Arches *teinté*, with die stamp in paper

For further details, see Appendix (p.181).

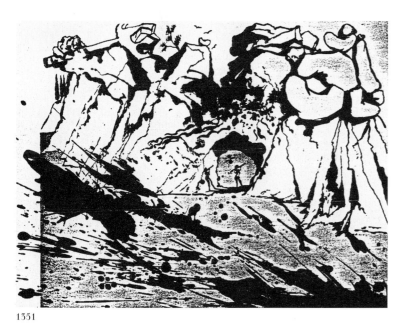

1351

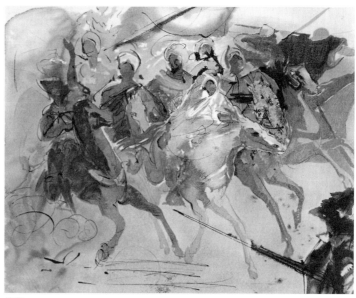

1352

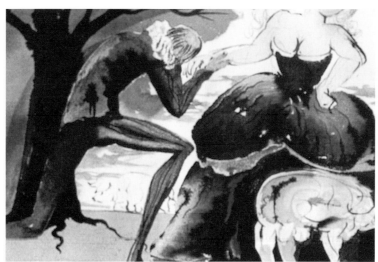

1353

1353

Baisemain, 1971

Hand-Kiss

Coloured lithograph

33.1 x 49

Les Heures Claires

Printer unknown

1–145 on Arches, with die stamp in paper

For further details, see Appendix (p.181).

1354

El Templo de la Sagrada Familia, 1971

The Temple of the Holy Family

Original coloured zinc lithograph

54 x 39.5 (64 x 53)

Edition Cric S.L.

Torrents

1000 on wove paper

Executed by a photo-engraver after a work specially created for this edition and lithographically reworked and corrected by Dalí himself. Reproductions in other sizes are known.

1355

Dalí's Presentation (Colored Lithographs for the People), 1971

Lithograph

80 x 62.5 (sheet)

Sidney Z. Lucas

Printer unknown

(a) 300 in sepia, grey and ochre

(b) 300 in black, grey and purple

Poster advertising the six lithographs entitled *Currier & Ives* (see cat. 1345–1350).

1356

Dulcinea, 1971/2

Coloured lithograph

49 x 33

Les Heures Claires

Printer unknown

145 on Arches, with die stamp in paper

For further details, see Appendix (p.181).

1357

La Pêche au thon, 1971/2

Catching Tuna

Coloured lithograph

30 x 60.5 (53.3 x 76)

Les Heures Claires

Printer unknown

145 on Arches, with die stamp in paper

For further details, see Appendix (p.181).

1358

Bullfighter, 1972

Coloured lithograph

75 x 54.5 (sheet)

Publisher unknown

Printer unknown

1–250 on Arches

For further details, see Appendix (p.181).

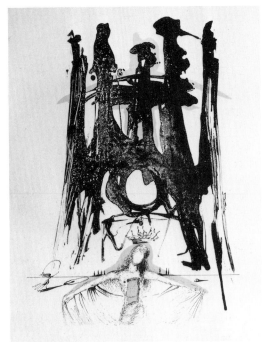

1354

1355

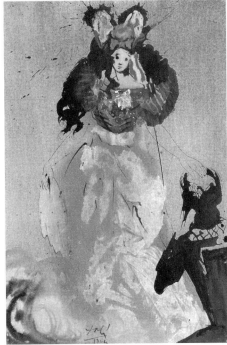

1356

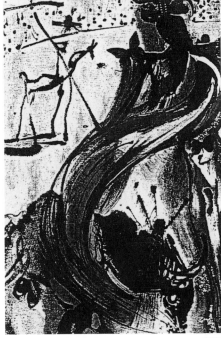

1358

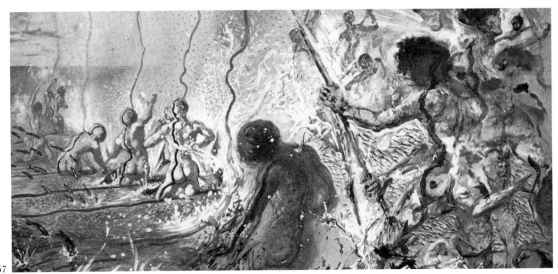

1357

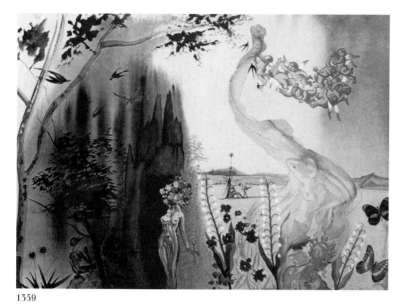
1359

1361

1360

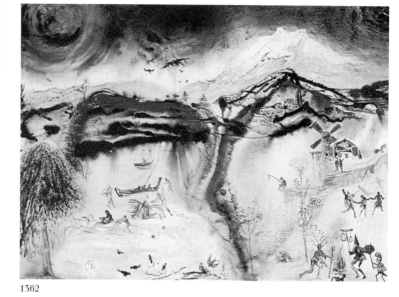
1362

1359–1362
The Four Seasons, 1972
4 coloured lithographs
40 x 55 or 55 x 40 (53 x 67 or 67 x 53)
Les Heures Claires
Printer unknown

1–195 on Arches

1363–1367 (plates 64–68)
Anamorphoses, 1972
5 coloured lithographs
For dimensions see individual titles
WUCUA
Matthieu

1363 **Chevalier aux papillons** *(Butterfly Horseman)*, 63.5 x 78
1364 **Le Crâne** *(Skull)*, 76.5 x 57
1365 **Arlequin** *(Harlequin)*, 88 x 62
1366 **Lys** *(Lily)*, 87 x 60.5
1367 **Nu** *(Nude)*, 76 x 57

(a) 1–300 on Rives
(b) *Le Crâne* was printed partly on Rives and partly on Japan nacré

Our information derives from Charles Sahli (catalogue, 1985), nos. 191–195.

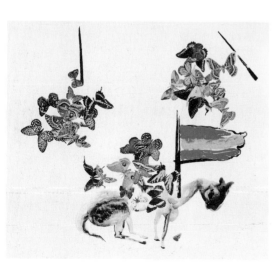
1363

1364

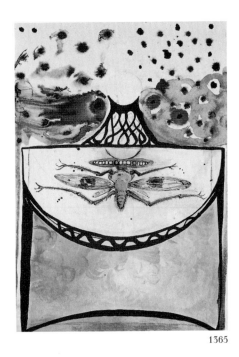

1365

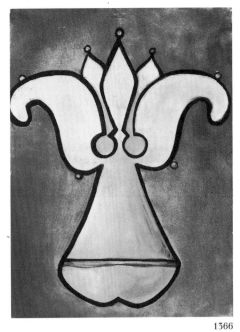

1366

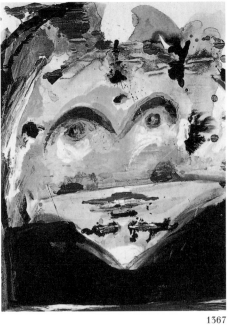

1367

1368–1371

Les Saisons, 1972
The Seasons
4 coloured lithographs
70 x 50 or 50 x 70 (sheet)
EGI
Desjobert

350 on handmade paper

1372

Man and the Sea, 1972
Silk-screen print
119 x 84 (sheet)
Edition Olympia
MAN Druck

(a) 200 on wove paper, signed
(b) Some pulls on poster paper

Poster for the Olympic Games of 1972,
Munich/Kiel.

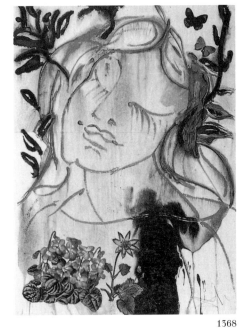

1368

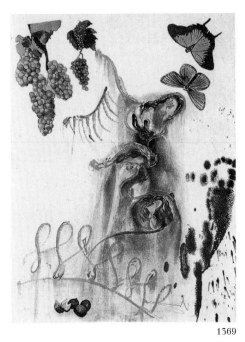

1369

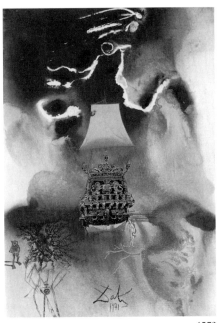

1372

1370

1371

1375

1374

1373–1380 (plate 56)
Nus, 1972
Nudes
8 lithographs
76 x 56 or 56 x 76 (sheet)
EGI
Desjobert

(a) 250 in sepia on Arches and Rives
(b) 120 in red on Arches and Rives

Total edition unknown

These lithographs appeared between 1972 and
1976.

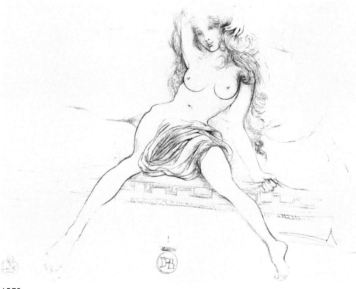

1375

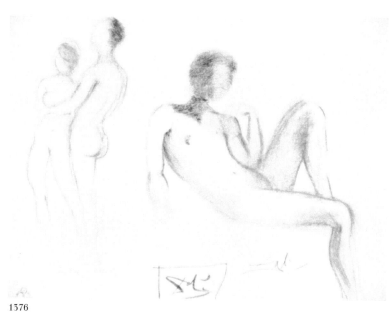

1376

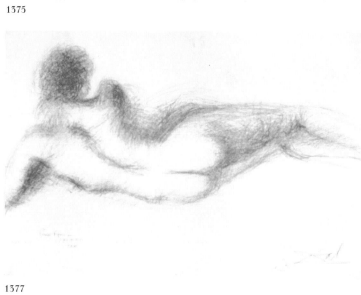

1377

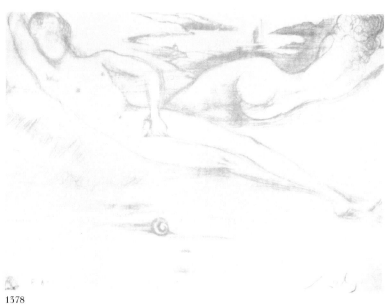

1378

1379

1380

1381
Une de Mai, 1972
Coloured lithograph
60 x 100
Waintrop
Desjobert

150 on wove paper

The title refers to the name of a racehorse.

1382–1384
Les Bouches (Papillons surréalistes), 1972
Mouths (Surrealist Butterflies)
3 coloured lithographs
53 x 39.5 (65 x 50)
EGI
Desjobert

(a) 350 on handmade paper
(b) 150 on wove paper

1381

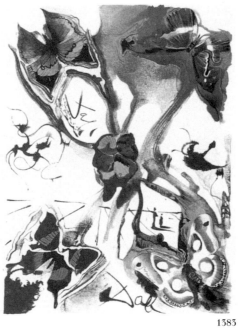

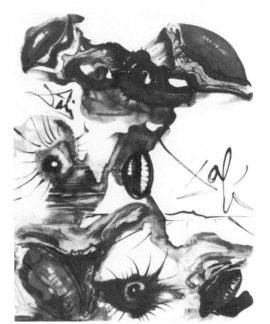

1382

1383

1384

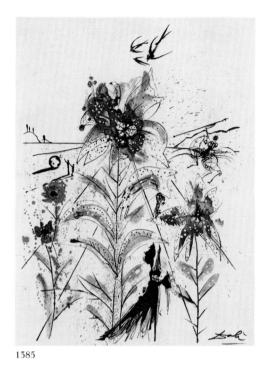

1385

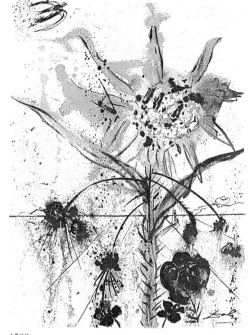

1386

1385–1386 (plates 58, 59)
Two Exquisite Flowers, 1972
2 coloured lithographs
76 x 56 (sheet)
Sidney Z. Lucas
Printer unknown

1385 Flower Magician
1386 Sun Goddess Flower

(a) 1–250 on Rives
(b) 1–50 on Japanese paper

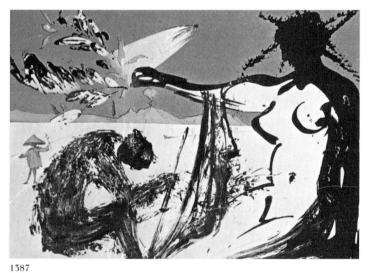

1387

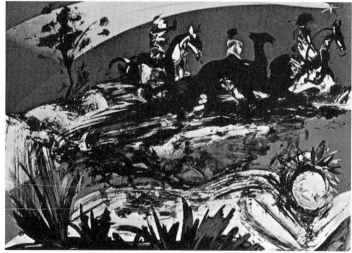

1388

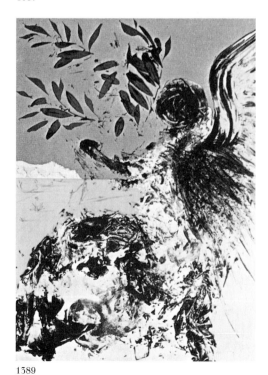

1389

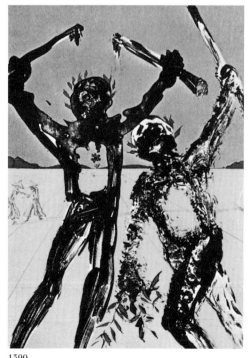

1390

1387–1390
Vietnam Suite (Peace Suite), 1973
4 original coloured zinc lithographs
40.5 x 57 or 57 x 40.5 (56 x 73.5 or 73.5 x 56)
Fidelity World Art
Torrents

1387 Liberation: The Prisoners Are Free
1388 Warrior's Dream
1389 Angel of Peace Covering a Calmer World
1390 Peace at Last

(a) 1–300 on Pierra
(b) I–C designated 'AP'
(c) A few pulls from the cancelled plate

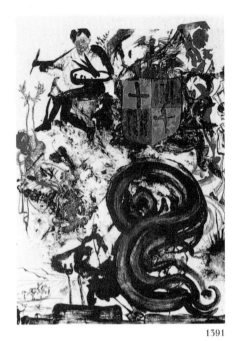

1391

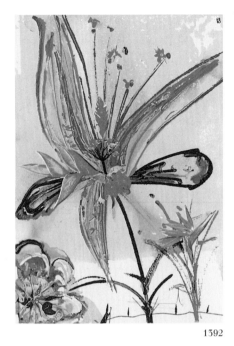

1392

1393

1391
Project of Monument to Picasso, 1973
Original coloured zinc lithograph
62.8 x 46 (76 x 56)
Lorilleux/Janeck
Torrents

(a) 500 on Arches
(b) 50 *épreuves d'artiste*
(c) 1 *hors commerce*
(d) 1 BAT (*bon à tirer*, or final corrected proof)

The black plate is an original lithograph; the colour plates were executed by a photo-engraver.

1392–1393
Hawaii-California Suite, 1973
2 coloured lithographs
65 x 50 (sheet)
Cory Gallery
Printer unknown

(a) 1–250 on Arches
(b) I–L on Japanese paper
(c) 50 on Arches, designated 'AP'

1394–1397 (plate 57)
Four Dreams of Paradise, 1973
4 coloured lithographs
55 x 44 (72 x 54)
Zeit Magazin/Observer
Grapholith

1394 **Romantic**
1395 **Heroic (Satyr)**
1396 **Mystic (Indian)**
1397 **Gala**

(a) I–LXXV on Japanese paper, designated 'EA'
(b) 1000 on Arches

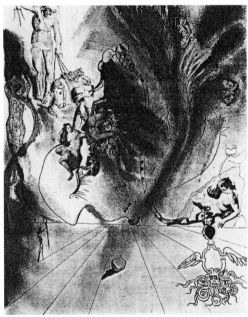

1394

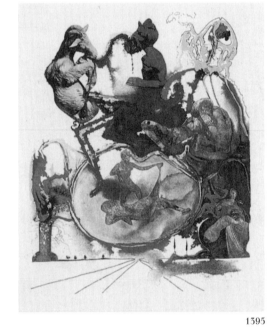

1395

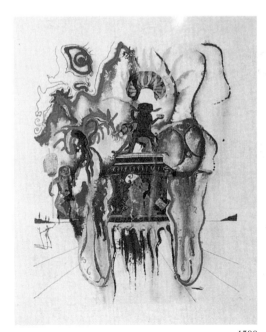

1396

1397

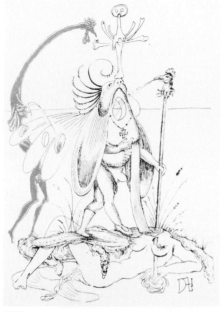

1398

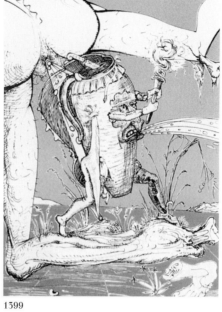

1399

1398–1422
Les Songes drolatiques de Pantagruel, 1973
Pantagruel's Comical Dreams
25 lithographs
76 x 56 (sheet)
Carpentier
Grapholith

(a) 1–250 on Japanese paper (coloured)
(b) EA1–EA25 on Japanese paper (coloured)
(c) 15 designated 'A–O'(coloured)
(d) 1–50 on Japanese paper (black-and-white)
(e) I–L on Japanese paper (black-and-white)
(f) EA1–EA50 on Japanese paper (black-and-white)
(g) 15 designated 'A–O'(black-and-white)

Contained in the portfolio of the same name.

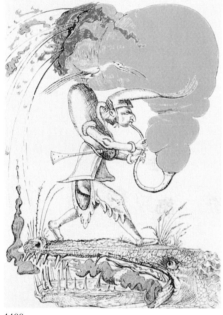

1400

1401

1402

1403

1404

1405

1406

1407

1408

1409

1410

1411

1412

1413

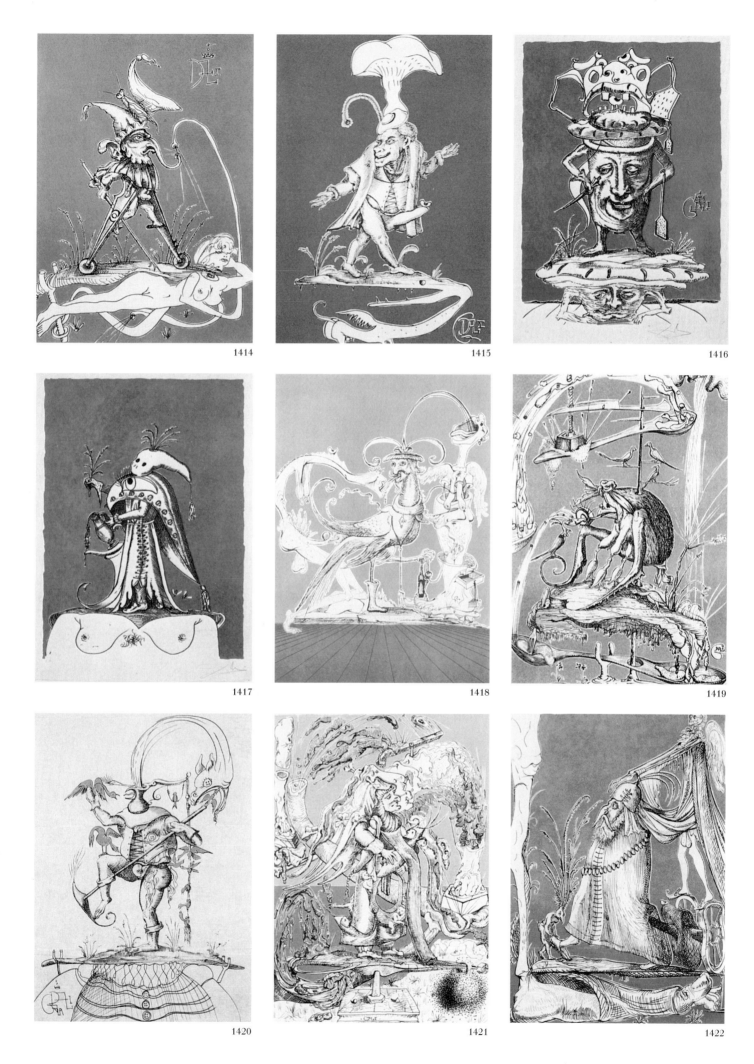

1414

1415

1416

1417

1418

1419

1420

1421

1422

1423–1424

Sports entendre, 1973
Understanding Sports
2 original coloured zinc lithographs
48.5 x 40.5 or 40.5 x 48.5
(60 x 50 or 50 x 60)
Fidelity World Art
Torrents

1423 The Golfer
1424 Sports

(a) 1–199 on Arches
(b) I–CI on Arches
(c) AP1–AP20 on handmade paper

1424

1423

1425–1426

**The Magic Butterfly and the Flowers,
1973**
2 coloured lithographs with original
reworking
58 x 43 (75 x 55)
Levine & Levine (Merrill Chase)
Dumas

1425 Release of the Psychic Spirit
1426 Apparitions of the Rose

(a) 1–250 on Arches
(b) 1–150 on Japanese paper
(c) I–CL on Arches, designated 'I'
 (= International)
(d) I–C on Japanese paper, designated 'I'
 (= International)
(e) HC1–HC65

1425

1426

1427

España, 1973
Spain
Coloured lithograph
70 x 50 (76 x 56)
Arts Contacts
Desjobert

200 on Arches

1428

Symbiosis, 1973
Coloured lithograph
70 x 50 (76 x 56)
Arts Contacts
Desjobert

200 on Arches

1427

1428

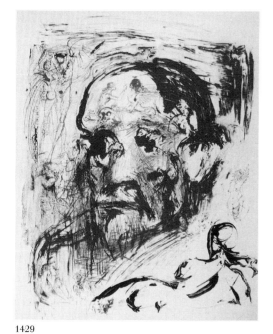

1429

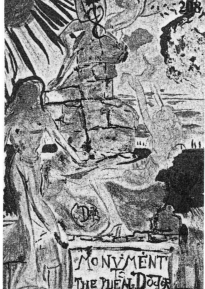

1430

1429 (plate 89)
Freud, 1973
Original coloured lithograph
78 x 61.7 (90 x 63.5)
Cric S.L.
Torrents

(a) 1000 on Arches *teinté*
(b) 100 *épreuves d'artiste*
(c) 25 in other colours

Executed by a photo-engraver after a work specially created for this edition and lithographically reworked and corrected by Dalí himself.

1430
Monument to the Ideal Doctor, 1973
Coloured lithograph
77.5 x 55.5 (sheet)
Publisher unknown
Desjobert

(a) 1–350 on Arches
(b) I–L on Japanese paper

1431–1434 (plates 69–72)
Edades de la vida, 1973
Ages of Life
4 original coloured zinc lithographs
76 x 56 (sheet)
Spectra (Hecker)
Pinon

1431 **Puberty**
1432 **Youth**
1433 **Maturity**
1434 **Old Age**

300 on Arches

1435
Kabuki Dancer, 1973
Coloured lithograph
75 x 56 (sheet)
EGI
Desjobert

(a) 1–200 on Arches
(b) I–CC on Japanese paper

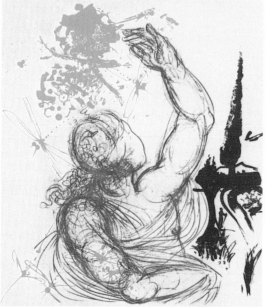

1431

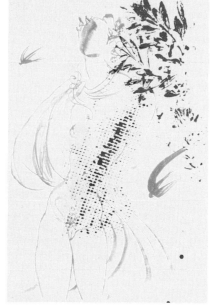

1432

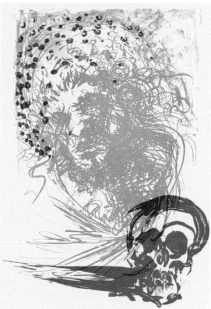

1433

1434

1435

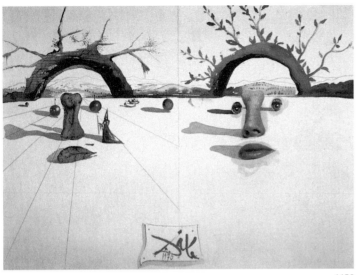

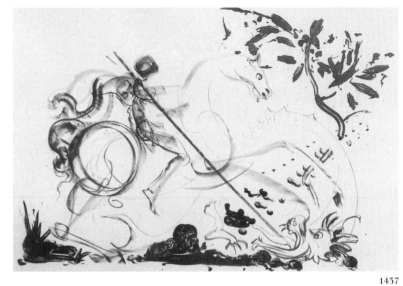

1436

1437

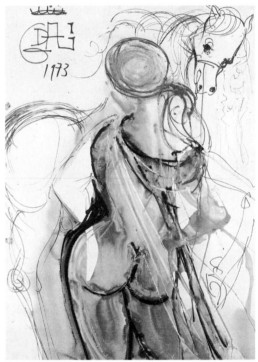

1438

1436
Winter and Summer (Patient Lovers),
1973
Coloured lithograph
Dimensions unknown
Circle Gallery
Bellini

300 on Arches

1437 (plate 65)
St George and the Dragon, 1973
Original coloured lithograph
47 x 68 (56 x 76)
Graphik International
Torrents

(a) 1–250 on Arches
(b) 50 *épreuves d'artiste* on handmade
 paper

1438 (plate 60)
Ecuyère et cheval, 1973
Horsewoman and Horse
Original coloured silk-screen print
100 x 72.5 (sheet)
Spectra (Hecker)
Dietz Offizin Lengmoos

(a) 300 on handmade paper
(b) 24 designated 'EA'

1439–1462
Les Vitraux (24 temi dal surrealismo),
1973
Stained-Glass Windows (24 Surrealist
Subjects)
24 coloured lithographs
65 x 48 or 48 x 65 (sheet)
Carpentier
Grapholith

1439 **L'esaltazione mistica** *(Mystical*
 Exaltation)
1440 **La trasfigurazione** *(The Trans-*
 figuration)
1441 **La parola divina** *(The Divine*
 Word)
1442 **L'arcangelo** *(The Archangel)*
1443 **La Pietà nera** *(The Black*
 Madonna)
1444 **Vittoria dell'uomo primitivo**
 (Victory of Primitive Man)

1439

1440

1441

1442

1443

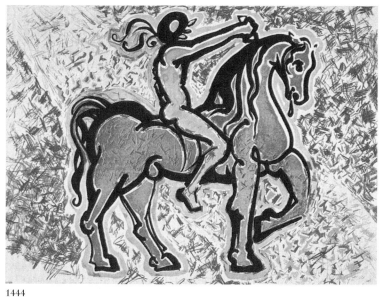

1444

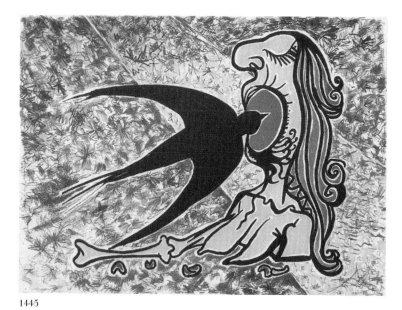

1445

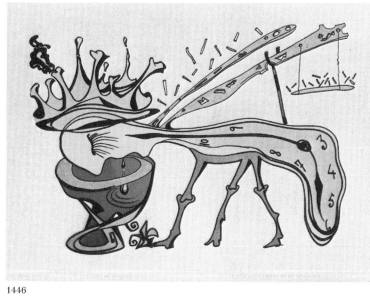

1446

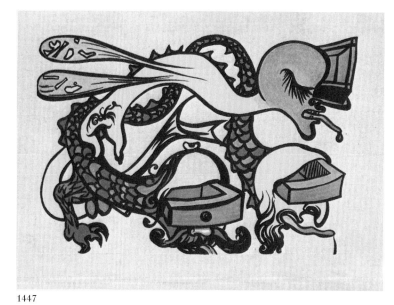

1447

1445 **La civiltà sconfitta** *(Civilization Defeated)*
1446 **Rigetto della civiltà** *(Civilization's Reject)*
1447 **Idra a tre teste** *(Three-Headed Hydra)*
1448 **Il pesce** *(The Fish)*
1449 **Giraffa che brucia** *(Burning Giraffe)*
1450 **Elefante-cicogna** *(Elephant-Stork)*
1451 **La potenza della croce** *(The Power of the Cross)*
1452 **Il Paradiso perduto** *(Paradise Lost)*
1453 **La serenità nella Fede** *(Serenity in Faith)*
1454 **Amplesso allucinogeno** *(Hallucinogenic Embrace)*
1455 **Angoscia eterosessuale** *(Heterosexual Distress)*
1456 **Senza tempo** *(Timeless)*
1457 **Il sonno del feto** *(Sleep of the Foetus)*
1458 **L'ermafrodito** *(The Hermaphrodite)*
1459 **La vergine e il rinoceronte** *(The Virgin and the Rhinoceros)*
1460 **Viso celato** *(Hidden Face)*
1461 **Il sole** *(The Sun)*
1462 **La Fede che vacilla** *(Wavering Belief)*

(a) 1–250 on Arches, designated 'Eu' (Eldec S.p.A.)
(b) I–CCL on Arches
(c) EA1–EA25 on Arches
(d) EAI–EAXXV on Arches
(e) HC1–HC25 on Arches
(f) HCI–HCXXV on Arches

Contained in the portfolio *Les Vitraux du musée de Salvador Dalí à Figueras*. In 1977 the lithograph *La Pietà nera* was published as a single print entitled *Pietà*. The same year saw the publication of *La trasfigurazione* and *La parola divina* as single prints entitled *Angels in Flight*. In 1980 six subjects from the series were re-published under the title *La Jungle Humaine Suite*. For further details, see Appendix (p. 181).

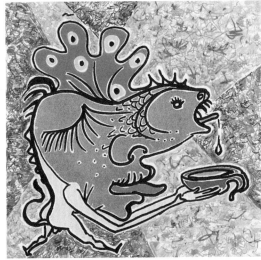

1448

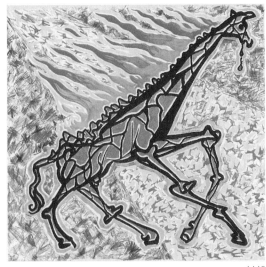

1449

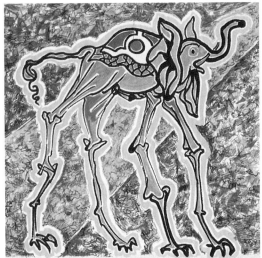

1450

1451

1452

1453

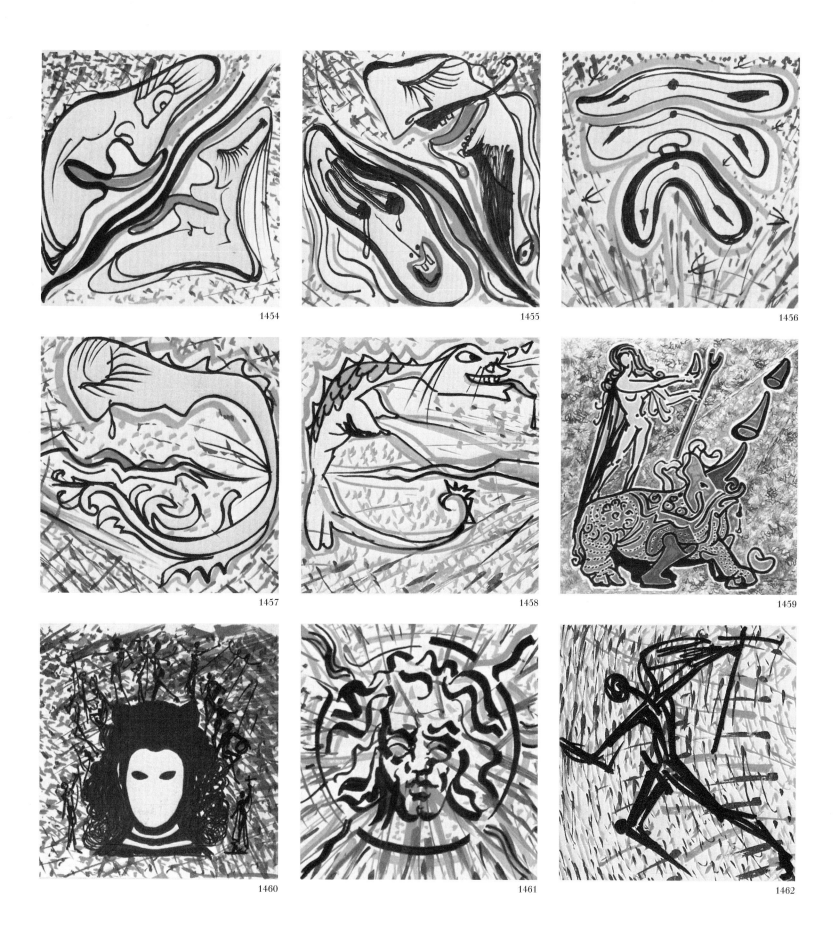

1454

1455

1456

1457

1458

1459

1460

1461

1462

1463–1466

The Puzzle of Life, 1974
4 coloured lithographs
124.4 x 135.2 (sheet)
Gala Publications
Grapholith

(a) 1–250 on Arches, designated 'I'
 (= International)
(b) EA1–EA50 on Arches, designated 'I'
 (= International)
(c) 1–250 on Arches
(d) 30 on Arches, designated 'AP'
(e) 20 on Arches, designated 'HC'

Taken from the portfolio *Les Vitraux*
(cat. 1439–1462), these four subjects made up a
composite puzzle.

1467

The Glorious Horsemen, 1974
Lithograph
38.5 x 50.5 (sheet)
EGI
Mourlot (?)

150 on handmade paper

For further details, see Appendix (p. 181).

1468

Le Musée de Figueras, 1974
Figueras Museum
Lithograph
Dimensions unknown
EGI
Desjobert

Details of edition unknown

This lithograph served as an invitation to the
opening of the museum.

1469

Black Mass, 1974
Lithograph
55.5 x 75 (sheet)
EGI
Desjobert

Details of edition unknown

1470

Montres molles, 1974
Soft Watches
Coloured lithograph
40.5 x 57 (54 x 67.5)
Les Heures Claires
Printer unknown

195 on Arches

For further details, see Appendix (p. 181).

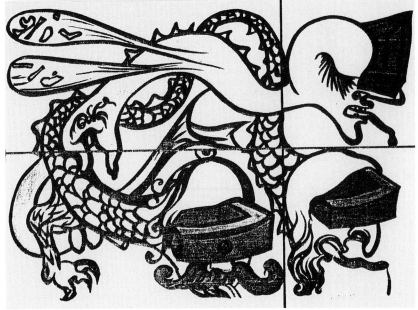

1463–66

1467

1468

1469

1470

1472

1473

1471

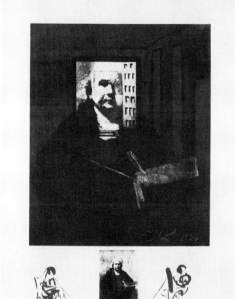

1474

1475

1476

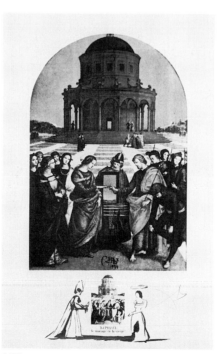

1477

1471
Hommage à Gala, 1974
Tribute to Gala
Coloured lithograph
49 x 38
EGI (?)
Desjobert

350 on wove paper

1472–1477
Changes in Great Masterpieces, 1974
6 coloured lithographs
For dimensions see individual titles
Sidney Z. Lucas
Printer unknown

1472 **Dalí: Persistance de la mémoire**
(*Dalí: The Persistence of Memory*),
75 x 77.5
1473 **Velázquez: La Reddition de Breda**
(*Velázquez: The Surrender of
Breda*), 75 x 77.5
1474 **Rembrandt: Portrait du peintre
par lui-même** (*Rembrandt: Self-
Portrait*), 84 x 63.5
1475 **Vermeer: La Lettre** (*Vermeer:
The Letter*), 89 x 63.5
1476 **Velázquez: Les Ménines** (*Veláz-
quez: Las Meniñas*), 90.2 x 64.8
1477 **Raphael: Le Mariage de la Vierge**
(*Raphael: The Marriage of the
Virgin*), 90.2 x 55.9

350 on Rives

1478

Hommage à Arno Breker, 1975

Tribute to Arno Breker

Lithograph on brown clay block
37.5 x 27 (sheet)
Galerie Marco
Mourlot

(a) 1–150 on Japanese paper
(b) 1–150 on Arches
(c) 500 with lilac margins as a poster,
 unsigned

1479

Avenue de Girafes en feu, 1975

Avenue of Burning Giraffes

Coloured lithograph
43 x 63.5 (56 x 76)
EGI/Fireworks Factory, Avignon
Desjobert

Details of edition unknown

1479

1478

1480

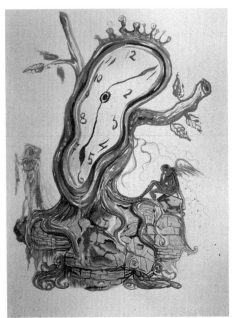

1481

1482

1480–1484 (plates 73, 74)

Time Suite, 1975/6

5 coloured lithographs
75 x 54 or 54 x 75 (sheet)
Levine & Levine
Guillard-Gourdon

1480 Daphne
1481 Stillness of Time
1482 Timeless Statue
1483 Essence of Time
1484 Desert Jewel

(a) 300 for the USA
(b) 250 for Japan
(c) 200 for South America
(d) 125 for Germany (Grafos Verlag),
 designated 'GI–GCXXV'

1483

1484

*These lithographs were executed after jewel-
lery designs. For further details, see Appendix
(p.181).*

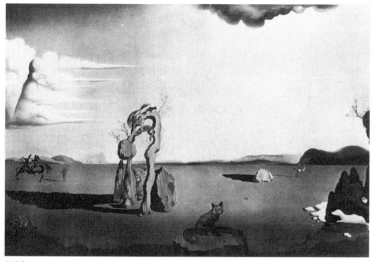

1485

1485

Savage Beasts in the Desert (Little Animal Kingdom), 1976
Coloured lithograph
48 x 72 (62 x 89)
Levine & Levine
Bellini

(a) 200 for the USA
(b) 450 for Europe, of which 60 numbered I–LX for Grafos Verlag.

1486

Pantocrator, 1976
The Almighty
Coloured lithograph with original reworking
76 x 56 (sheet)
Beverly Hills Gallery
Torrents

(a) 150 on Arches
(b) I–CL on Japanese paper
(c) 20 on Japanese paper, designated 'AP'
(d) 30 on Arches, designated 'HC'
(e) 14 portfolios for the artist
(f) 1 for the Vatican
(g) 5 designated 'PP'

Contained in the portfolio of the same name

1487–1490

Surrealistic Visions, 1976
4 coloured lithographs with original reworking
75 x 54 (sheet)
Bowles & Hopkins
Dumas

1487 **The Mystery of Sleep**
1488 **Coronation of Gala**
1489 **Obsession of the Heart**
1490 **Enigma of the Rose**

(a) 250 on Arches
(b) 25 on Arches, designated 'AP'
(c) 100 on Japanese paper
(d) 25 on Japanese paper, designated 'AP'

Total edition unknown

1487

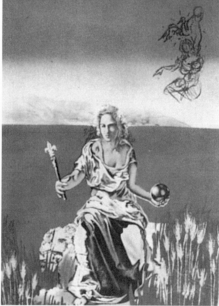

1488

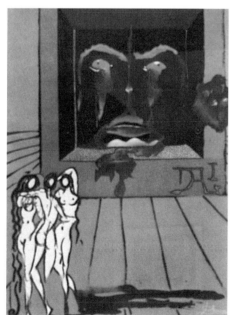

1489

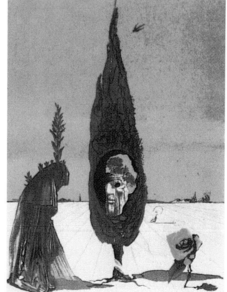

1490

1491–1494

Papillons anciennes, 1976

Old Butterflies

4 coloured lithographs, in part with original reworking
58.5 × 41 (75 × 52)
Bowles & Hopkins
Siena Studio, N.Y.

(a) 1–150 on Arches (International)
(b) 1–100 on Japanese paper (International)
(c) 65 *épreuves d'artiste* on Japanese paper
(d) I–CL on Japanese paper
(e) 1–250 on Arches
(f) I–CL on Arches
(g) 6 designated 'API–APVI'

Contained in the portfolio of the same name

1491

1492

1493

1494

1495–1496

Hommage à Homer, 1977

Tribute to Homer

2 coloured lithographs
76 × 56 (sheet)
Diversified
Torrents

1495 The Return of Ulysses
1496 Helen of Troy

Total edition 1125, of which
(a) 2 × 350 on Arches
(b) G1–G125 on Arches (for Grafos Verlag)

The lithograph *The Return of Ulysses* additionally bears an etching (see Volume I, cat. 934).

1495

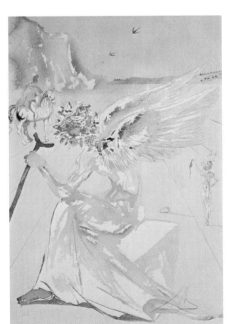

1496

1497

1498

1497–1499
Coal Today, Tomorrow, the Day after Tomorrow, 1977
3 coloured lithographs
52 x 62 (sheet and printed area)
Gesamtverband Deutscher Steinkohlen-
bergbau
Printer unknown

1497 **Coal Today**
1498 **Coal Tomorrow**
1499 **Coal the Day after Tomorrow**

(a) 2000 on wove paper, unsigned
(b) a few examples on wove paper,
 signed with coal

1499

1500

1500
Troisième dimension (La Chambre), 1977
Third Dimension (The Room)
Coloured lithograph
52 x 40 (sheet)
EGI
Studio Mic Mac

Details of edition unknown

1501–1503 (plates 75–77)
Love's Trilogy, 1977
3 coloured lithographs with original
reworking
76 x 55 (sheet)
Levine & Levine
Dumas

(a) 150 on Arches
(b) 100 on Japanese paper
(c) EAI–EAC on wove paper

1501

1502

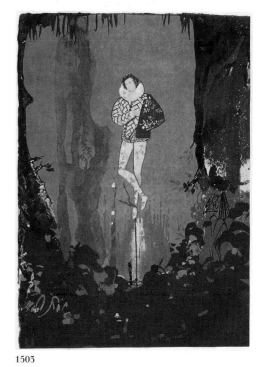

1503

1504–1515

Knights of the Round Table, 1977

12 coloured lithographs
49.5 x 45.7 (65 x 48)
Waintrop/Carpentier (?)
Printer unknown

(a) 350 on wove paper
(b) 50 *épreuves d'artiste*

This series was distributed in Spain under
the title *The Twelve Apostles*. It was there
numbered 1–250 (49 x 46).

1504

1505

1506

1516

Blue Lady, 1977

Coloured lithograph with original
reworking
58.5 x 43 (75 x 53)
Levine & Levine
Dumas

(a) 250 on Arches
(b) I–CL on Arches
(c) I–C on Japanese paper
(d) 75 designated 'EA'
(e) 75 designated 'AP'
(f) 65 designated 'HC'
(g) 5 designated 'PP'

1507

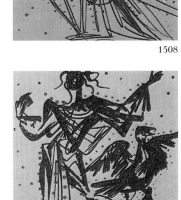

1508

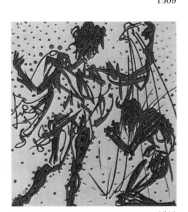

1509

1516

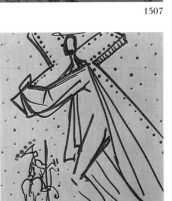

1510

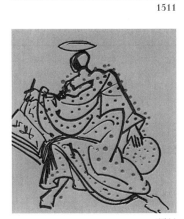

1511

1512

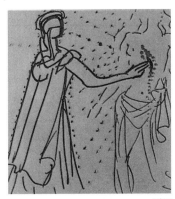

1513

1514

1515

1517

1518

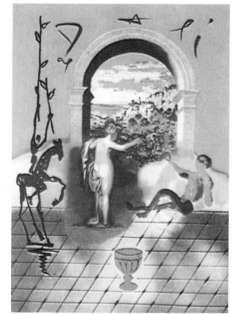

1519

1520

1521

1522

1517

Prince of Cups, 1977
Coloured lithograph with original
reworking
58.5 x 43 (75 x 54)
Levine & Levine
Dumas

(a) 250 on Arches (for the USA)
(b) 250 on Arches (International)
(c) 150 on Japanese paper
(d) 75 on Japanese paper, designated 'AP'

1518

Manhattan Skyline, 1977
Coloured lithograph
76 x 55 (sheet)
Levine & Levine
Dumas

Details of edition unknown

1519–1520

Dalí Discovers America, 1977
2 coloured lithographs with original
reworking
76 x 55 (sheet)
Levine & Levine
Siena Studio, N.Y.

(a) 650 on various papers
(b) 65 designated 'HC'

1521

Dreams of a Horseman, 1977
Coloured lithograph with original
reworking
58.8 x 45.5 (75 x 53)
Levine & Levine
Dumas

(a) 250 on Arches
(b) I–CL on Arches
(c) I–C on Japanese paper
(d) 75 designated 'EA'
(e) 75 designated 'AP'
(f) 65 designated 'HC'

1522

Pilgrim's Journey, 1977
Coloured lithograph with original
reworking
58.5 x 43 (75 x 54.7)
Levine & Levine
Dumas

400 on Arches

1523

Golden Calf, 1977
Coloured lithograph with original
reworking
76 x 55 (sheet)
Levine & Levine
Dumas

(a) 250 on Arches (for the USA)
(b) 150 on Arches (International)
(c) 100 on Japanese paper

Total edition unknown

1524

The Golden Chalice, 1977
Coloured lithograph with original
reworking
76 x 55 (sheet)
Levine & Levine
Dumas

Details of edition unknown

1523

1524

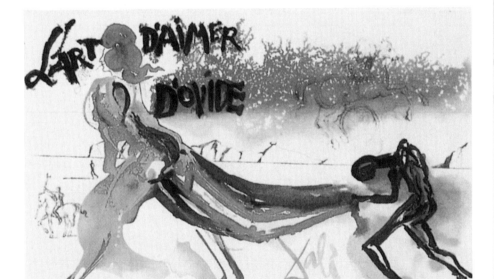

1525

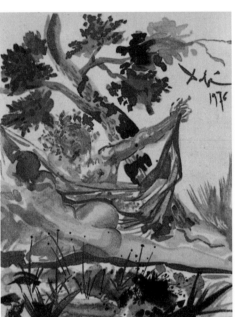

1526

1525–1538 (plates 79–83)
L'Art d'aimer d'Ovide, 1978
Ovid, The Art of Love
13 wood engravings and 1 coloured litho-
graph
38 x 56 or 56 x 38 (sheet)
Centre Culturel
Matthieu/Gourdon

1525 **Romains, s'il est quelqu'un parmi
vous à qui l'amour soit inconnu,
qu'il lise mes vers...** *(Romans, if
there is one amongst you to whom
love is unknown, let him read my
verse...)*
1526 **Infidèle épouse de Ménélas...**
(Unfaithful Spouse of Menelaus...)
1527 **Phœbus, ce dieu couronné de
lauriers...** *(Phoebus, the Crowned
God...)*
1528 **Apollon...** *(Apollo...)*

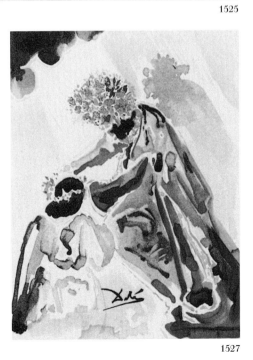

1527

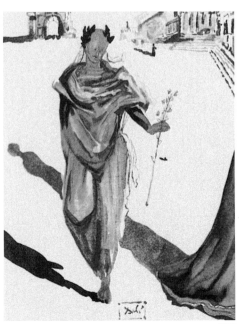

1528

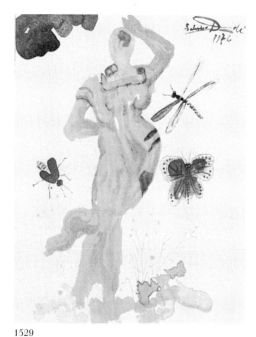

1529

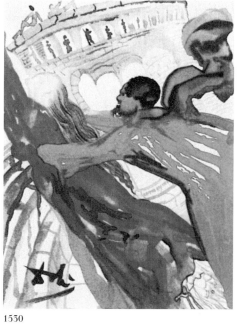

1530

1529 **Divine Erato**...
1530 **Mais ô belle Dionée**...
 (Yet, O Beautiful Dione...)
1531 **Vénus**... *(Venus...)*
1532 **La Déesse de Cythère**...
 (The Goddess of Cythera...)
1533 **On voit cette reine**... *(One Can
 See this Queen...)*
1534 **Le jeune Icare**... *(The Young
 Icarus...)*
1535 **Pylade aimait Hermione**...
 (Pilades Loved Hermione...)
1536 **C'est là que l'amour se plût à
 livrer bataille**... *(Where Love Took
 Pleasure in Battle...)*
1537 **Un Généreux Coursier**...
 (A Generous Courier...)
1538 **Fille de Minos**... *(Daughter of
 Minos...)*

(a) 3 on parchment designated 'EA', plus
 1 signed suite on parchment, 1 suite
 in sanguine on Arches, and the
 colour separations of 1 wood en-
 graving
(b) I–IX on parchment, plus 1 signed
 suite on parchment, 1 suite in
 sanguine on Arches, and the colour
 separations of 1 wood engraving
(c) X–LVII on Japanese paper, plus
 1 signed suite on Japanese paper and
 1 suite in sanguine on Arches
(d) 1–44 on Arches, plus 1 signed suite
 on Arches
(e) 45–144 on Arches, plus 1 signed suite
 of 4 illustrations on Arches
(f) 6 numbered *épreuves d'artiste* on
 Japanese paper, plus 2 suites as in (c)
(g) 10 numbered *épreuves d'artiste* on
 Arches, plus 1 suite as in (d)
(h) 30 numbered *épreuves d'artiste* on
 Arches, plus 1 suite as in (e)

Contained in the portfolio of the same name,
which has 1 etching inserted (see Volume 1,
cat. 933). For further details, see Appendix
(p. 181).

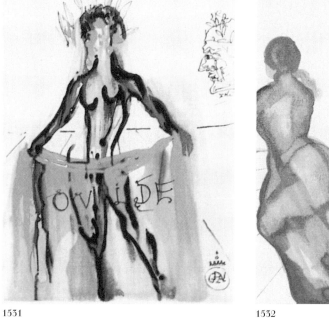

1531

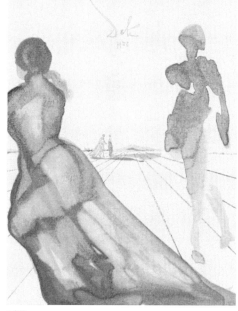

1532

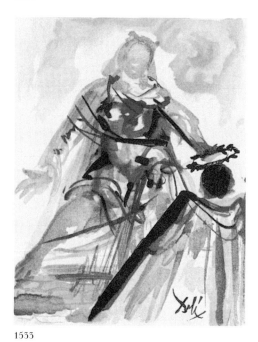

1533

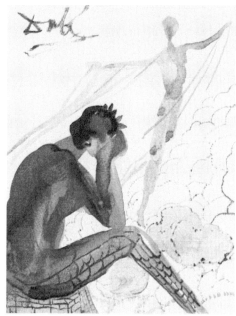

1534

1535

1536

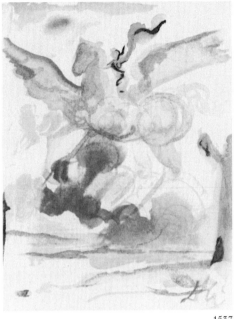

1537

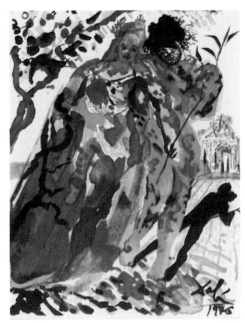

1538

1539–1540

Triomphe de l'amour, 1978
Triumph of Love
2 coloured lithographs with original
reworking
58 x 43 (76 x 55)
Bowles & Hopkins
Dumas

(a) 175 on Arches
(b) 75 *épreuves d'artiste* on Arches
(c) 75 on Japanese paper
(d) 75 *épreuves d'artiste* on Japanese
 paper
(e) 150 on Arches (International)
(f) 65 *hors commerce* on Arches (Inter-
 national)
(g) I–C on Japanese paper (International)

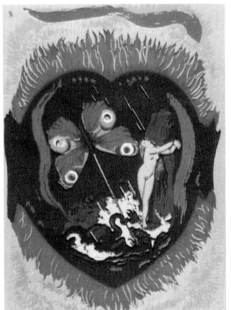

1539

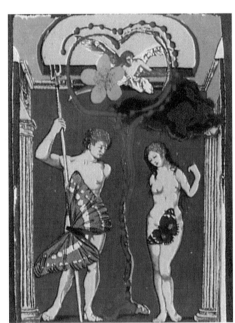

1540

1541–1542

Dalí Dreams/Dalí's Inferno, 1978
2 coloured lithographs with original
reworking
76 x 56 (sheet)
Levine & Levine
Dumas

(a) 250 on Arches (for the USA)
(b) 150 on Arches (International)
(c) 100 on Japanese paper

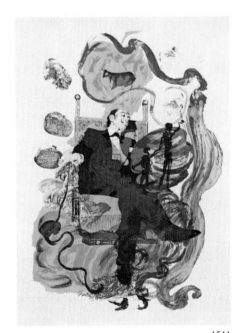

1541

1542

1543

1544

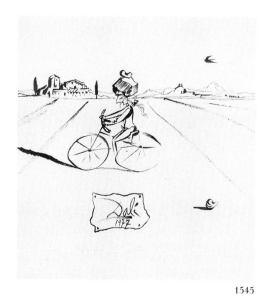

1545

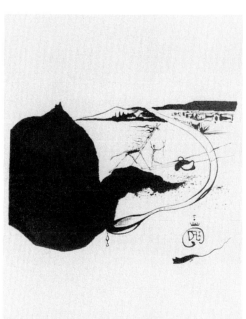

1546

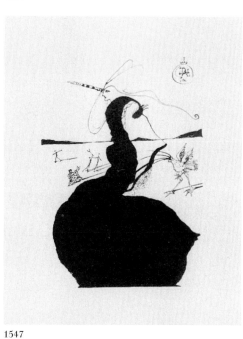

1547

1543–1549
Babaou, 1978
7 wood engravings
21 x 30 or 30 x 21 (sheet)
Centre Culturel
Ateliers d'Art Jean Mathan

(a) I–LXXX on Japanese paper,
plus 1 suite on Rives
(b) 1–90 on Rives
(c) 91–205 on Rives
(d) 206–395 on Arches

Contained in the portfolio of the same name,
which has 1 etching inserted (see Volume I,
cat. 932). For further details, see Appendix
(p. 181).

1550
**The Poet Advising the Maiden
(The Hand), 1978**
Coloured lithograph
73.6 x 53.3 (sheet)
Edition Touché
Dumas (?)

1065 on various papers

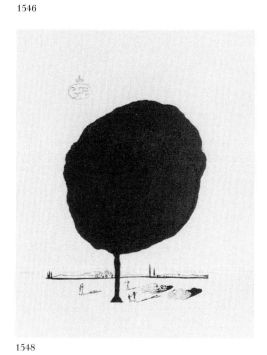

1548

1549

1550

1551 (plate 90)
Venise (La Basilique et le Campanile), 1978
Venice (The Basilica and Campanile)
Coloured lithograph with embossing
42 x 57.5 (54 x 75)
Lavigne
Bellini/Mourlot

(a) USA1–USA450 on Arches
(b) USA1–USA250 on Japanese paper
(c) 50 designated 'EA'for the USA
(d) E1–E450 on Arches (Europe)
(e) E1–E250 on Japanese paper (Europe)
(f) 50 designated 'EA' for Europe
(g) c. 550 size 70 x 100

This print was originally intended, in an un-
signed and unnumbered version, for the
'Comité Français pour la Sauvegarde de
Venise'. For further details, see Appendix
(p.181).

1552
The Three Graces of Hawaii, 1978
Coloured lithograph with original
reworking
58 x 42
Center Art
Siena Studio, N.Y.

(a) 250 on Arches
(b) 250 on Japan nacré
(c) 75 on Arches, designated 'AP'
(d) 75 on Arches, designated 'EA'
(e) 65 on Arches, designated 'HC'
(f) 5 designated 'PP'

1553–1556 (plates 84, 85)
Dalí Retrospective, 1978/9
4 coloured lithographs
58 x 43 (74.8 x 54.5)
Levine & Levine
Dumas (?)

1553 **The Lance of Chivalry**
1554 **The Path to Wisdom (Drawer)**
1555 **The Flowering of Inspiration
(Gala en fleurs)**
1556 **The Agony of Love (Unicorn)**

(a) 350 on Arches (for the USA)
(b) 350 on Arches (International)
(c) 150 on Japanese paper
(d) 65 on Arches, designated 'HC'
(e) 75 on Japanese paper, designated 'EA'
(f) 75 on Japanese paper, designated 'AP'
(g) G1–G125 on wove paper (for Grafos
Verlag)

Contained in the portfolio of the same name

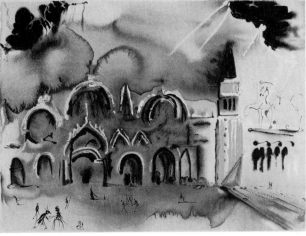

1551

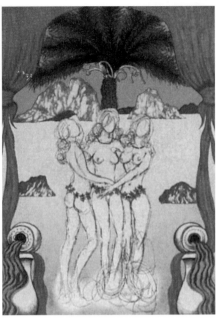

1552

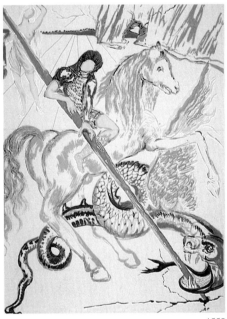

1553

1554

1555

1556

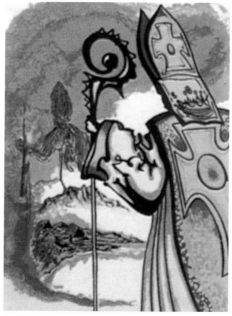

1557

1558

1559

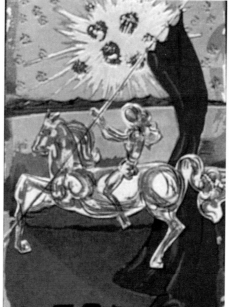

1560

1561

1562

1557–1560

Ivanhoe, 1979

4 coloured lithographs with original
reworking
75 x 55 (sheet)
Levine & Levine
Siena Studio, N.Y.

(a) 150 on Japanese paper
(b) I–CL on Arches
(c) I–C on wove paper
(d) 250 on Arches
(e) 65 designated 'HC'
(f) 5 designated 'PP'

1561

Dalí's Renaissance, 1979
Coloured lithograph with original
reworking
76 x 56 (sheet)
Levine & Levine
Dumas (?)

(a) 250 on Arches (for the USA)
(b) I–CL on Arches (International)
(c) I–C on Japanese paper
(d) 75 on Japanese paper, designated 'AP'
(e) 75 on Japanese paper, designated 'EA'
(f) 65 on Arches, designated 'HC'

1562 (plate 86)

The Judgement of Paris, 1979
Coloured lithograph
74.8 x 54 (sheet)
Levine & Levine
Printer unknown

(a) 250 on Arches
(b) 150 on Arches (International)
(c) 100 on Japanese paper
(d) 75 on Japanese paper, designated 'AP'
(e) 75 on Japanese paper, designated 'EA'
(f) 65 on Arches, designated 'HC'
(g) 5 designated 'PP'
(h) G1–G125 on wove paper (for Grafos
Verlag)

1563–1568

Les Amoureux, 1979

The Lovers

2 portfolios each containing 3 coloured
lithographs
58 x 46 (74.8 x 54.5)
Levine & Levine (Duall Graphics)
Printer unknown

1563 **Garden of Eden**
1564 **Woman Leading Horse**
1565 **Les Amoureux** *(The Lovers)*
1566 **Girl Horse**
1567 **The Kingdom**
1568 **Anthony i Cleopatra**

(a) 350 on Arches
(b) 75 on Japanese paper, designated
 'AP'
(c) I–CCCL on Arches
(d) 150 on Japanese paper
(e) 65 on Arches, designated 'HC'
(f) 5 designated 'PP'
(g) G1–G125 on wove paper (for Grafos
 Verlag)
(h) 75 on Japanese paper, designated
 'EA'

These lithographs were originally intended for
the portfolio *L'Art d'aimer d'Ovide*
(cat.1525–1538) but not included in it.

1563

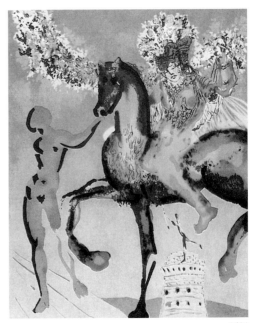

1564

1565

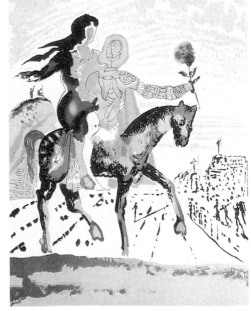

1566

1569–1570

**The Immaculate Conception/
The Resurrection, 1979**

2 coloured lithographs, in part with
original reworking
76 x 56 (sheet)
Gala Publications
Torrents

(a) 250 on Arches
(b) 65 on Arches, designated 'HC'
(c) 75 on Japanese paper, designated
 'EA'
(d) 75 on Japanese paper, designated
 'AP'
(e) I–CL on Arches (International)
(f) I–C on Japanese paper (Inter-
 national)
(g) 5 designated 'PP'

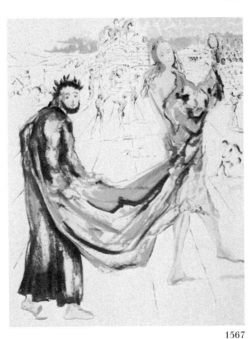

1567

1568

1569

1570

1571–1572
Fleurs Surréalistes, 1979/80
Surrealistic Flowers
2 coloured lithographs
57 x 45.5 (74 x 53.5)
Levine & Levine
Dumas

1571 **Flowers for Gala**
1572 **Printemps de Gala** (*Gala's Spring-time*)

(a) 1–350 on Arches
(b) AP1–AP75 on Japanese paper
(c) 350 on Arches (International)
(d) 150 on Japanese paper (International)
(e) 75 on Japanese paper, designated 'EA' (International)
(f) 5 on wove paper, designated 'PP'
(g) 65 on wove paper, designated 'HC'
(h) G1–G125 on Arches (for Grafos Verlag)

1571

1572

1573
Portrait of Autumn (The Joys of Bacchus), 1979/80
Coloured lithograph
74 x 54 (sheet)
Levine & Levine
Dumas

(a) 350 on Arches
(b) 350 on Arches (International)
(c) 75 on Japanese paper, designated 'AP'
(d) 75 on Japanese paper, designated 'EA'
(e) 150 on Japanese paper (International)
(f) 65 on wove paper, designated 'HC'
(g) 5 designated 'PP'
(h) G1–G125 on wove paper (for Grafos Verlag)

1574
Chevalier surréaliste (Hommage à Velázquez), 1979/80
Surrealistic Knight (Tribute to Velázquez)
Coloured lithograph
57 x 46 (74 x 53)
Levine & Levine
Torrents

(a) 350 on Arches
(b) 350 on Arches (International)
(c) 150 on Japanese paper
(d) 75 on Japanese paper, designated 'AP'
(e) 75 on Japanese paper, designated 'EA'
(f) 65 on Arches, designated 'HC'
(g) 5 designated 'PP'
(h) G1–G125 on Arches (for Grafos Verlag)

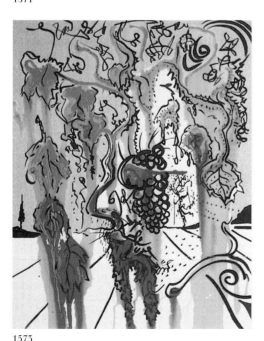

1573

1574

1575–1576

L'Aventure médicale, 1979/80
Medical Adventure
2 coloured lithographs
57 x 45.5 (74 x 53.5)
Levine & Levine
Dumas (?)

1575 La Lumière de la guérison
(The Light of Recovery)
1576 La Lutte contre le mal *(Fighting Disease)*

(a) 1–350 on Arches
(b) I1–I350 on Arches
(c) I1–I150 on Japanese paper
(d) AP1–AP75 on Japanese paper
(e) EA1–EA75 on Japanese paper
(f) HC1–HC65 on Arches
(g) G1–G125 on Arches (for Grafos Verlag)
(h) PP1–PP5 on Arches

Contained in the portfolio of the same name.
For further details, see Appendix (p.181).

1575

1576

1577–1579

The Professions, 1979/80
3 coloured lithographs
57 x 45.5 (74 x 53.5)
Levine & Levine
Dumas (?)

1577 Couturier
1578 Restaurateur
1579 Chemist

(a) 350 on Arches
(b) 350 on Arches (International)
(c) 150 on Japanese paper
(d) 75 on Japanese paper, designated 'AP'
(e) 75 on Japanese paper, designated 'EA'
(f) 65 on Arches, designated 'HC'
(g) 5 designated 'PP'
(h) G1–G125 on Arches (for Grafos Verlag)

For further details, see Appendix (p.181).

1580

Diamond Head, 1979/80
Coloured lithograph
58.2 x 45.5 (76.2 x 55.8)
Levine & Levine
Dumas

1070 impressions on various papers

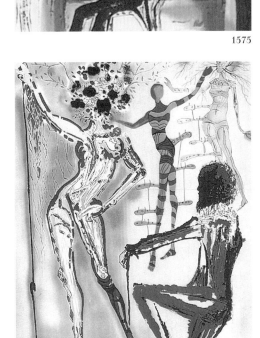

1577

1578

1581–1585

Retrospective II, 1979/80
5 coloured lithographs
74.8 x 54.5 (sheet)
Levine & Levine
Dumas

1579

1580

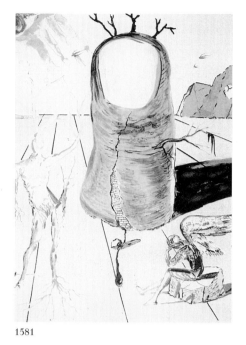

1581

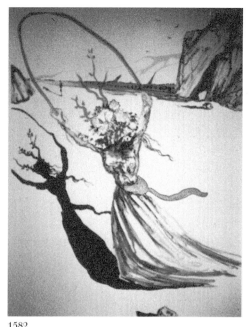

1582

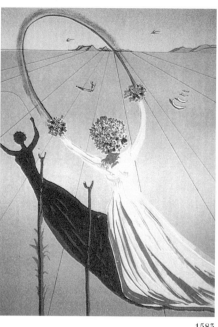

1583

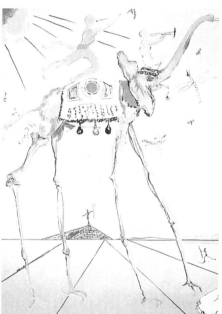

1584

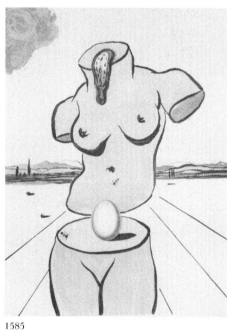

1585

1581 **La visión del Angel de Cap de Creus** *(Vision of the Angel of Cape Creus)*
1582 **Daphne I**
1583 **Daphne II**
1584 **Celestial Elephant**
1585 **Torso (Birth of Venus)**

a) 1–350 on Arches
(b) I1–I350 on Arches (International)
(c) 75 on Japanese paper, designated 'AP'
(d) 75 on Japanese paper, designated 'EA'
(e) 1–150 on Japanese paper
(f) 65 on Arches, designated 'HC'
(g) 5 on Arches, designated 'PP'
(h) G1–G125 on wove paper (for Grafos Verlag)

1586 (plate 87)
Flordali® I, 1981
Coloured lithograph after an original collage specially created for this edition by Dalí himself
65 x 97 (75.8 x 106)
WUCUA
Matthieu

(a) 4880 on Arches
(b) 4600 posters with text

With die stamp in French, English or German, and bearing the impression number on the back of every pull. The signature forms part of the printing. See Explanatory Remarks, p. 12.

Our information derives from Charles Sahli (catalogue, 1985), no. 233.

1587 (plate 88)
Flordali® II, 1981
Coloured lithograph after an original collage specially created for this edition by Dalí himself
88 x 63 (103 x 72.7)
WUCUA
Matthieu

(a) 5000 on Arches
(b) 4600 posters with text

With die stamp in French, English or German, and bearing the impression number on the back of every pull. The signature forms part of the printing. See Explanatory Remarks, p. 12.

Our information derives from Charles Sahli (catalogue, 1985), no. 233.

1586

1587

1588–1607

Below is an additional selection of books and portfolios illustrated by Salvador Dalí. The subjects were printed, most of them lithographically, after his designs (gouaches, watercolours, drawings, etc.) and published in limited and sometimes signed editions. During the 1970s various publishers reissued some of these book illustrations in a signed version as single-print editions.

1588 *Second Manifeste du Surréalisme*, Simon Kra, Paris 1930
1589 *Violette Nozières*, Nicolas Flamel, Paris 1933
1590 *Le Somnambule*, René Laporte, Paris 1935
1591 *Fantastic Memories*, Doubleday, New York 1944
1592 *The Life and Achievements of the Renowned Don Quichotte de la Mancha*, Random House, New York 1946
1593 *Essays*, Doubleday, New York 1947
1594 *The Autobiography of Benvenuto Cellini*, Doubleday, New York 1948
1595 *Das Haus ohne Fenster*, Morgarten, Zurich 1948
1596 *Tutto è bene quel che finisce bene*, Bestetti Collezione dell'Obelisco, Rome, 1948
1597 *Les Bois Surréalistes*, Intermundo, 1956
1598 *El ingenioso Hidalgo Don Quixote*, Emece Editores, Buenos Aires 1957
1599 *Paternoster*, Rizzoli, Milan 1966
1600 *Biblia Sacra*, Rizzoli, Milan 1967
1601 *Romeo e Julia*, Rizzoli, Milan 1967
1602 *Le mille e una notte*, Rizzoli, Milan 1969
1603 *Les Métamorphoses érotiques*, Edita, Lausanne 1969
1604 *L'Odyssée*, Les Heures Claires, Turin 1974
1605 *Scarab*, Scabal, Brussels 1977
1606 *Cadaqués i l'art*, Art 3, Figueres 1978
1607 *Obres de Museu*, Dasa Edicions, Barcelona 1980

Appendix
Further Editions, Reproductions and Forgeries

Cat. 1001–1012, 1013
In 1981 at least 3 x 300 copies on various papers, 58 x 46 (76 x 56), were reproduced with wide margins and forged signatures. In the case of some subjects, pulls were taken in various colours prior to the printing of the edition.

Cat. 1016
Reproductions exist numbered 1–300 or designated 'EA'.

Cat. 1039–1138
Lithographs of the same format were made after the wood engravings. These bear forged signatures. An immense number of original impressions with forged signatures also exist.

Cat. 1139
Between 1966 and 1980 editions with a wide variety of numberings were made on various papers, with or without an engraved signature. Many of these prints bear forged signatures.

Cat. 1141
Forgeries measuring 58 x 46 cm. were produced after 1980, but not on Arches *teinté*.

Cat. 1145
Forgeries of this original lithograph are found, particularly on the European market. They can be identified by variations in detail.

Cat. 1181–1192
Forgeries exist with different numbering.

Cat. 1193–1217
Some pulls bear forged signatures.

Cat. 1232–1256
Some pulls bear forged signatures.

Cat. 1258–1282
An edition of 4980 offset reproductions (56 x 38) appeared in 1983.

Cat. 1287–1303
Very many forgeries exist.

Cat. 1304–1328
Many pulls, most of them designated 'EA', bear forged signatures.

Cat. 1351
Reproductions are known to exist in other sizes.

Cat. 1352
Lutz Löpsinger was often shown pulls with forged signatures. On p. 75 of his book *The Dalí Scandal* (Gollancz, London 1987) Mark Rogerson reproduces a print that bears the same type of signature and was characterized as a forgery by Dalí himself.

Cat. 1353
The remarks relating to cat. 1352 apply.

Cat. 1356
The remarks relating to cat. 1352 apply.

Cat. 1357
The remarks relating to cat. 1352 apply.

Cat. 1358
Some pulls bear forged signatures.

Cat. 1439–1462
The publisher Eldec S.p.A. lists an extra edition of 5 copies made for the Dalí Museum in Figueres, as well as 2 copies for the Dalí Museum in St Petersburg, Florida, and 28 for museums in the United States, Japan and Australia.

Cat. 1467
Forgeries on paper originated after 1980 (check watermark).

Cat. 1470
The remarks relating to cat. 1352 apply.

Cat. 1480–1484
Some pulls bear forged signatures. An additional edition of 100 copies was published by Edition Broutta.

Cat. 1525–1538
Reprints of the portfolio were made after 1980. They bear forged signatures.

Cat. 1543–1549
Reprints on paper were made after 1980. They bear forged signatures.

Cat. 1551
Forgeries in widely varying sizes have been produced. Their numbering also varies widely.

Cat. 1575–1576
The two subjects, together with nine other designs, were silk-screened on sterling silver in an edition of 6000 copies and entitled *The Professions* (Tobo Arte). German edition: 999 copies. Published by the Hilliard Collection.

Cat. 1577–1579
The three subjects were printed on sterling silver like cat. 1575–1576. We have been unable to discover if all eleven subjects of *The Professions*, the designs for which Dalí executed in 1973, have been printed as lithographs.

Index of Titles in Catalogue Raisonné (Vol. I)
Salvador Dalí: Etchings and Mixed-Media Prints, 1924–1980

Works are listed under their original title as well as under their English translation;
series titles are also listed. Catalogue numbers are given after the titles.
Entries marked with * refer to cat. numbers in the 2nd edition.

Index of Titles in Catalogue Raisonné (Vol. II)
Salvador Dalí: Lithographs and Wood Engravings, 1956–1980

*Works are listed under their original title as well as under their English translation;
series titles are also listed. Catalogue numbers are given after the titles.*

Photographic Acknowledgements

Photographs for all illustrations, except those listed below, were kindly provided by the publishers or came directly from the archive of Galerie Michler. Editions by Werbungs- und Commerz Union Anstalt were reproduced by kind permission of Galerie Orangerie Reinz, Cologne.

Artco France, 'L'Univers Fantastique', Paris 1989 cat. 1018–1037, 1039–1138, 1525–1538

Salvador Dalí, 'A Retrospective of Master Prints' Art Source International, Carson City 1993 cat. 1181–1192, 1193–1217, 1232–1256, 1304–1328, 1333–1344, 1487–1490, 1504–1515, 1518, 1519–1520, 1539–1540, 1550, 1575–1576

Robert Descharnes/Gilles Néret, 'Salvador Dalí', Cologne 1993 cat. 1140

Gerhard Habarta, 'Salvador Dalí – The Graphic Art', Vienna 1988 cat. 1016, 1158, 1174, 1219, 1284, 1286, 1331, 1332, 1359–1362,

1373–1380, 1382–1384, 1391, 1429, 1469, 1479, 1500, 1516, 1543–1549

'Hommage à Dalí', Musée de l'Athénée, Geneva 1970 cat. 1286, 1329

Phyllis Lucas Gallery, 'Salvador Dalí-Prints', New York 1971 cat. 1143–1157, 1160, 1345–1350, 1355, 1472–1477

Reynolds Morse Foundation, 'The Draftmanship of Salvador Dalí', Cleveland 1970 cat. 1038

'Salvador Dalí', The Stratton Foundation, Rosenheim 1989 cat. 1439–1462